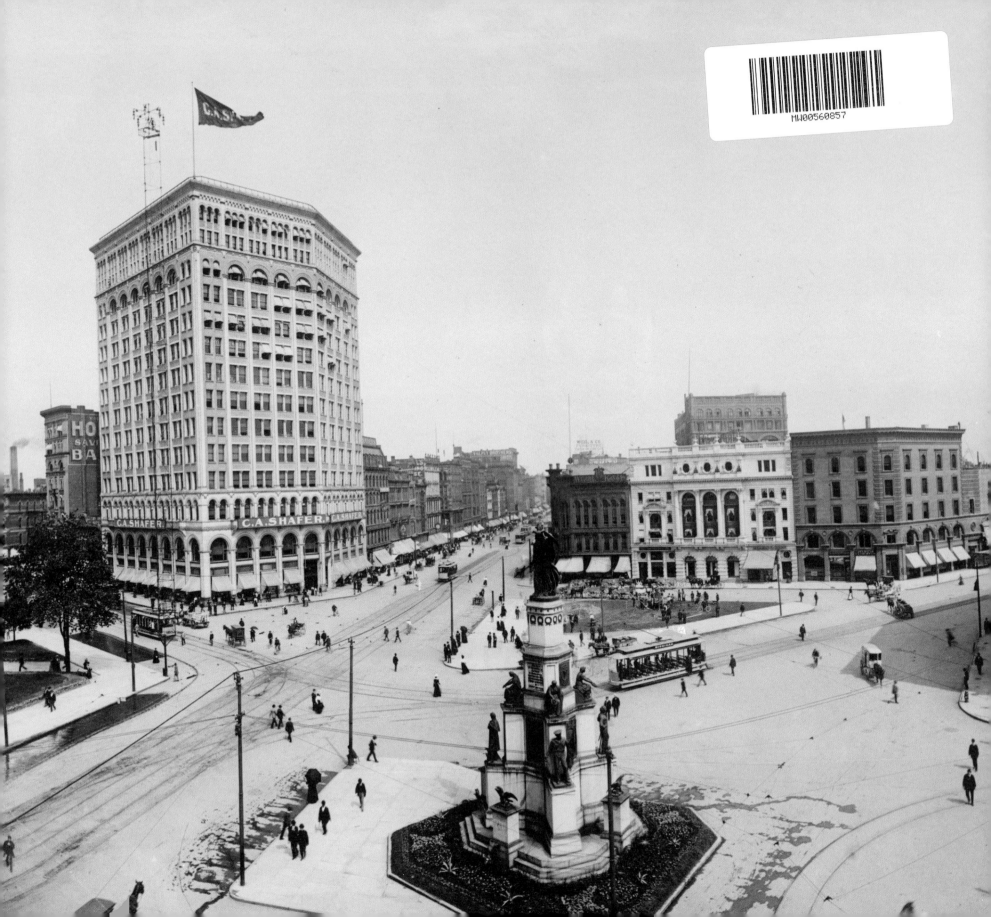

LOST DETROIT

Dedication
To Giancarlo, with gratitude.

Special thanks to: Leslie S. Edwards, Cranbrook Archives; Danielle Kaltz, *Detroit News* Archives; Gregory Piazza, Palmer Park historian; Michelle Fields, Lyon Township Public Library; Ed Burns, Ferndale Public Library.

Selected bibliography
Anderson, Janet. *Island in the city: Belle Isle, Detroit's beautiful island* (Heitman-Garand Co., 2001)
Blum, Peter H. *Brewed in Detroit: breweries and beers since 1830* (Wayne State University Press, 1999)
Brinkley, Douglas. *Wheels for the world: Henry Ford, his company and a century of progress, 1903–2003* (Viking, 2003)
Burke, Thomas. *The history of the Ford rotunda, 1934–1962* (Exposition Press, 1977)
Burton, Clarence. *The city of Detroit, Michigan, 1701–1922* (S.J. Clarke Publishing Co., 1922)
Catlin, George B. *The story of Detroit* (The Detroit News, 1926)
Cohen, Irwin J. *Tiger stadium, Comerica Park: history & memories* (Boreal Press, 2011)
Ewald, Dan. *Celebrating 150 years: YMCA of Metropolitan Detroit, 1852–2002* (YMCA of Metropolitan Detroit, 2002)
Farmer, Silas. *History of Detroit and Wayne County and early Michigan* (Gale Research, 1969)
Ferry, W. Hawkins. *The buildings of Detroit: a history* (Wayne State University Press, 1968)
Freeberg, Ernest. *The age of Edison: electric light and the invention of modern America* (Penguin, 2013)
Gavrilovich, Peter and Bill McGraw, eds. The Detroit Almanac: *300 years of life in the Motor City* (Detroit Free Press, 2000)
Hyde, Charles K. *Detroit: an industrial history guide* (Detroit Historical Society, 1980)
———. *The Dodge brothers: the men, the motor cars, and the legacy* (Wayne State University Press, 2005)
———. *Storied independent automakers: Nash, Hudson and American Motors* (Wayne State University Press, 2009)
Leland, Ottilie M. *Master of precision: Henry M. Leland* (Wayne State University Press, 1996)
Livingston, Patrick. *Summer dreams: the story of Bob-Lo Island* (Wayne State University Press, 2008)
Lodge, John C. *I remember Detroit* (Wayne State University Press, 1949)
Loomis, Bill. *Detroit's delectable past: two centuries of frog legs, pigeon pie and drugstore whiskey* (History Press, 2012)
Magid, Martin. "Jex Bardwell: portrait of an early Michigan photographer" *Michigan History* (Nov/Dec 1989)
Mason, Philip P. "Grace…" *Pacemaker* (Fall 1987)
Poremba, David Lee, ed. *Detroit in its world setting: a three hundred year chronology, 1701–2001* (Wayne State University Press, 2001)
Szudarek, Robert. *The first century of the Detroit Auto Show* (Society of Automotive Engineers, 2000)
Tottis, James W. *The Guardian Building: cathedral of finance* (Wayne State University Press, 2008)
Voyles, Kenneth H. *The enduring legacy of the Detroit Athletic Club: driving the Motor City* (History Press, 2012)
Woodford, Frank B. and Arthur M., *All our yesterdays: a brief history of Detroit* (Wayne State University Press, 1969)
Woodford, Frank B. *Parnassus on Main Street: a history of the Detroit Public Library* (Wayne State University Press, 1965)

Internet Resources: www.historicdetroit.org; www.detroitnews.com; www.freep.com

Other resources: Cranbrook Archives; *Detroit Free Press* Historical Database; *Detroit News* Archives; Detroit Public Library, Burton Historical Collection and National Automotive History Collection; Wayne State University, Walter Reuther Archives.

Picture credits
Library of Congress: 7, 14–20, 21 (left), 22–23, 26–30, 31 (left), 34 (left), 35–38, 40–42, 43 (right), 44–46, 49 (right), 51–54, 57, 59, 61–63, 65–69, 70 (left), 73, 76, 78, 79 (left), 80–81, 84–87, 88 (left), 89, 92 (left), 93, 98–99, 101–103, 106–107, 109–111, 114 (top), 116, 118–119, 122–125, 126 (top), 128, 129 (left), 130–131, 134 (top), 135–136, 139.
Detroit Public Library: 8–9, 10 (above and above left), 12–13, 21 (right), 24–25, 33, 34 (right), 39, 43 (left), 47 (left), 48, 50, 55, 58, 64, 72, 74, 77 (right), 79 (right), 88 (right), 90, 92 (right), 94, 104, 108, 112, 113 (left), 114 (bottom), 115, 120–121, 126 (bottom), 127, 134 (bottom), 140. **Anova Image Library:** 10 (below), 47 (sidebar), 56, 60 (right), 70 (sidebar), 95, 105 (right), 113 (sidebar), 138 (bottom), 141 (bottom). **Corbis:** 60 (left), 82, 100, 132, 141 (top). **Walter P. Reuther Library, Wayne State University:** 31 (sidebar), 49 (left), 71, 91, 142. **Henry Ford Museum:** 83 (below and below right). **Cranbrook Archives:** 96–97. **AP Photo/Bill Ingraham:** 83 (sidebar). **Tom A. Wilson:** 105 (left). **Donn Thorson:** 117. **British Library:** 129 (right). **Central Business District Foundation:** 133. **Sony Music Entertainment:** 137. **Kevin Mueller:** 138 (top). **Goldnpuppy:** 143.

Endpapers
Front: Campus Martius, 1899 (Library of Congress).
Back: Bird's Eye View of Detroit, 1889 (Library of Congress).

First published in the United Kingdom in 2013 by
PAVILION BOOKS
10 Southcombe Street, London W14 0RA
An imprint of Anova Books Company Ltd

© Anova Books, 2013

ISBN: 978-1-90910-871-4

A CIP catalogue record for this book is available from the British Library.

10 9 8 7 6 5 4 3 2

Repro by Rival Colour Ltd, UK
Printed by 1010 Printing International Ltd, China

www.anovabooks.com

LOST DETROIT

Cheri Y. Gay

PAVILION

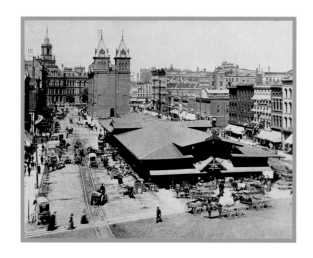
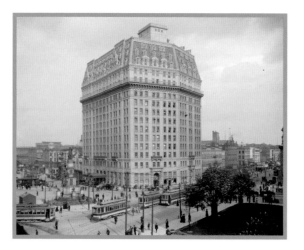
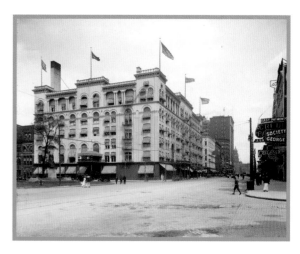

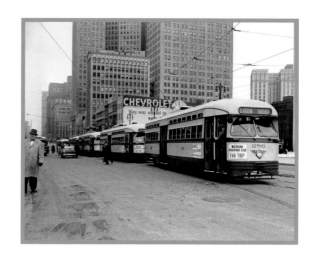
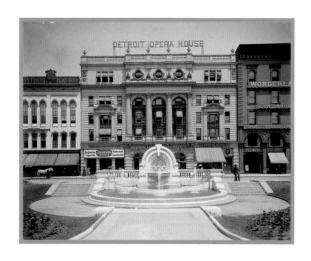
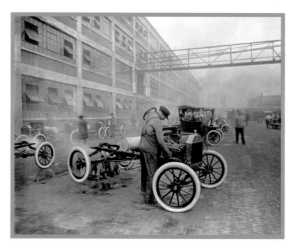
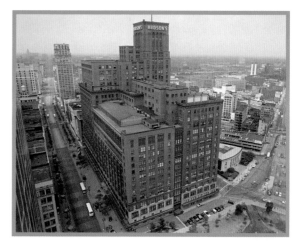

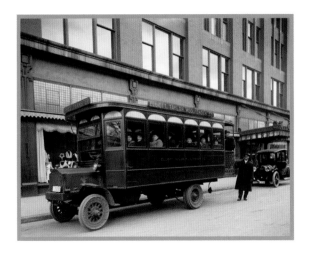

LOST IN THE...

INTRODUCTION

Founded on the Detroit River in 1701, Detroit's first loss came with the fire of 1805 that destroyed the entire town. It was rebuilt, a new and improved Detroit, using the plan devised by Judge Augustus Woodward, one of three territorial justices sent by President Thomas Jefferson to administer the newly created territory. Judge Woodward, drawing upon ideas espoused by his friend Jefferson, and an acquaintance, Charles L'Enfant, designer of Washington, D.C., created the diagonal pattern of streets and parks that gives Detroit its unique downtown, and spoke-like street configuration.

Detroit's location on the Detroit River, connecting Lakes Erie and St. Clair, spawned the early ribbon farms, narrow parcels of land about two acres wide, and around 40 acres in length, that began at the Detroit River and ran perpendicular to it. Those farm parcels are represented today by streets with names like Campau and Rivard, after the early land owners. It all started at the river.

With its 1805 redesign, Detroit began its transition from a military and fur trading outpost to industrial center of the Midwest. Shipbuilding companies dominated the riverfront in the early and mid 19th century and businesses hugged Jefferson Avenue parallel to the river. When the Erie Canal opened in 1825, Detroit was on its way. Immigrants and others began flooding the Midwest and beyond.

Once the business district moved from Jefferson to Woodward Avenue, which runs north from the river, the flow of activity took a turn and downtown Detroit began to take shape, taking the form familiar to us today. Detroit and Michigan's access to natural resources created the lumber industry, then iron-related industries (Detroit was the largest producer of iron stoves in the country), which in turn brought more people and other industries, like shoe making and the manufacture of men's clothing. Michigan Central Railway, laying tracks from Detroit to Chicago, and the other railroad companies, were a major factor in Detroit's growth. Population effectively doubled each decade, from 1840 until 1930, and the city more than doubled in land size between 1880 and 1907.

This book is about returning to those days of Detroit's past, and looking at what's gone, what was "lost." Photographs of buildings, businesses, and parks that are no longer part of the Detroit landscape, and descriptions of their history, architecture and the personalities behind them help us renew our collective memory and maybe provide some pleasure as we reminisce about what once was. By no means comprehensive, this book takes a look at some of Detroit's "oldies but goodies" along its journey through the late 19th and into the 20th century.

The Wayne County Building, built between 1896 and 1902, standing at the eastern end of Cadillac Square, reminds us of what we are missing: old City Hall with its statue-adorned architecture couldn't survive the mid-century move toward modernism; the old Federal Building and Post Office on Fort Street fell victim to outdated and undersized facilities; the Hammond and Majestic Buildings, framing City Hall, gave way to the need to reinvent.

We know Detroit's iconic merchants and industrialists: Fred Sanders, J.L. Hudson, Henry Ford; are familiar with the well-known brands of Goebel, Packard, and Cadillac; have visited the places where Detroiters played, Belle Isle and Bob-Lo. But have you heard of Elliott-Taylor-Woolfenden, or seen the first Detroit Edison Power plant, or the 100–200-foot street light towers that lit up the city at the end of the 19th century? What do you know of the Walker Block, or the Edelweiss Café where the Kiwanis were founded, or Whitney Warner Music Publishers that gave ragtime composer Fred S. Stone a break?

Today, as Detroit and the metropolitan region work to solve the mass transit problem, reflect on the fact that Hazen Pingree, a populist 19th century mayor, decried the private franchise monopoly on streetcar services, and advocated for city management of the system. It was the same with city lighting. Nineteenth-century Detroiters had their own problems as two competing light companies filled the landscape with duplicate sets of light towers, guy wires strung out in all directions, creating real hazards. Ironic though it is now, the solution was found in city management of the lighting department.

Stadiums outlived their usefulness as teams and team owners wanted more modern, more comfortable facilities. Whether we attend Detroit Tigers' games in Comerica Park or not, there's an ache in our hearts for what stood at Michigan and Trumbull. The rafter-shaking roars at Olympia Stadium still ring out in our memories.

Theaters, the Michigan, United Artists, and others, whose elegant and fancy interiors gave one a thrill upon entering, all long closed, as television, then theater complexes, replaced them. Kern's, Crowley's, and Hudson's fought to maintain their downtown stores, forced to close because shoppers stopped coming to the city center, preferring the shopping malls' free parking and other conveniences. Many of those bygone buildings grace this book.

On the edges of downtown, haunting us with the disgrace of their neglect, sit the Michigan Central Railroad Station, the Packard plant and the as yet intact remains of the Highland Park Ford factory. These are lost in a different sense, still with us, but abandoned.

The automobile industry blossomed here in part, because of Detroit's skill and experience with metal and iron work, along with human resources the likes of Henry Ford, Ransom Olds and Henry Leland, to name a few, and the workers of course. The complex and rapidly changing evolution of the early car companies is a story in itself, not to mention that of its architectural accomplice, Albert Kahn. Besides the vacant hulks of Packard and Highland Park's Ford plant, little is left of those early days. But we remember.

Several of the lost buildings found their end in the inglorious razing of a number of structures for Detroit's hosting of the 2006 Super Bowl. The Statler Hotel and Madison-Lenox Hotels were demolished at that time.

As Detroit begins its 312th year, gathering itself, taking a breath, and preparing to meet its challenges head on, there's a large and deep historical reservoir from which to draw strength. At this particularly difficult time in Detroit's history, we can look back, and take some solace in the fact that history is a cycle and this is not the first time that Detroit, "Arsenal of Democracy," has met challenges.

In 1968 W. Hawkins Ferry, Detroit's preeminent chronicler of buildings and architecture, commented "Constantly destroying itself, the city has radically changed from generation to generation, and each generation has remolded it to satisfy its own ideals." As we look back to what was lost in Detroit, we look forward to its reformation.

RIGHT *Elliott-Taylor-Woolfenden department store, c. 1910 (see page 43).*

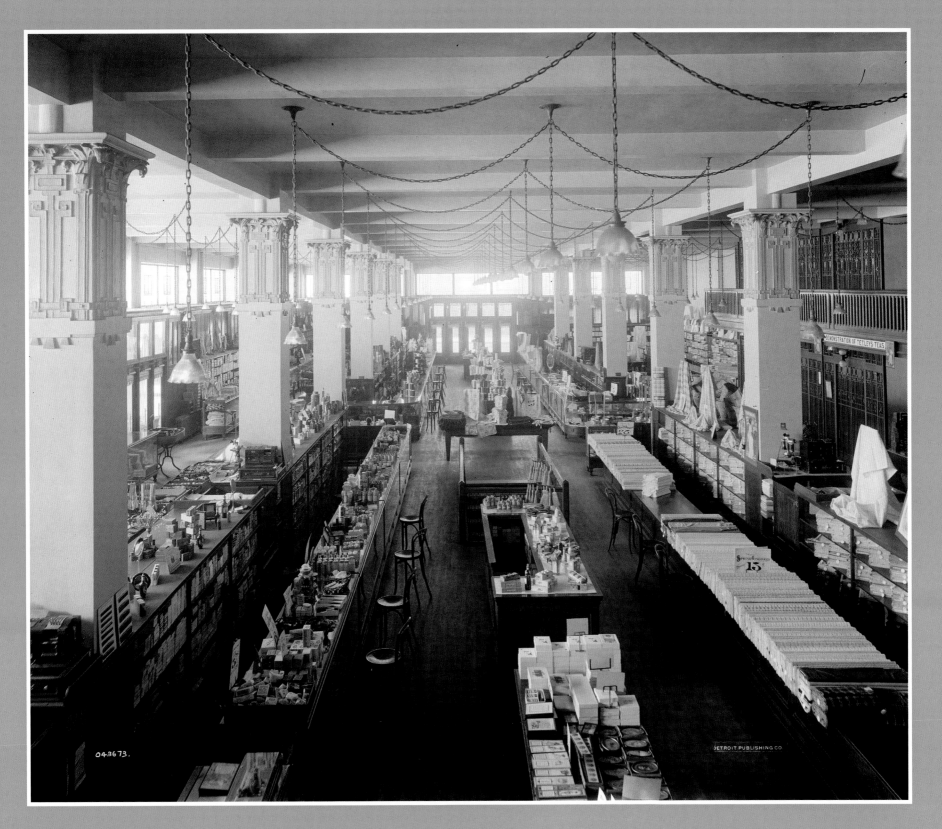

Central Market Building DEMOLISHED 1893

Architects George D. Mason and Zachariah Rice joined forces in 1878 as Mason & Rice, and for 20 years designed a number of notable local buildings including the first Dexter M. Ferry warehouse, the Detroit Opera House, the Hiram Walker and Sons building in Windsor, the Grand Hotel on Mackinac Island, plus many private homes. The firm was also known for mentoring Albert Kahn; their office was his training ground from 1884 to 1895. In 1898 George Mason struck out on his own and continued to create significant structures in Detroit.

In these early years the young architects still had to prove themselves, and after building a stable for Thomas Berry of Berry Brothers, they were awarded the commission for Detroit's Central Market Building. Built in 1879–80, and sandwiched between the Detroit Opera House to its north, and the Russell House hotel to its south, the three-story brick structure with stone accents fit in perfectly.

The building occupied the spot where old City Hall stood, on the east side of Woodward at Michigan Avenue, directly across from the new City Hall. After the new City Hall opened the old one came down in 1872. The area behind it had been a site for a vegetable market since 1843, having moved up Woodward from the riverfront. In an effort to make the area more organized, an architect was hired in 1860 to build a substantial shelter for vendors and shoppers alike. John Schaffer designed a 70 by 242 foot structure supported by 48 iron columns, with a slate roof. At first just fruits and vegetables were sold in the market but gradually everything from clothing, shoes and labor was offered.

The Central Market building housed butchers on the first floor, city offices on the second and the superior court on the third floor. In 1883 the city earned $9,800 in revenue from the first floor rental to butchers, over $200,000 today. Ten years later, as the city battled to close and demolish the market building, officials recalled some of the logic behind its construction, "it would give the working people of the city a hall in which their meetings could be held, but it proved a serious disappointment in this direction."

In 1892 the city decided it had had enough of the disturbances caused by a market in the center of downtown, wanting to clean up the area and create a more park-like setting. A year earlier

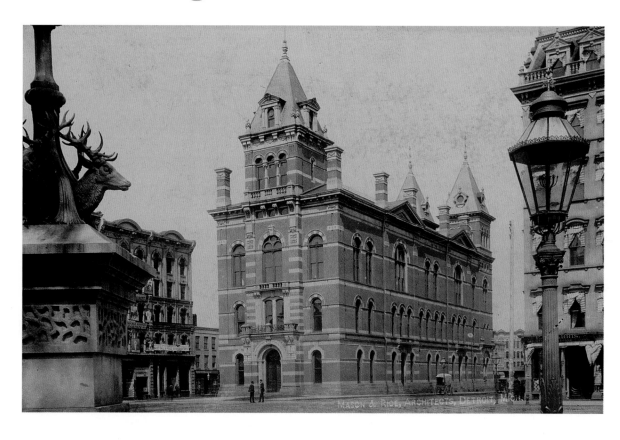

Eastern Market had opened at Gratiot and St. Aubin, and Western Market at Michigan Ave. and 18th St., providing the city with extensive market areas. But the butchers in the market shed would not go quietly, even taking their case to the Michigan Supreme Court after the City Council voted to close the market. In 1893 the cadre of cleaver-wielding butchers was defeated, and the Central Market Building was demolished. The shed behind it was disassembled and moved to Belle Isle, where it was put to use as a horse shelter.

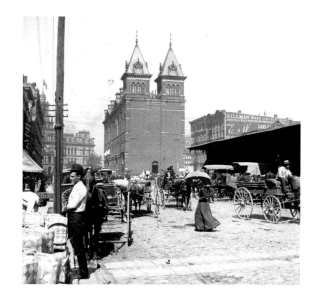

ABOVE *Central Market, between the Detroit Opera House on the left, and the Russell House on the right.*

RIGHT *Many city officials wanted the building and its assorted peddlers removed from downtown Detroit.*

OPPOSITE PAGE *Looking west over the shed with City Hall and the Central Market Building in the background.*

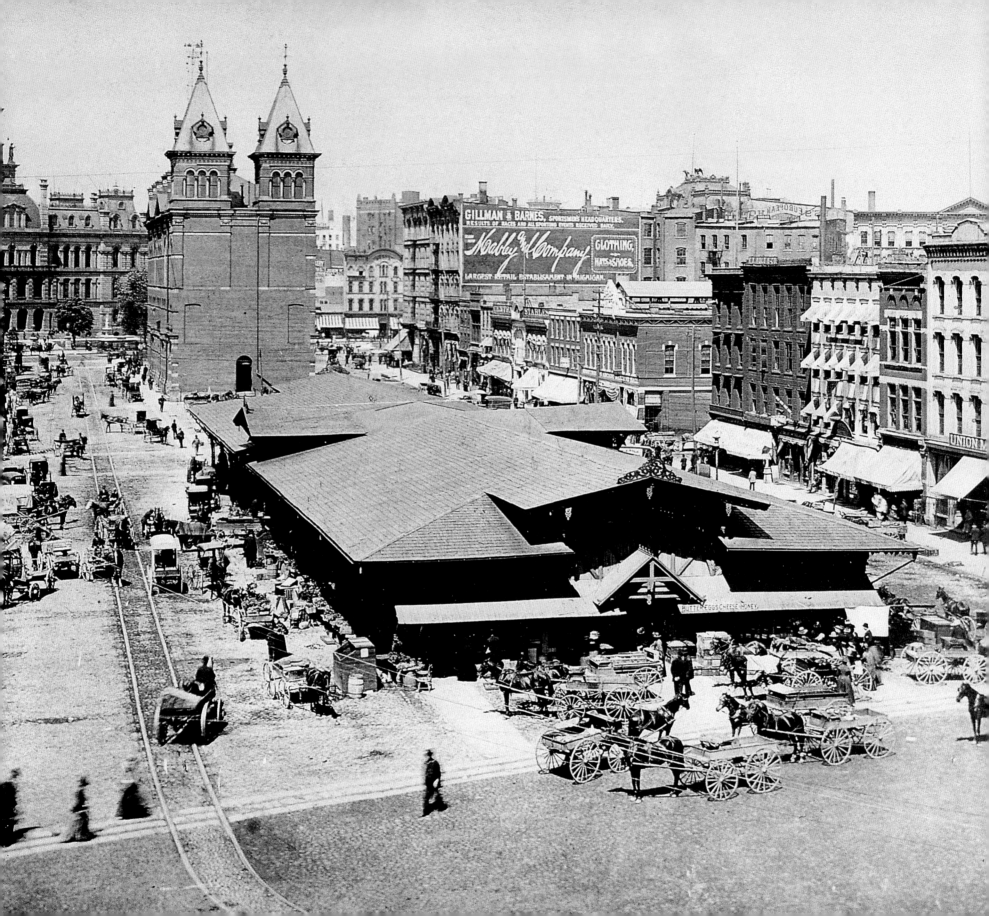

Detroit International Fair and Exposition Pavilion **LAST HELD 1893**

When it opened on September 17, 1889, it was called the largest exhibition building in the world. Architect Louis Kamper, inspired by the towers and Gothic detail of London's Houses of Parliament, designed this building in all-wood, but with an attitude of permanence. German-born Kamper had worked in the New York office of McKim, Mead and White and moved to Detroit one year before. He would go on to design major landmark buildings in Detroit, including the Frank H. Hecker house, the Book-Cadillac Hotel and the Water Board building, all still standing.

Built on the outskirts of the city between the western edge of Fort Wayne and the unincorporated suburb of Delray, the pavilion was situated on West Jefferson, on 70 acres of Detroit riverfront, four miles from City Hall. It wasn't connected to the Michigan State Fair, though there were barns, animal exhibits, industrial displays and of course, the largest pumpkin. It was more akin to a World's Fair, coming on the heels of the Philadelphia Exposition of 1876 and aspiring to be the site of the Columbian Exposition of 1893, which landed in Chicago.

Detroiters worked themselves into a frenzy for the preparations. The former wasteland where the Fair was to be held was readied in four months, costing over $500,000. Five hundred benches were spread around the grounds for the weary fairgoers and the main building would blaze with 150 lights in the evening. The daily newspapers carried an "Exposition Bulletin" for days ahead of the opening, informing visitors of the fair hours, admission, railroad rates, ferry departures, street car lines and hotels.

Exhibitors came from around the country, including 31 railroad cars of sheep, cattle and swine from Buffalo and tobacco exhibits from Georgia and North Carolina. Local stores hastened to take advantage of the increased traffic to the city, a Mabley announcement advising: "Strangers visiting the Detroit Fair should not fail to cover the expenses of their trip by making their purchase where prices are guaranteed to be 10 to 15 per cent lower than can be found elsewhere." The Wright Kay jewelry company was sponsoring an English bell ringer who would play the 15 bells in the large tower of the exposition building.

A more exotic attraction was the hot air balloons carrying aloft trapeze artists, who would perform in the troposphere. There was also an art gallery, restaurant and race track. Eight ferries from downtown Detroit obligingly added routes to the fair, operating day and night, and 1,800-foot-long docks were built for the purpose. Seventy deputy sheriffs would oversee the festivities during the 10 days of exhibition.

The last exposition was held in 1893, outdone as it was by the Columbian Exposition in Chicago. In 1895 the land was purchased by the Solvay Process Company, which made products derived from salt, like soda ash.

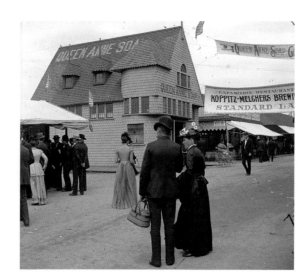

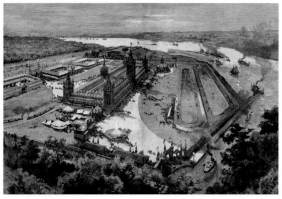

ABOVE *Local companies, like the Detroit Soap Co. with its Queen Anne's Soap, and Koppitz-Melchers Brewing, found plenty of opportunity to promote their businesses at the Fair. Perhaps this couple is listening to a huckster's invitation from the booth before them.*

ABOVE LEFT *Tractors were just one of the machines exhibited, along with other agricultural implements and halls full of mechanical and industrial equipment.*

LEFT *This detailed drawing shows the extent of the Exposition on its 70 acres of grounds on the riverfront where the Detroit and Rouge Rivers converge.*

RIGHT *The stately Gothic architecture of the Exposition building belied all the fun that the Fair provided. The 20-story main tower gave visitors a rare, bird's-eye view of the area.*

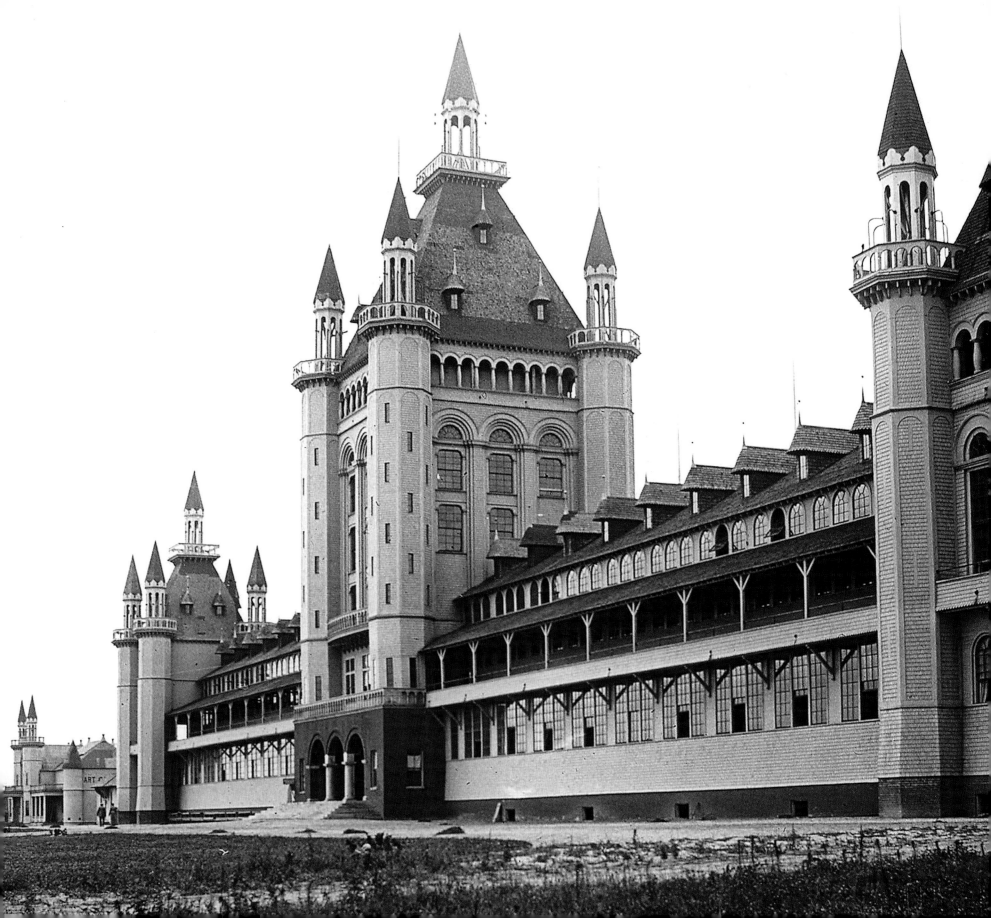

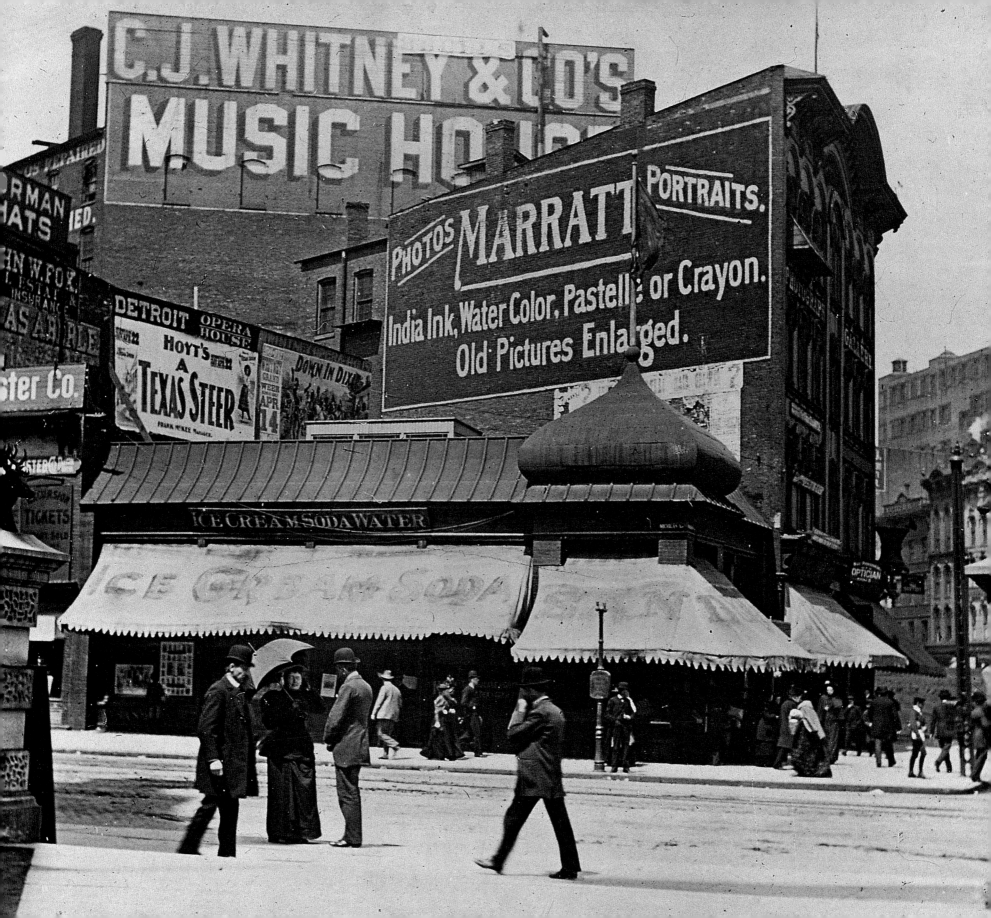

Sanders Pavilion of Sweets TORN DOWN 1894

What could be better than an ice cream soda on a hot day? It's hard to believe that prior to 1875, this treat was unknown, in Detroit at least. These photos show the second location, at Michigan and Woodward, of the Pavilion of Sweets. Its founder, Fred Sanders, was German-born, and returned to Germany as an adult to study chocolate-making. Originally named Frederick Sanders Schmidt, he shortened his name to avoid competition with his father, a baker in Illinois. After owning several confectionaries elsewhere, he wound up in Detroit where he opened a store at Woodward and Gratiot in 1875.

The much repeated story is that, not wanting to disappoint customers thirsting for a cream soda, and finding he was out of cream, Fred Sanders used ice cream instead to mix with the soda water and chocolate, thereby concocting the ice cream soda. The novelty increased his business so much that he had to put additional horse blocks outside. In 1876 he moved north to Campus Martius, opening a larger store at Woodward and Michigan Avenues, and naming it the Pavilion of Sweets. This distinctive-looking building, though from another era, represents Sanders to many Detroiters today.

The Pavilion was a popular spot for tourists and Detroiters alike. In 1893 Sanders bought a magnificent soda fountain, originally displayed in the Chicago World's Fair, for his Campus Martius store, which he enlarged by purchasing the Fisher Block next door. A year later, however, he was forced to move to accommodate the construction of the Majestic Building on that corner, and the iconic store was torn down.

After a brief interlude at a temporary spot, the business eventually settled into its last downtown location, on the west side of Woodward between Michigan and State, in 1896. It was the site of an earlier Hudson's store, as evidenced by the advertisement on the building. The Pavilion of Sweets was renamed the Palace of Sweets, the main attraction still its soda fountain and its candy. It wasn't until 1913 that the company added baked goods to their repertoire of sweets.

The business expanded so that by the 1920s it had more than a dozen locations throughout the city. In 1956 a fire destroyed the downtown store and it was rebuilt with a contemporary, midcentury modern facade.

Like the food they served, the early Sanders stores were made with the finest materials, marble counter tops and beautiful lighting fixtures. The later stores were more contemporary but still with the "soda fountain feel." They were meeting places for an afternoon hot fudge cream puff or a stopping place for lunch while shopping. Sanders was the first to lower lunch counters to table level, a popular innovation.

The family-owned company was sold in 1988 to Country Home Baker's, then felicitously in 2002, to Michigan-based Morley's Candy Company. Its products still line grocer's shelves and Sander's stores have reopened throughout the area. Sander's fudge sauce and bumpy cakes live on.

OPPOSITE PAGE *The exotic-looking Pavilion of Sweets, at the corner of Michigan and Woodward Avenues, was the second location for Fred Sander's confectionary shop and attracted locals and tourists alike in search of an ice cream soda or other treat.*

BELOW *In 1893 Fred Sanders expanded his store along Woodward, occupying the Fisher Block. The flamboyant Hotel Cadillac is visible farther down Michigan Avenue.*

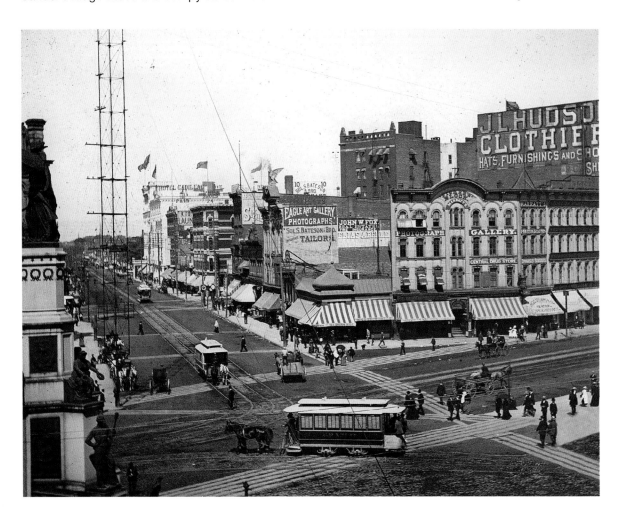

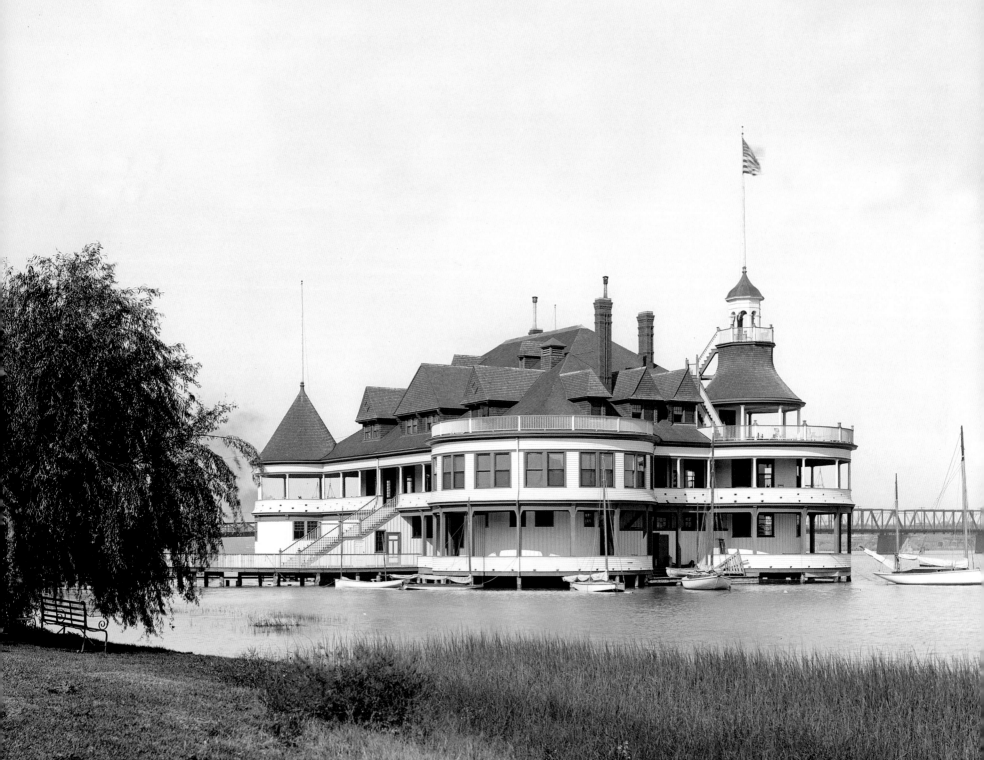

07383 DETROIT BOAT CLUB, BELLE ISLE. DETROIT PHOTOGRAPHIC CO.

Detroit Boat Club DESTROYED BY FIRE 1901

The Detroit Boat Club burned three times in a little over 60 years, but kept rebuilding. The photo opposite is of the third building that burned. Organized in 1839, it calls itself the oldest yachting club in the Americas, oldest continuous rowing club in the world and the oldest boating club in the U.S. Not to mention being the oldest social club in Michigan.

Racing began almost immediately after the club's founding. The route was between the first club house on the river's edge at Hastings Street and Hog Island (not yet acquired by the city and renamed Belle Isle). Still, it had the reputation of a social club. Historian Friend Palmer describes the scene: "In those early days the club was largely a social organization and barge parties on the river were extremely popular. …Garbed in [a] natty uniform the young sailors were wont to take the barges up the river on balmy, moonlit nights, the foremost young ladies of Detroit's society by their sides … "

But race they did. At first, four-oared and 10-oared barges were used, then the shells known today. In 1867 the Detroit River Navy was formed by a coalition of rowing clubs for the purpose of regattas. In August 1877, during the annual contests among rowing associations, the Detroit River Navy held its second annual regatta in the channel between Belle Isle and the Detroit shore. The National and Northwestern Amateur Rowing Associations also took part in the races for 10-oared barges, single sculls and double sculls. All race participants had to wear "rowing costumes that fully covered the body" and part of the entertainment for the week was an excursion on three ferry steamers "lashed side by side."

The Detroit Boat Club's first two clubhouses were on the mainland, the third, fourth and fifth on Belle Isle. The first Belle Isle building (1891–93), was on the north shore of the island by the bridge. After it burned, this second building was designed in 1894 by architects Donaldson and Meier, who also built the first Belle Isle Casino. Long verandas that wound around the building offered excellent viewing of races on the Detroit River. Unfortunately, in 1901 this club also was destroyed by fire.

The fifth and final club, opened in 1902, was a fireproof concrete structure built by Alpheus Chittenden. It remains today, but the Detroit Boat Club, declaring bankruptcy after the city raised the rental fee on the club house property, moved out of Detroit in 1996. The building is now used by the Detroit Rowing Club.

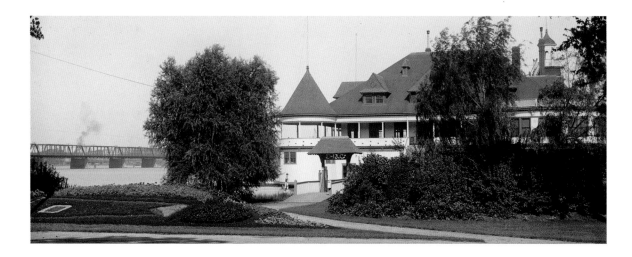

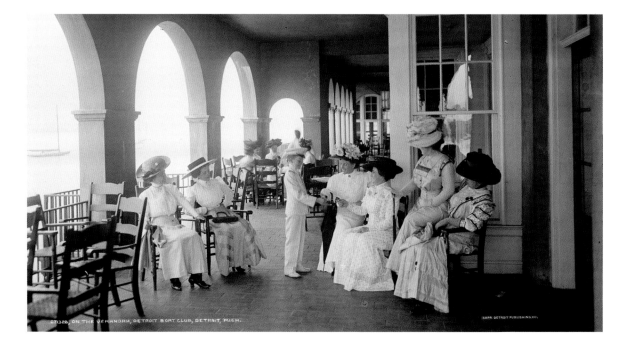

OPPOSITE PAGE *The third home of the Detroit Boat Club featured wide verandas, excellent for viewing the many racing and boating events on the Detroit River.*

TOP LEFT *The 1894–1901 Detroit Boat Club building was located where the current building is today, on the north shore of Belle Isle, next to the Belle Isle Bridge.*

LEFT *These women are seated on the porch of the final structure of the Detroit Boat Club, which still exists today. Opened in 1902, this fireproof building replaced the wooden, turreted club that burned in 1901.*

Russell House CLOSED 1905

Overlooking the city's Campus Martius, the closest thing Detroit has to a town square, the Russell House saw much in its day. In 1861 the First Michigan Regiment received its colors before marching off to the Civil War. Mobs crowded Campus Martius the day after Lincoln's death. After the Civil War, a 60-foot tall Soldiers and Sailors Monument took its place just outside its doors. In 1891 hordes of Civil War veterans paraded past the hotel as the Grand Army of the Republic celebrated its silver anniversary. And at the turn of the century, just before the hotel's demise, it witnessed street cars, horse-drawn vehicles, and the new-fangled automobile all jostling for position at the city's main intersection.

In its day the Russell House was Detroit's most prominent hotel, and in a prominent location, on the southeast corner of Woodward and Michigan Avenues. The Prince of Wales stayed there in 1859, perhaps the most oft-repeated example of the hotel's status. The National Hotel occupied the spot before, since 1836, going through various owners and renovations. When the Russell House opened on September 28, 1857 it was practically a new building; its $2.50 a day rate, for one of its 225 rooms, was considered outrageous. W.H. Russell was the owner, therefore the name. As with the previous hotel, changing owners and building improvements became constant.

Only men were allowed in the bar, but both sexes dined in the restaurant which offered such delectable fare as *fricandeau* of lamb, snipe broiled á l'American, French pease [sic] and dry Manhattan cocktails. In 1874 the meal schedule was: Breakfast 6:30–10; Dinner 1–2:30; Tea 6–8; and Supper 8–10, in the European style. The hotel was rebuilt in 1881 with, as W. Hawkins Ferry put it, "an inevitable Mansard roof."

An interesting story, told by Hudson store chronicler Jean Maddern Pitrone, is that C.R. Mabley's clothing store, adjoining the Russell House, had a secret door that led into the Russell House bar, to which Mabley would repair for several hours at a time. J.L. Hudson, who roomed at the Russell House and was working for Mabley, was sometimes called upon by Mrs. Mabley to locate her wayward husband and steer him home.

In 1890 the hotel was refurbished with 30 additional bathrooms, no doubt a result of

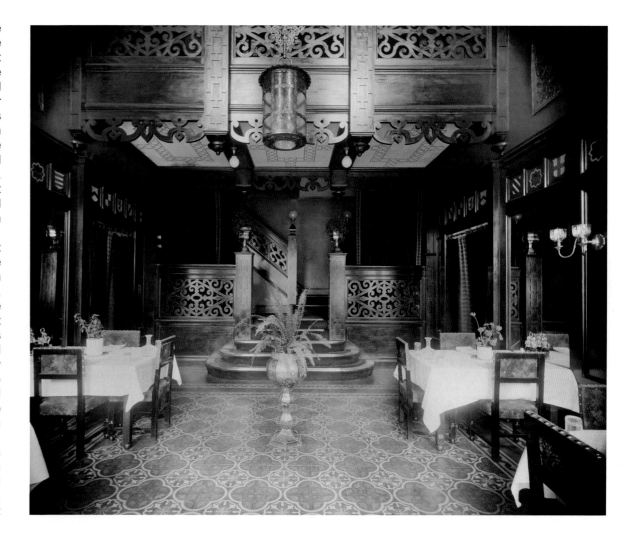

competition from the recently opened Hotel Cadillac. At the same time, the "ordinary" and breakfast rooms were outfitted with Spanish mahogany wainscoting, and "elegant chiseled stone and tile fireplaces" were put in. But when the Hotel Ste. Claire opened in 1893, the Russell House could no longer compete.

The hotel closed on November 19, 1905 and demolition began one year later. It had a 50-year run before being replaced by the Pontchartrain Hotel, which opened in 1907. William J. Chittenden, Jr. son of chief clerk, and part owner of the Russell House, went on to manage the Pontchartrain.

ABOVE *Many a delectable meal was enjoyed in the fashionable restaurant of the Russell House, where events from weddings to company luncheons were hosted for close to 40 years.*

RIGHT *The Russell House is mentioned in an 1866 letter from Ralph Waldo Emerson to his wife Ellen as "where the Prince of Wales and I always stop." As "one of the most comfortable, convenient, and desirable stopping places for the tourist seeking immunity from monotony," the Russell House was the focus of Detroit's downtown scene.*

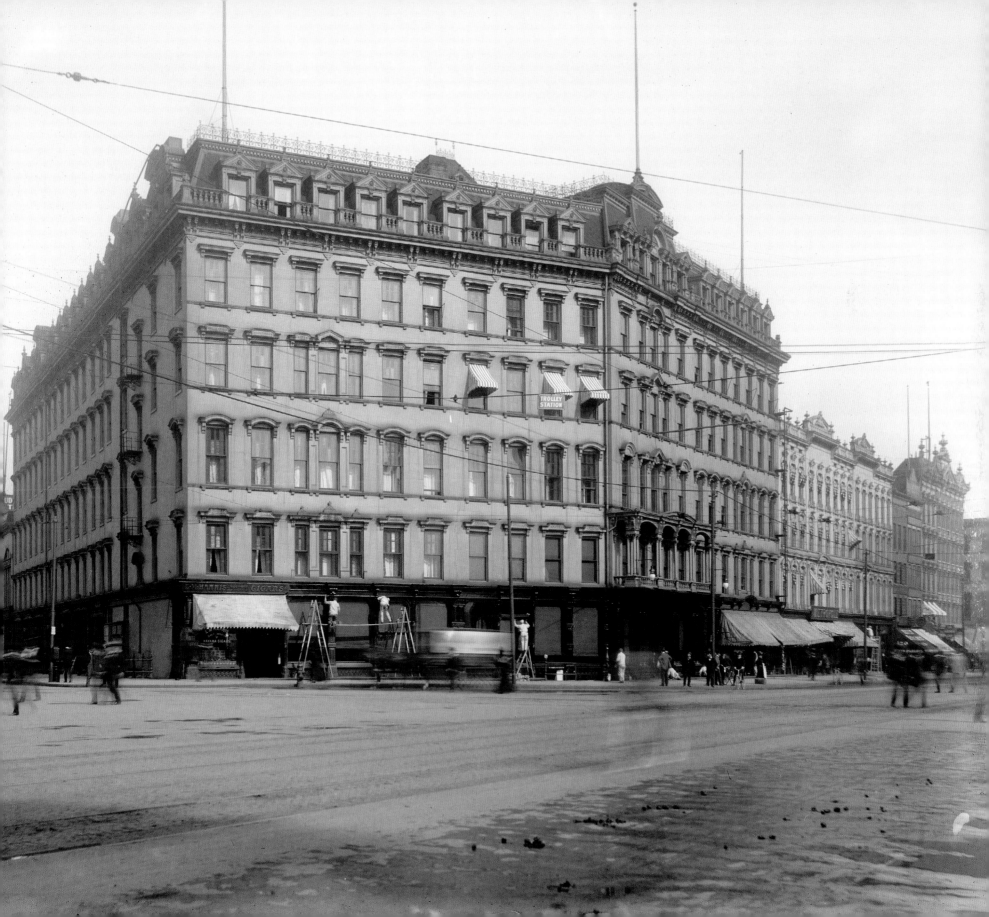

Belle Isle Casino REPLACED 1908

What was once called Hog Island became a beautiful isle after Frederick Law Olmsted put his touch to it. Belle Isle, in the Detroit River midway between Detroit and Windsor, Canada, has provided more than a century's worth of year-round pleasure with its structures, water and open spaces. It's still there, and enjoyed by all, though over the years the buildings have come and gone.

The island was purchased in 1879, one year before Detroit's population would double from the previous decade. A State Act authorized the purchase of the island for $200,000, against much opposition although other large cities, like Cincinnati, San Diego, Milwaukee and New York

City had already established major public parks, some with water reservoirs as a central feature. The same State Act also included authority to buy land necessary to create Grand Boulevard, the city-encircling street whose eastern end would begin on the shore opposite Belle Isle.

It wasn't until 1882 that James McMillan, president of the Belle Isle Park Commission, informed Detroit Common Council that it had hired Frederick Law Olmsted, for $7,000 "to furnish a general comprehensive plan for the improvement of the Park … " Perhaps best known for designing New York City's Central Park, Olmsted's ideas for a naturalistic park included a central avenue, canal

system and opening of the landscape by removing unnecessary foliage from the forest. Some of these ideas were adopted but amidst much bickering among Council Aldermen, Olmsted resigned in 1885.

Against his advice, a number of structures were put on the island, including this casino, completed in 1887 and designed by Donaldson and Meier. Featuring the shingle-style construction popularized in the late 19th century, the 8,000 square foot casino was the second structure to be completed on the island, after the ferry dock. Located at the western tip of the island, the charming building with its generous use of balconies and verandas lasted until 1908. A new casino, designed by architects, Van Leyen and Schilling using construction techniques developed by Albert Kahn's brother, Julius, was built near the Canadian-facing side of the island and opened in May 1908. Today it is still used by Belle Isle visitors.

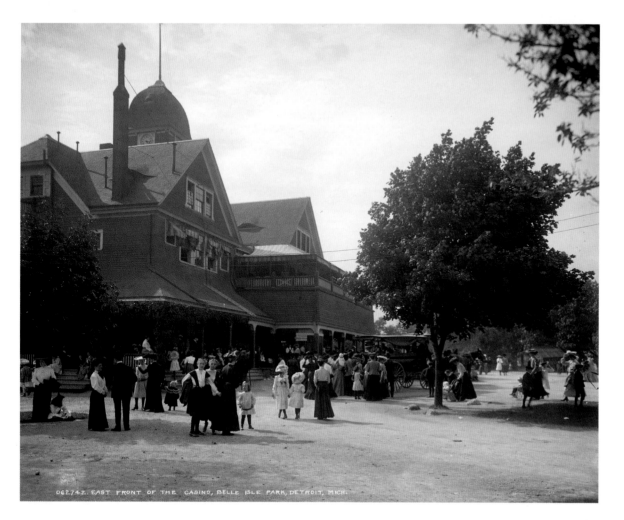

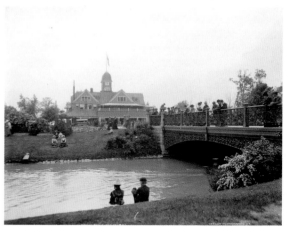

ABOVE *A canal next to the Casino, with its decorative, wrought iron bridge, provides grassy banks for relaxation and contemplation.*

LEFT *With 8,000 square feet of space, the Casino was the site for many a summer fête.*

RIGHT *The comfortable and cool retreat was popular in the summertime with its proximity to the Detroit River, near the ferry dock at the western end of Belle Isle.*

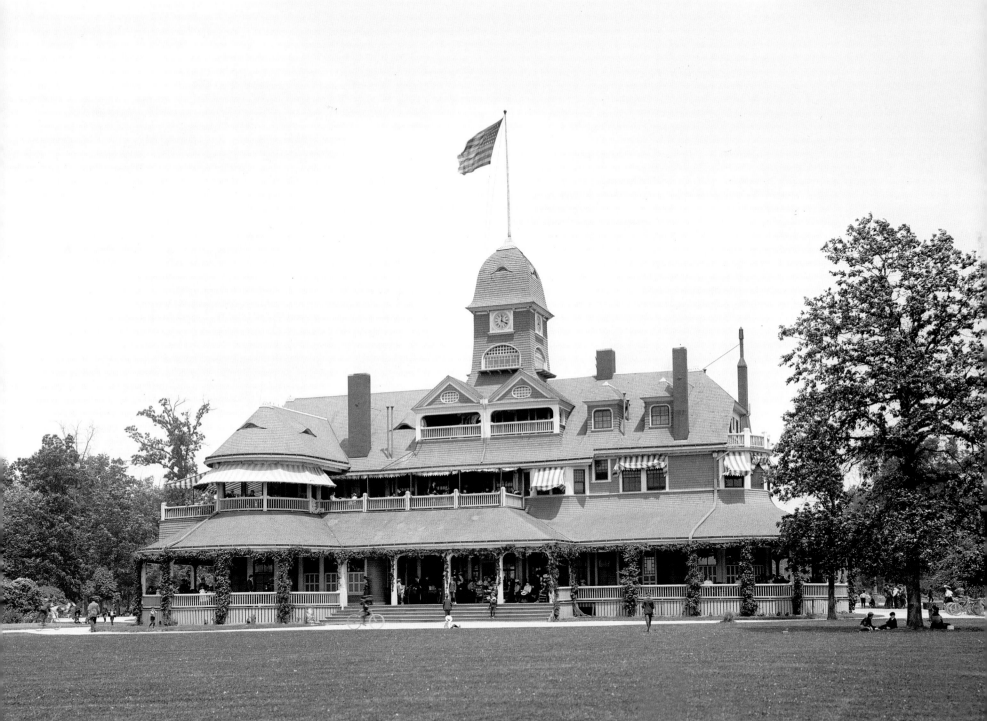

08985, THE CASINO, BELLE ISLE, DETROIT.

DETROIT PHOTOGRAPHIC CO.

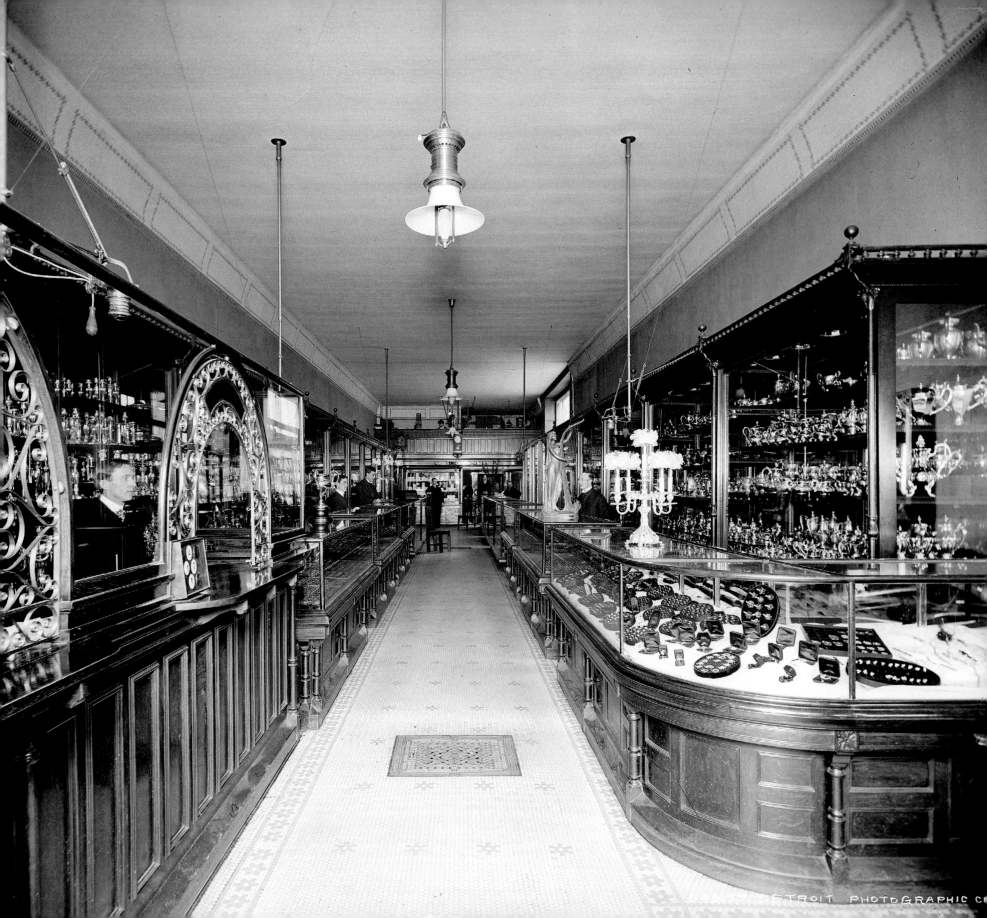

DETROIT PHOTOGRAPHIC CO.

Traub Bros. & Co.

WOODWARD AND CONGRESS STORE CLOSED 1909

Christian and Jacob Traub came to America from Germany in 1848 and settled with their family in Ann Arbor. Christian began working in the jewelry business in Detroit in 1856. He next worked at Duncan & Traub, on Jefferson next to the Biddle House, then took in his younger brother Jacob, the two forming their own company, Traub & Brothers in 1860.

Around 1870, Traub Brothers did the silver plating for the Pullman Company, when Pullman cars were made in Detroit. One of a dozen jewelers in Detroit in the late 19th century, Traub specialized in Swiss and American watches, door plates, sea shells and "fancy goods." The company had several locations on Jefferson, as they slowly made their way toward Woodward.

In 1879 the company relocated to the new center of commerce, Woodward and Congress, near the Russell House hotel, where they first set up business at 118 Woodward. While keeping that store, the brothers moved "uptown" in 1895 to the

southwest corner of Woodward and Grand River. When Jacob died in 1915, Christian retired, turning the business over to his sons, Robert C. and William H., thus maintaining the Traub Brothers company name. The building at 118 Woodward, occupied up to 1909, was taken over by Grand Trunk railway as a ticket office, and is in use today as a pub. After closing that store, the business occupied a nearby 110 Woodward location until 1915.

The remaining Traub Brothers Jewelry Store at Grand River stayed in that location until 1933 when it moved to Washington Boulevard and Clifford. After the move, as the building was being prepared for a new tenant, the Sallan jewelry store, workmen uncovered murals on the walls showing scenes of Oriental tea gardens. Before Traub occupied the store it had been the home of well-known tea merchant, L.B. King.

When the Woodward and Grand River store closed in 1933, it took with it a large, round clock topped by a giant, spread-winged eagle, which like

the Kern clock farther south on Woodward, was a landmark for many. The clock was originally at the corner of Woodward and Jefferson, above the M.S. Smith & Company jewelry store. When the Smith Company moved to Woodward and State, the clock was put in storage, but the eagle landed at the Grand Trunk ticket office at Woodward and Larned.

Traub Brothers had a reputation for "enterprise, reliability and superior workmanship in jewelry circles throughout the country." The Orange Blossom wedding and engagement ring design is attributed to Traub Brothers, and by 1915 they had their own manufacturing plant.

The business was maintained by a family member until 1952, when it was bought out by Boston's Gordon Brothers.

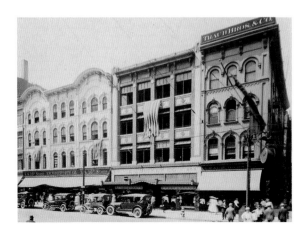

ABOVE *Traub Brothers Jewelry opened three stores on Woodward and this one, the "uptown" store at Woodward and Grand River, remained open the longest, from 1895 to 1933. Note the landmark clock hanging on the corner.*

LEFT *When the jewelry store left its 118 Woodward location, a Grand Trunk railway ticket office took its place, remodeling the building to include a ceiling with vaulted arches. The building exists today, vaulted ceiling intact, as Foran's Grand Trunk Pub.*

OPPOSITE PAGE *Elaborate wooden showcases display silver and jewelry in the Traub Brothers' first "downtown" store at 118 Woodward, where they stayed from 1879 to 1909. In 1910, having closed that store, they reopened nearby at 110 Woodward, staying until 1915.*

Walker Block at Fort and Griswold

DEMOLISHED 1911

A newspaper article put it best: "The corner is conversant with things ecclesiastical, dramatic, alcoholic, narcotic, politic and gastronomic." The third structure of the First Baptist Church provided the base for this amalgam of shops and offices when it was purchased in 1872 by Hiram Walker, of whiskey fame. Mr. Walker lived a block away on the northeast corner of Fort and Shelby, in the former home of Oliver Newberry, purchased after Newberry's death in 1860. The church, on the northwest corner of Fort and Griswold, was built in 1859 on the site of two earlier church buildings and became a theater.

The Detroit Theatre, which hosted melodramas and variety shows, was a popular source of entertainment. Its opening was announced in the August 1874 *Detroit Post* telling readers that "well-known managers G.A. and W.H. Hough" would be in charge. An opera company performed "Bohemian Girl." When William Hough left the business after a few months, Gary Hough changed the entertainment to vaudeville, renaming the place Detroit Variety Theatre, then New Adelphi. A billiard hall followed for a brief time, in 1876, then it was the Theatre Coliseum before being converted to a store and office buildings.

Chambers Cigar Store, on one corner, attracted the politicos of the day; City Hall was just across the street. Around the corner Cottington's, advertising local beer from the Koppitz-Melchers brewery, was home to the gambling trade. The University Club resided for a while in the upper stories of the church building, until forced out by the sale of the property in 1908. Fortunately the Walker home was available, Hiram Walker having died in 1899, and it became their meeting place, from 1909 to 1913.

On the Griswold side, a chop house owned by Norm Sharp offered "a small cut of steak which went with French fried potatoes for 30 cents [that] came near to making him famous in the far corner of the state." The small rooms of the church, originally used for choir practice and dressing areas, added charm to the restaurant.

In 1908, a *Detroit Free Press* article referred to the Walker Block as "... the most dilapidated business structure of the down town district." It had been sold the day before, December 6, to the Dime Savings Bank for $750,000, called the largest real estate transaction of the day. Though referring to the Walker Block as having "historic significance," the article went on to say, "The building is now a mass of unsightly structures in which may be discerned the old church, now thoroughly encrusted with business places."

A lively place of politicians and theater would now become the location for a stanchion of the financial district, the Dime Building, today known by the name Chrysler House.

RIGHT *The First Baptist Church formed the nucleus of this block and is clearly visible in the middle of the outcropping of businesses that attached themselves to it.*

BELOW *A view facing Fort Street shows Cottington's, a gambling establishment, and an out-of-business cigar store. Nearby City Hall would have no doubt provided customers for both.*

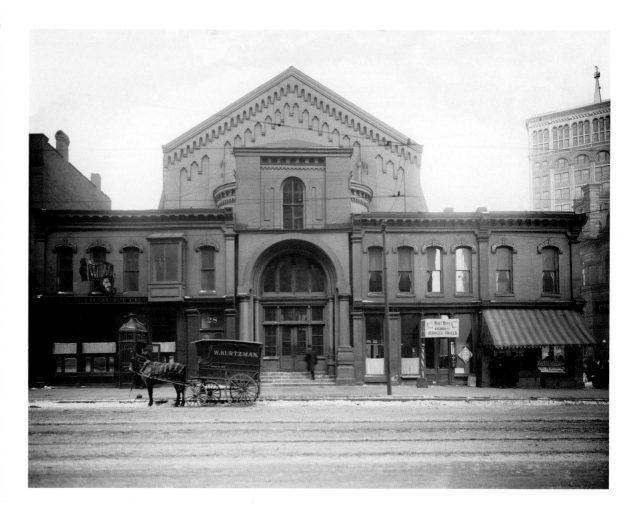

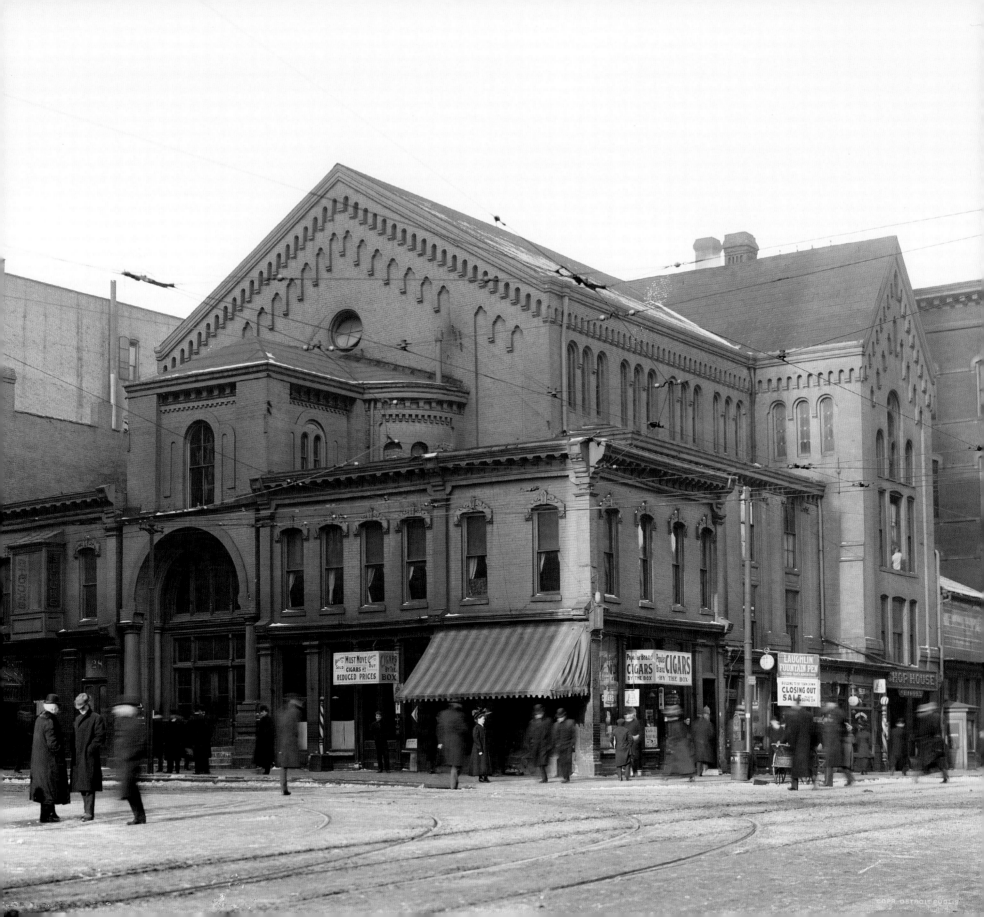

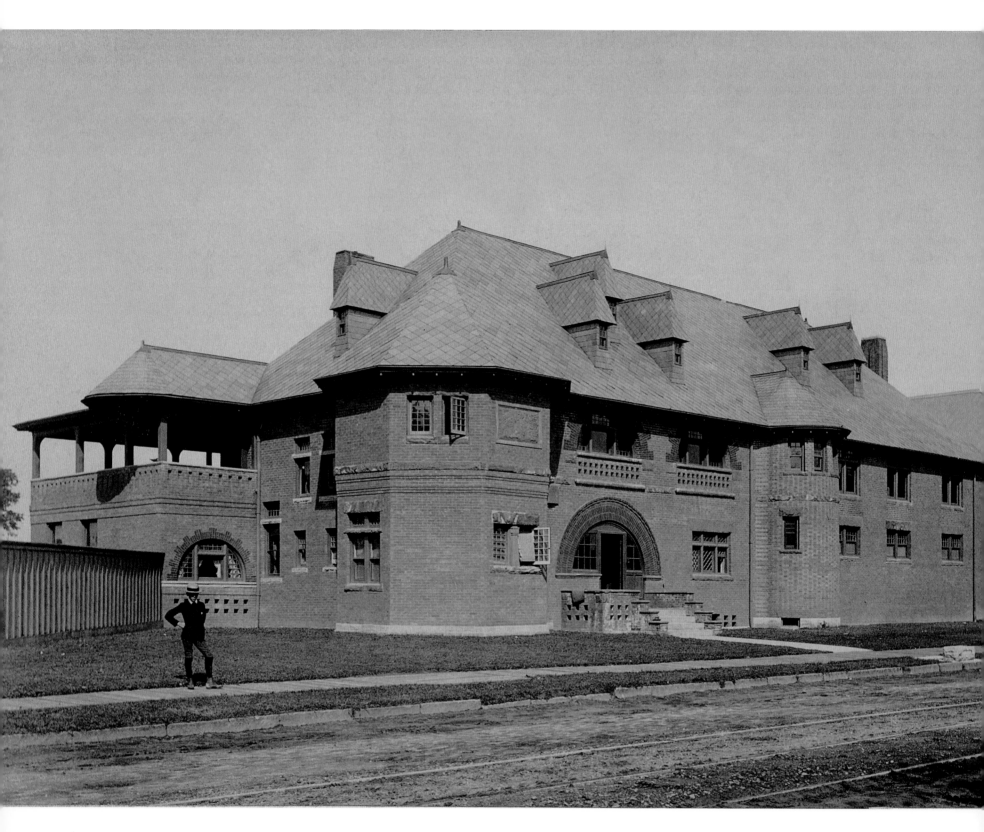

Detroit Athletic Club at Woodward & Forest

CLUB HOUSE ABANDONED 1912

Detroit's fame as "City of Champions" began with the achievements of this group of amateur athletes. The club formed in 1887 and the building opened in 1888, after a quick six months of construction. Its location, known as Grindley Field on Woodward Avenue between Canfield and Forest, was the former playing field of the Peninsula Cricket Club. The club house faced Woodward, just north of David Whitney's mansion, but the playing fields and track took up the entire block behind the building, extending to Cass Avenue.

Today people think of the Detroit Athletic Club (D.A.C.) as a social club for affluent men and women, or know about its role as a meeting place for the early automotive pioneers. But the founders of the D.A.C., though coming from privileged families, really were athletes. They were baseball and cricket players and participated in Amateur Athletic Association competitions. When the Detroit Amateur Athletic Association formed in 1886, it provided the impetus for the organization of the D.A.C., which in effect replaced it.

One of the founding members of the club was John C. Lodge, who served in city government, on the Detroit City Council and as mayor, for close to 40 years. The John C. Lodge freeway is named after him. Another illustrious name is Henry B. Joy, who went on to become president of the Packard Company. Other prominent, early members were Hugh Chalmers, of the Chalmers Motor Company, and Frederick K. Stearns, son of the founder of the Stearns Pharmaceutical Company.

Joseph V. Gearing, the architect hired to design the building was a club member. The red brick structure had a reception hall and reading room that resembled a well-to-do home of the era. Upstairs was the gymnasium with open rafters, replaced in 1889 by an addition to the north side of the building. A billiards room and a six-lane bowling alley completed the inside sports facilities. The locker room was outfitted with 300 lockers, showers, a foot bath and a plunge pool.

Outside a quarter-mile cinder running track and playing fields for baseball, cricket, football and tennis courts made up the rest of the complex, along with grandstands for spectators. It was a first rate facility

and the club had no problem attracting members. It quickly expanded its limit from 500 to 650.

Members of the D.A.C. were serious competitors. In baseball they won the Amateur Athletic Union national championship in 1890 at the New York Polo Grounds, and won again in 1892. In track, four of their members proved to be outstanding: John Owen, who broke the world record for the 100-yard dash; Harry Jewett, who won a national title in the 220 yard dash; Fred DuCharme, a hurdler who set records in the U.S. and Canada; and Theodore Luce, who set a pole vault record of 11 feet and three-quarters of an inch that was unmatched for nine years.

Their baseball team, the D.A.C. Deltas, was good enough that people paid admission to watch them play. One summer, in 1906, Detroit Tigers' slugger Ty Cobb was on the Tigers' disabled list, but was apparently fit enough to play with the Deltas. The man with a .366 lifetime batting average must have greatly increased the fan base at Grindley Field.

When the Spanish-American War broke out in 1898, 13 members of the club were part of the Michigan Naval Brigade and served on the USS *Yosemite*. After a scant five months, and one skirmish, the men returned to a heroes' welcome. Others had also left for the war, and club membership went into a decline. As a result, with only the ticket revenue from athletic events to sustain it, the building began to fall into disrepair.

A movement advocating a new D.A.C. in downtown Detroit was successful and on January 4, 1913 the new club was chartered and six days later, the old club was dissolved.

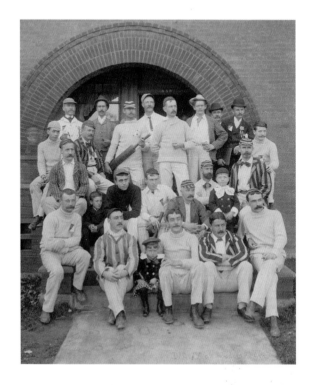

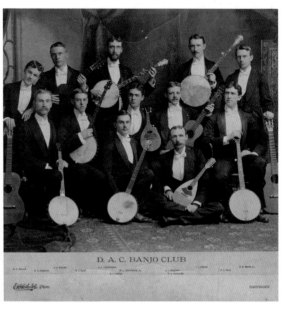

D. A. C. BANJO CLUB

OPPOSITE PAGE *This chateauesque building began falling into disrepair when members began turning from athletics to automobiles.*

TOP RIGHT *This serene group of cricket players represented Detroit's best and brightest young men at the turn of the 19th century. John C. Lodge is the gentleman in the top row wearing a suit jacket with a ribbon pinned to it and a bowler hat.*

RIGHT *Sports were not all that was played at the D.A.C.*

Edelweiss Café MOVED 1915

It had a reputation as a bohemian hangout, for the mix of artists, politicians and newspapermen which frequented the place. Also known as Glaser's Edelweiss Café, after the owner, Charlie Glaser, the restaurant was located at Broadway and John R. The restaurant took up the entire building and was known, in its subsequent locations, for its *Stammtisch*, or "regulars' table" where frequent customers convened.

When it opened in 1913, a journalist experienced "...[an] inability to reproduce in words the daintiness of the decorations, the alluring strains of the orchestra, the seductiveness of the viands, the elaborateness of the menus, and the general atmosphere which transports one from the commonplace into the realms of older days ..."

Charlie Glaser, born in Germany, had traveled in Europe to gather ideas for his venture. Glaser came to Detroit in 1901 and the Edelweiss, said to mark a new era in café service, was his first restaurant. The main dining room was on the second floor, accessed by a grand staircase. The room reached the length of the building with space for an orchestra at one end. The orchestra was direct from Vienna with a Viennese conductor, Herr Sommer. In addition to the main dining room there were five smaller rooms, separated by folding walls that descended from the ceiling. Each room had a name—American, English, French, Italian and German—and was decorated with shields from the appropriate country. The rooms could be combined or separated as needed.

On the first floor, besides two grill rooms, there was, notably, the Colonial Tea Room, reserved for women only from 11 a.m. to 6 p.m. After 6 p.m. however, women were not admitted without an escort, "an inexorable rule."

In 1910 Germans made up one third of the nearly 500,000 population in Detroit. They were the largest ethnic group, with German-language newspapers, clubs and participation in the city's businesses and industries. The Edelweiss served imported German beer (though a number of the local breweries were German-run), German food and perpetuated the old world tradition of the *Stammtisch*.

The international organization Kiwanis allegedly began at the Edelweiss. Detroit Kiwanis Club No. 1 was formed in August 1914 by a group of businessmen, led by Allen Brown. The fraternal club of businessmen was initially called "Benevolent Order of Brothers," but disliking their acronym, B.O.B., they changed the name to "Nunc-Keewanis" from a Native American language and later shortened it to "Kiwanis." The club's focus went from business networking to service and today has over 200,000 members worldwide.

For unknown reasons, after two years the Edelweiss moved from its prime spot near the theater district to a smaller space on Broadway and Gratiot in 1915. The restaurant was most popular with newspaper reporters, who followed Glaser to that location on Pingree Square. They nicknamed the place the *Schützengraben*, German for trench, appropriate for the times. It was here that the *Stammtisch* was born, according to two newspapermen Norman Beasley and George Stark.

In 1918 Glaser managed a restaurant named Liberty Kitchen on Monroe and Library Avenues, then a few years later had his own place again, near the same location. Charlie Glaser retired from the restaurant business in 1938, and died in 1945.

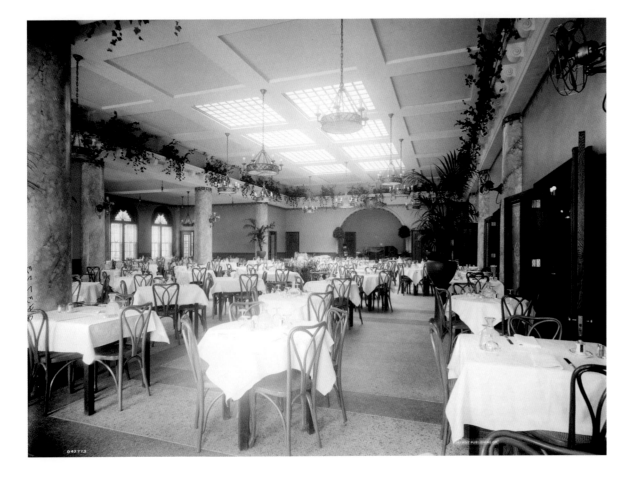

LEFT *The second floor dining room that seated 500 customers had a bandstand at one end of the room and "fancy dancing" was encouraged by the Viennese orchestra.*

RIGHT *Advertising for the restaurant proudly promoted its "famous Edelweiss beer," that gave the place its name, though owner Charles Glaser apparently thought that adding his appellation gave some cachet to the café.*

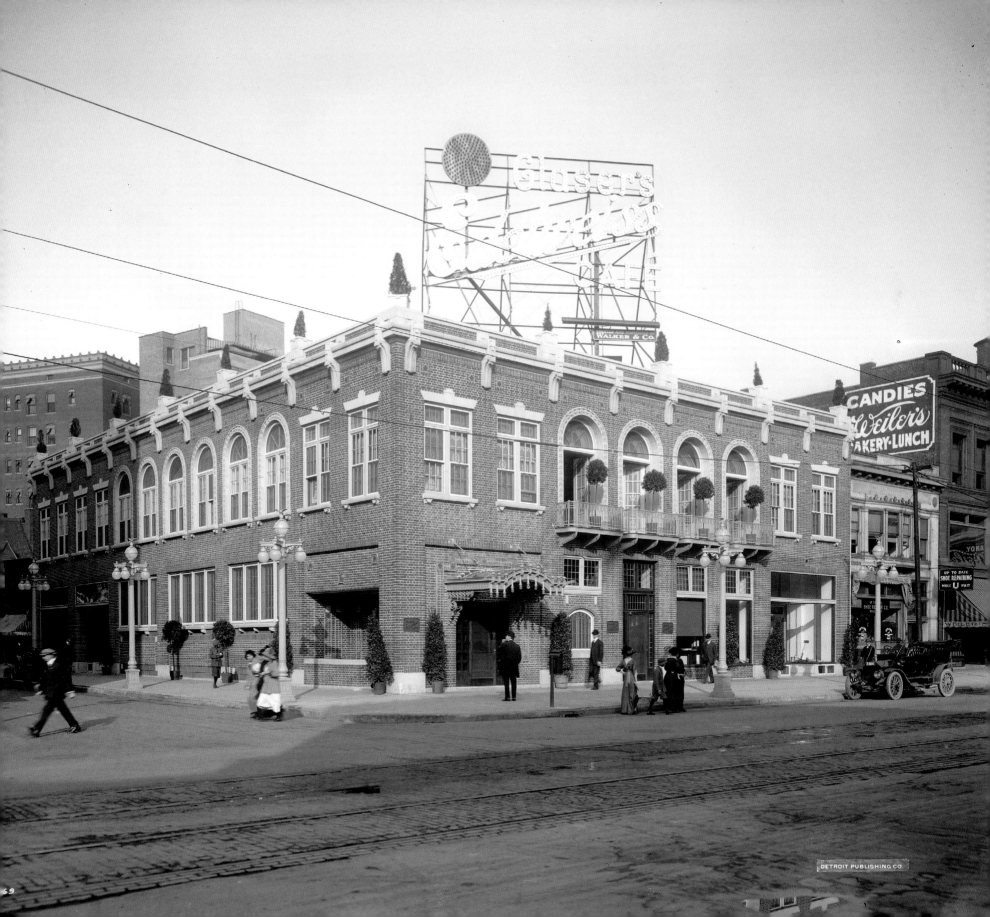

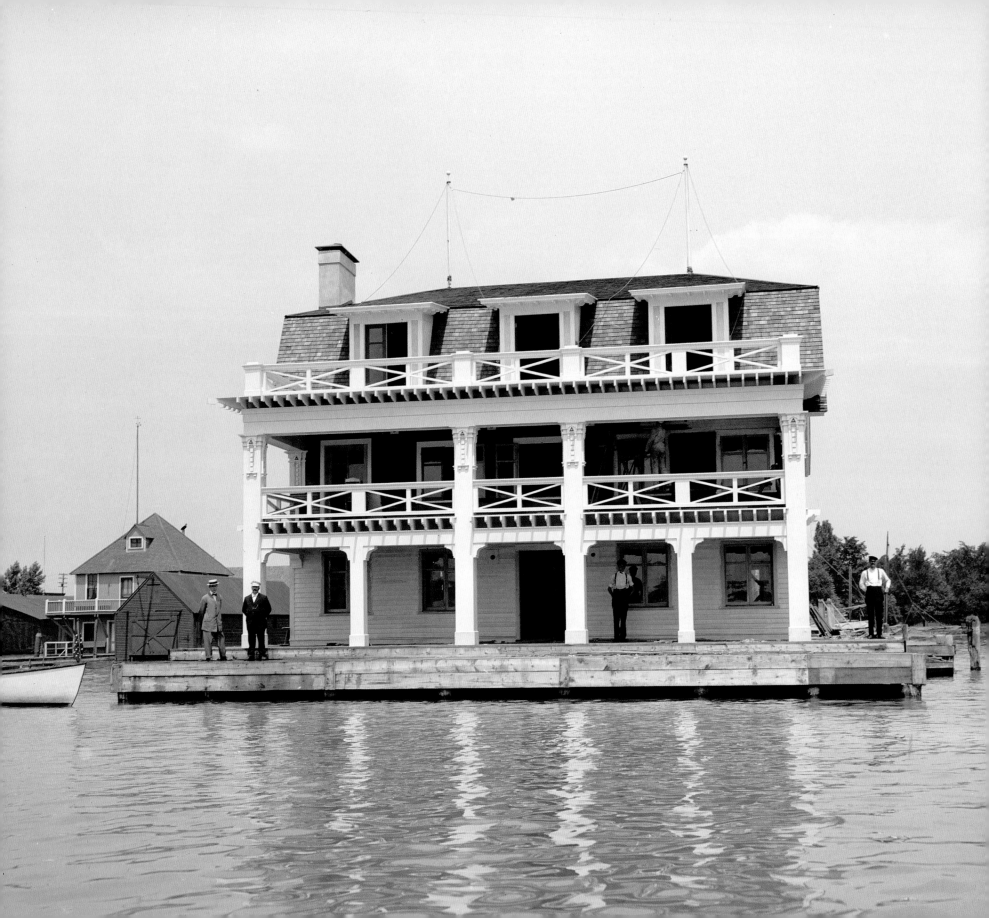

Detroit Motor Boat Club DISBANDED 1916

Detroit's love affair with engines and racing wasn't limited to automobiles. There was a huge interest in running private, motorized watercraft up and down the Detroit River. Detroit was, after all, a center for shipbuilding and shipping in the 19th century, so it was only natural that when the gasoline engine was developed, it found a place on water as well as land.

William E. Scripps, son of *Detroit News* founder James E. Scripps, was commodore of the Detroit Motor Boat Club in 1912 when the *Titanic* went down. As owner of Scripps Motor Company, he came up with the idea of sending his own motorized craft across the ocean, to illustrate the safety of the engine-driven boat.

He commissioned a 35-foot long ship named *Detroit* and equipped it with a Scripps-built motor. He hired Captain Thomas Fleming Day to pilot the boat, with a crew of three. Scripps would not be on the voyage. The small ship successfully made the trip through the Great Lakes, the Erie Canal, the Hudson River and out to sea. The racket from the ineffective muffler was the biggest complaint on their 21-day trip to Queenstown, Ireland, besides the usual inconveniences of such a sea journey. They wound up in St. Petersburg, Russia, which was their goal.

Day had kind words for Scripps for furthering the sport of yachting and vouched for the sea worthiness of the 16-horsepower Scripps Motor Company engine.

As for the Detroit Motor Boat Club, it was incorporated in 1907 and sponsored the first Detroit Motor Boat Show in 1908 at the Light Guard Armory. By that time it had over 400 members and a new clubhouse on the Detroit River near Waterworks Park.

Unlike the members of the Detroit Boat Club who invested in a more modest activity, Detroit Motor Boat Club members were wealthy industrialists who spent healthy sums of money to sustain their yachts.

In 1913, Horace Dodge was elected Commodore to replace Scripps. The club left its first club house in 1910 and was now meeting at the Lighthouse Inn on Windmill Pointe, where they continued until their dissolution in 1916. Horace Dodge, one of the two automotive Dodge Brothers, enjoyed yacht building and racing as his hobby and was part of the group that organized the Miss Detroit Powerboat Association, which built the 1915 Gold Cup-winning powerboat *Miss Detroit*.

The club inexplicably went bankrupt in 1915 and its property on Windmill Point was purchased by the Grinnell Company in bankruptcy proceedings in early 1916.

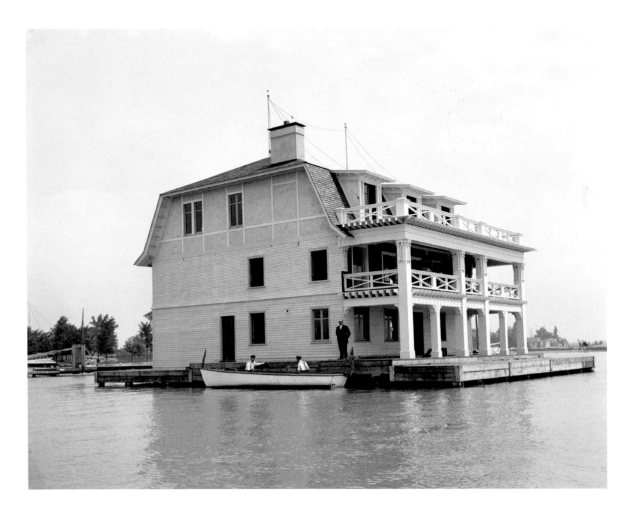

ABOVE *The address for this club house was simply Waterworks Park. This meeting place lasted only three years before the need was felt for a larger space and from May 1911 until the club's dissolution in 1916, meetings were held at the Lighthouse Inn at Windmill Point.*

OPPOSITE PAGE *This bungalow style clubhouse appears to be floating in the waters of the Detroit River, which is what the club members wanted, so "anchorage could be made at any desirable spot."*

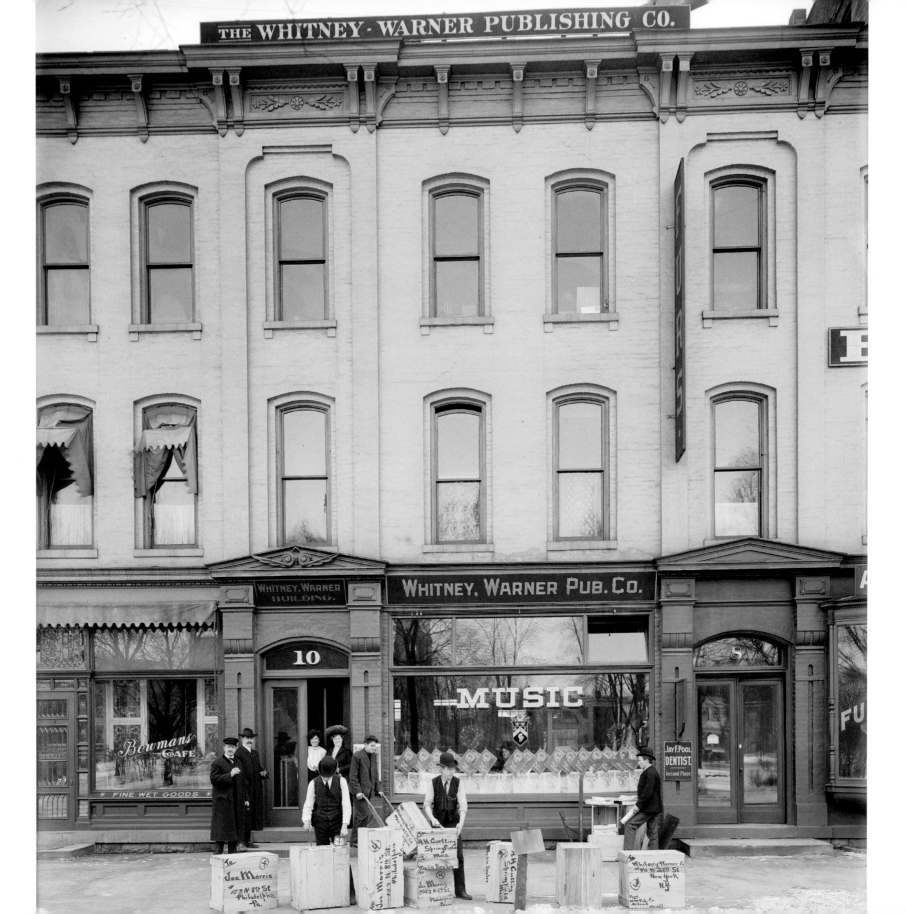

Whitney Warner Publishing

WITHERELL STREET OFFICE RAZED 1916

The name Whitney was well-known in Detroit music circles. Clark J. Whitney, or C.J., was owner of the Whitney Grand Opera House at Fort and Shelby and had a music store, C.J. Whitney & Co. on Woodward Ave. Growing tired of the music business, and wanting to concentrate his energies on the theater, C.J. passed the store on to his son Bert. Bertram C. Whitney was one half of the Whitney Warner Publishing Company.

The other half, Alton or "Allie" Warner had clerked for C.J., running sheet music from the store over to the opera house and selling tickets there. He and Bert worked in Whitney Marvin, now the name of the C.J. Whitney Co., until the business was liquidated in 1896.

In the meantime, they purchased a piece of music called "Dance of the Brownies," written by Ellie Kamman, paying $10 for the composition in 1893. The U.S. Copyright record indicates that Bert filed the copyright claim with his father, C.J. Whitney, as publisher. The purchase proved to be quite profitable, inspiring the two young men to start their own music publishing business in 1898. "Dance of the Brownies" was so successful that a 1929 article claimed that the sale of the piece was "…still going strong. No infant piano prodigy's education has had even a fair start unless he has mastered this piece."

By 1899, Allie Warner decided his real love was the theater, and for $5,000, turned his portion of the business over to Jerome H. Remick, a mutual friend who decided to try his hand at music publishing. He soon discovered the company was doing poorly, but was able to stave off bankruptcy with the publication of "My Ragtime Baby." Allegedly, the first ragtime piece ever written, the two-step was the work of Detroiter Fred S. Stone, an African American composer who also had a popular orchestra.

Music continued to be published under the Whitney Warner label until 1903, though Remick had become its sole owner by 1902. In 1904 he merged the company with a New York firm, and briefly the company was Shapiro, Remick & Co. In 1905, the company was reorganized again, reflecting the president and general manager's name, Jerome H. Remick & Co. Remick maintained the office on 10 Witherell in Detroit until 1906, when he closed it to operate out of his New York City location.

George Gershwin had his first job at Remick's company from 1914 to 1917, where he worked as a "song plugger," someone who played or sang the publisher's music at the store for prospective buyers to hear. While there, he also wrote his first piece of music, "Rialto Rag," with coworker Will Donaldson, which Remick published. After Gershwin, Remick signed up then unknown writers like Richard A. Whiting and Harry Warren. The company was bought out by Warner Brothers in 1929.

Allie went on to manage the Lyceum Theatre in Detroit. Bertram C. Whitney, known as B.C., was successful as manager of the Detroit Opera House, on Campus Martius, where he produced musical comedies with intriguing names like "The Isle of Bong Bong," and "Piff, Paff, Pouff." As for 10 Witherell Street, songwriter Harry P. Guy wrote songs there from 1913 to 1915, and in 1916 the building was razed to make way for the Madison Theater.

LEFT *Fred S. Stone's "Belle of the Philippines" is featured prominently in the window of the music publishing company as workers ready boxes of sheet music for shipping to Philadelphia and New York City.*

RIGHT *Judging by the activity in this bustling office, business appears to be good for Whitney Warner in a peak year of 1903.*

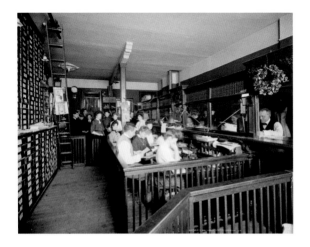

JEROME H. REMICK

Jerome Remick is honored in Detroit by the Remick Bandshell, opened on Belle Isle in July 1950. Remick was a star in the music publishing industry. The songs he published are considered old-fashioned today, but "Shine on Harvest Moon," "Oh, You Beautiful Doll" and hundreds like them made Remick one of the world's largest music publishers. Born on November 15, 1868 in Detroit, he worked in banking and bookkeeping in his family's lumber business before moving into music publishing. Following his music publishing career with Whitney Warner, Remick turned to dairy, becoming president and general manager of the Detroit Creamery in 1914. But the contribution that resonates today is his involvement with the Detroit Symphony Orchestra. As president of the Detroit Symphony Society, he helped raise money for the building of Orchestra Hall in 1919. Remick died on July 15, 1931 and is buried in Elmwood Cemetery.

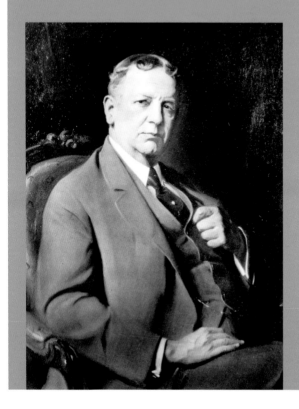

Electric Street Light Tower **LAST TOWER DISMANTLED 1918**

They were called, romantically, "moonlight towers." But it was a matter of opinion whether these wavering towers were more successful in lighting the earth or the heavens.

"Homely precursors of the Eiffel Tower," some of these structures rose as high as 190 feet. They contained from four to six arc lights at the top, the thought being that they would mimic the moon in casting light below. In reality they created as much shadow as light; at best they imparted "a twilight glow."

In Detroit, the first street lamps were lit by whale sperm oil, then by naphtha and gas. The use of electric street lamps began in 1883 with 24 arc lamps, in an area bounded north and south by Adams and Jefferson, and east and west by Brush and Third streets. A year later the supplier of the lamps, the Brush Light Company, received a citywide contract for 72 towers. It kept the lucrative contract for these towers of light and other street lighting for six years. As with the gas lamps, the arc lights were probably turned off when the moon was full.

The arc light was perfected by Charles Brush, a University of Michigan graduate who grew up in Ohio and first demonstrated his arc light in Cleveland. The arc light was powered by a dynamo that created an electric current passing between two carbon rods. The light it generated was described as harsh and strobe-like, but unlike gaslight, one could easily read by the light it cast.

The Detroit Electric Light and Power Company got the contract next, but had to build its own towers. The Brush Company claimed patent rights to its towers and other electrical components, causing Detroit Electric to erect new towers and light poles. Now there were two sets of swaying towers, many side by side, not to mention the entanglement of guy wires and braces that helped hold the towers erect.

People either hated or loved the towers. Some faulted them for interfering with the normal rhythms of day and night, causing poultry, unable to sleep, to die of exhaustion. Others found the light cast by the structures ethereal, though by stepping a few feet to one side or other a person found himself in complete shadow.

Travelers passing along the Detroit River thought the sight of the lit city a spectacle: "From a distant vantage point on the lake or river, the total effect was truly spectacular, and visitors who approached the city by boat and at night viewed as a modern wonder an entire city bathed in the brilliant glow."

The last tower to survive attacks by the wind and manmade accidents stood until 1918 at the corner of Ferry and St. Aubin. Little known is that, in 1894, Austin, Texas bought 31 of the towers and 17 are still used today.

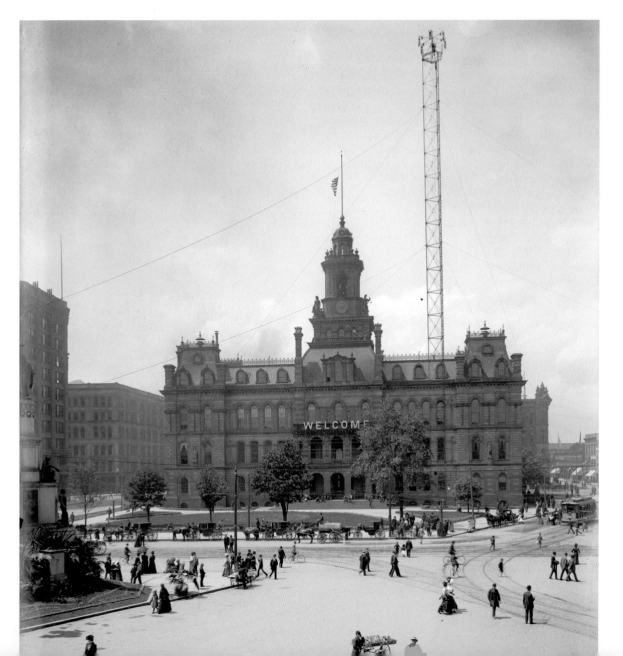

LEFT *Barely visible is the welter of wires that run from this light tower in front of City Hall, which was 190-feet tall.*

RIGHT *Two towers stand side by side in this photo taken during the Grand Army of the Republic parade in 1891. When a second company took over the city's lighting contract, the first company refused to sell or lease its towers, so new, additional ones had to be constructed.*

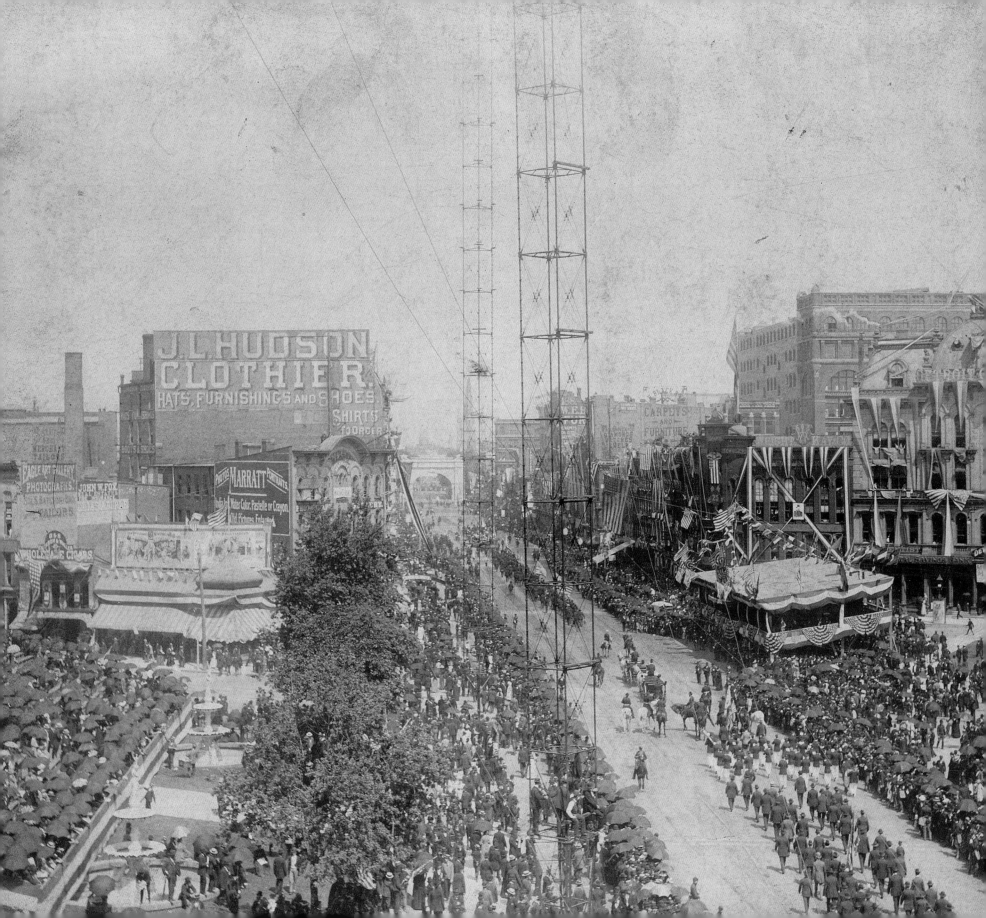

Pontchartrain Hotel

DEMOLISHED 1920

There couldn't have been a more exciting place to be at the beginning of the 20th century than the bar of the Pontchartrain Hotel. All the inventors and wheeler dealers of Detroit's burgeoning automobile industry were there, showing off their newest discoveries and discussing the latest innovations in the industry.

The hotel was built in 1907 to replace the 50-year-old Russell House which stood on the same spot, the southeast corner of Campus Martius. The work of Detroit architect George D. Mason, it was originally 10 stories, but in 1916 five floors were added, three of the stories part of a Mansard roof, giving the later building quite a different look than its original design. Mason used the Kahn system of reinforced concrete that was becoming the standard for automobile factories.

The name Pontchartrain came from Louis XIV's minister of marine, Jérôme Phélypeaux, Comte de Pontchartrain, first given to Fort Pontchartrain, the defense built by Cadillac on the Detroit River site destined to be Detroit.

Wirt C. Rowland was responsible for the interior finishes of the hotel. At the time he was an apprentice architect in the offices of George Mason, where Albert Kahn also got his start. Rowland went on to apprentice for, then work with Kahn. Some 13 years later, while chief designer at Albert Kahn and Associates, he would design the First National Bank building on the site of the Pontchartrain Hotel. His most acclaimed work is the Guardian Building.

The hotel's décor was typical of the period with Tiffany lighting in the lobby, a mahogany and marble bar and leather booths in the taproom. However, the hotel was not quite the height of luxury, as only half of the four hundred rooms had baths. This lack of amenity would, in the end, contribute to the hotel's short lifespan.

In 1909 it was at the center of the social scene in Detroit, and as such, headquarters for the 1909 Glidden Tour, in its sixth year. Participants in the race parked their Marmons, Jewels, Hupmobiles and Pierce-Arrows outside the hotel in Cadillac Square, where drivers undoubtedly compared notes and the general public got a closer look at the wave of the future.

In 1912, certain automobile enthusiasts and businessmen met at the Pontch to start a new Detroit Athletic Club, this time without an emphasis on athletics. Hugh Chalmers, Roy D. Chapin, Henry B. Joy, William E. Scripps and William E. Metzger were some of the automotive progenitors involved.

The Hotel Cadillac and nearby Hotel Ste. Claire were some competition to the Pontch, but the coup de grace was the opening of the Hotel Statler in 1915. The razing of the Hotel Pontchartrain in 1920 made way for a bank building. No longer would a hotel look upon Campus Martius.

LEFT *The City Hall's enormous light tower interrupts the view of the "Pontch," as it was called, in this photograph taken shortly before the hotel's renovation.*

OPPOSITE PAGE *In 1916 five floors were added, the top three encapsuled in a Mansard roof that appears to be covered with wooden shingles.*

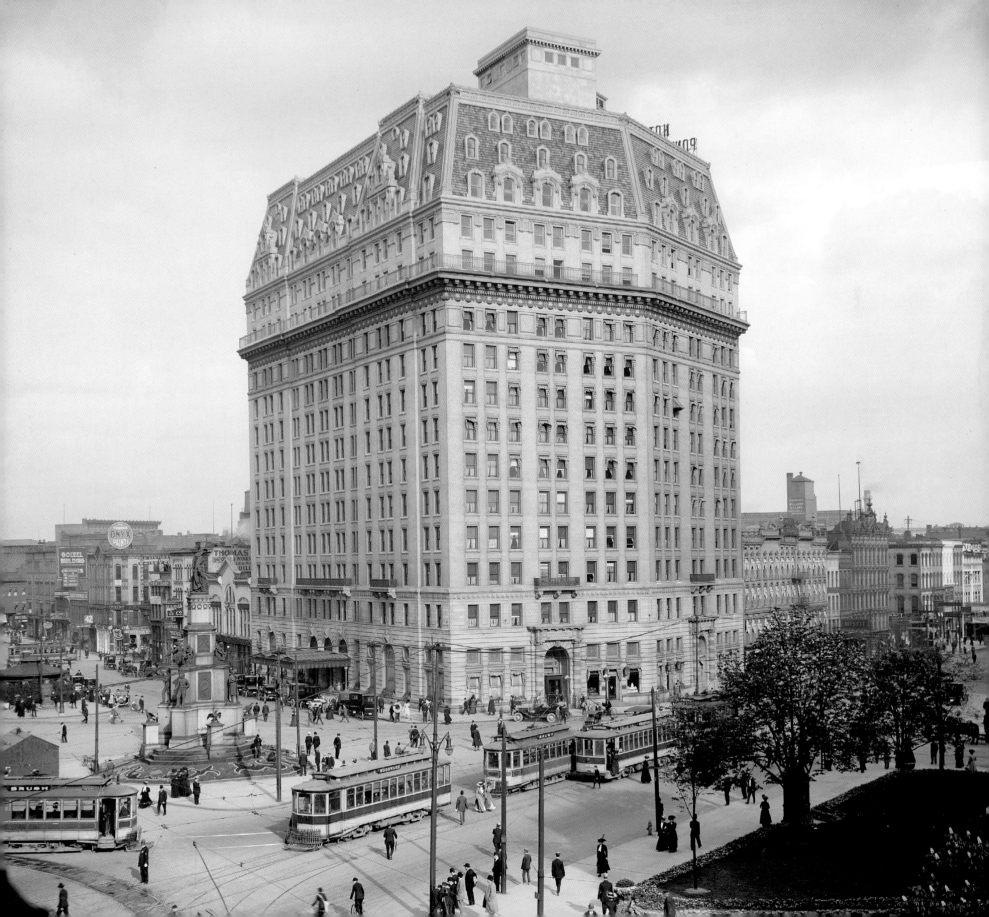

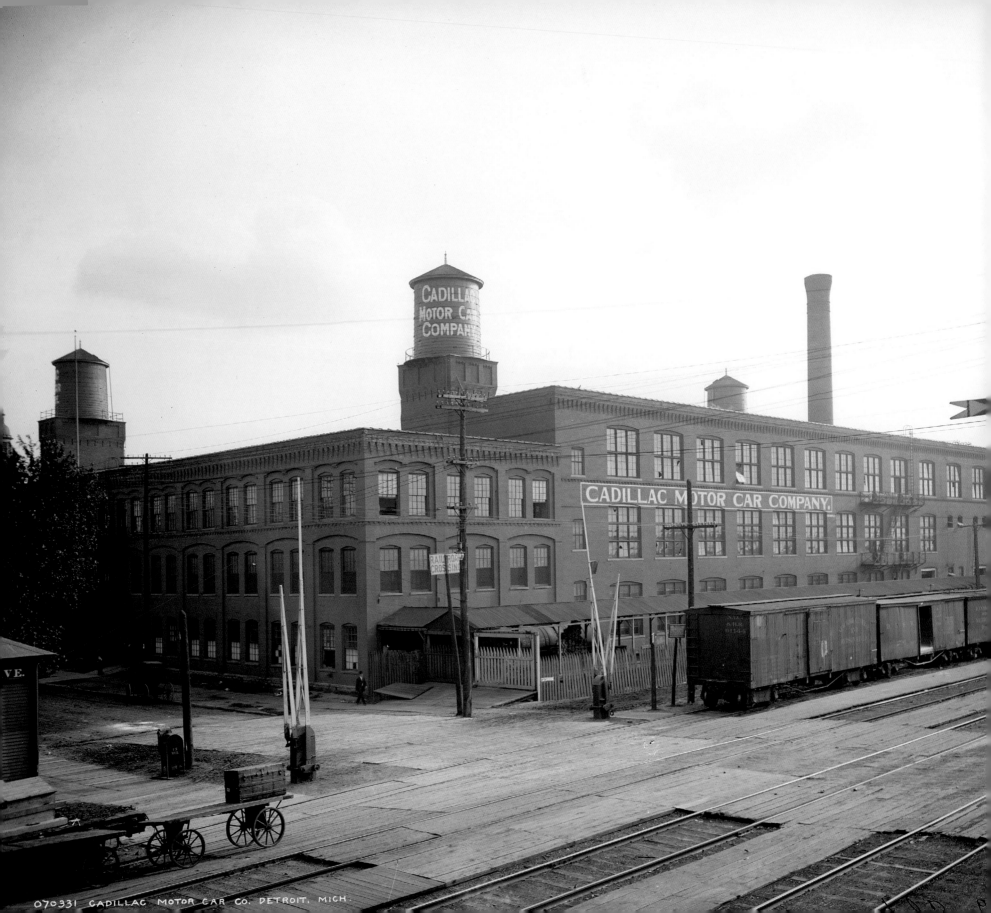

CADILLAC MOTOR CAR COMPANY

CADILLAC
MOTOR CAR
COMPANY

CADILLAC MOTOR CAR COMPANY.

RAILROAD CROSSING

VE.

U.S. MAIL

070331 CADILLAC MOTOR CAR CO. DETROIT, MICH.

Cadillac Motor Car Company MOVED OUT 1921

Henry Leland was a busy man. In 1890 he established a firm called Leland, Faulconer & Norton to manufacture machine parts. The firm, whose name changed to Leland & Faulconer (L&F) in 1894, originally tooled parts for bicycles and marine engines. The company switched to automobile transmissions in 1899, doing contract work for Ransom Olds.

Not long after, Leland was approached by backers of Henry Ford's second attempt at a company, to help get the company on the right track. Henry Ford was spending too much of his time and energy on automobile racing, not automobile manufacturing, and the men who put up their money wanted faster results. Frustrated by the control exerted by his backers, Ford left that company to form what would be the world famous Ford Motor Company. Enter Henry Leland.

"…the instant [Leland] entered the automobile industry he became the most respected figure in it," commented Henry Ford biographer Douglas Brinkley. Leland came from an East Coast trade background of precision tool-making, including guns and cutting tools. Consulted after Ford left the company in early 1902, Leland convinced the directors that he could turn the company around using a powerful motor developed for, and rejected by, the Olds company. The backers agreed and on August 27, 1902 the name was changed to the Cadillac Automobile Company, after Detroit founder, Antoine de la Mothe Cadillac, and Leland was made director.

The first three Cadillacs came out of the L&F factory on Trombly near Dequindre. They were chiefly Leland's Cadillac engine in a body designed by Henry Ford. The car was promoted at the 1903 New York Auto Show with great success by sales manager William Metzger, who took orders for over 1,000 cars. At the end of 1904, the directors of Cadillac asked Henry Leland and his son Wilfred, who had given up a medical career to run L&F with his father, to take over the day-to-day operation of Cadillac. Up to this point, the operation of L&F was still getting most of their attention.

Cadillac was running into the problem faced by many of the early car companies. They had little control over the shipment of parts to their "factories," which were really large assembly rooms. This problem could severely affect the timely delivery of vehicles to the dealers. Since the Lelands efficiently managed the manufacture of the Cadillac engines at L&F, Cadillac company owners William Murphy and Lemuel Bowen wanted them to have full control of the whole process. By this time, Henry Leland was 60 years old. The operation was fully consolidated in 1905 when Cadillac merged with Leland & Faulconer and the name changed to Cadillac Motor Car Company.

Detroit architect George Mason, who had trained Albert Kahn, designed a structure of reinforced concrete, using materials by Trussed Concrete Steel Co. of Detroit, the company owned by Albert Kahn's brother, Julius. It was built on Amsterdam between Cass and Second Avenues on the site of an earlier plant that burned in April 1904.

Part of the Cadillac fame was the interchangeability and precision of its parts. In 1908 it won the prestigious British Dewar trophy, given for "meritorious performance by an automobile manufacturer in the Certified Trials held by the [Royal Automobile] Club." To prove the precision of Cadillac parts, three Cadillacs were disassembled, the parts intermixed, with some replaced by stock parts. Then the cars were successfully reassembled, the mechanics using only screw drivers and wrenches, and driven for 500 miles without incident.

This boon to Cadillac's reputation came in the midst of negotiations between Cadillac, represented by Wilfred Leland, and General Motors founder William Durant, for GM's purchase of the company. Leland was willing to accept three and a half million dollars when negotiations first began, but winning the Dewar Trophy led to record sales. Durant purchased Cadillac for four and a half million dollars in 1909. His request that the Lelands remain as production managers was accepted, with the Lelands' stipulation that their high standards continue to be met. The Lelands, to whom Cadillac owes its reputation for quality and luxury, stayed at GM until 1917.

In 1921, the company moved to a new and larger facility on Clark Street, bringing all of its operations together. The Amsterdam Street building remains today as home of the Westcott Paper Co. Henry Leland went on to found the Lincoln Motor Company, but that's another story.

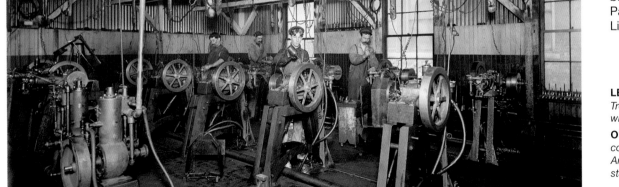

LEFT The testing room at Leland and Faulconer, located on Trombly and Dequindre. Henry Leland's company merged with Cadillac in 1905.

OPPOSITE PAGE *Eventually most of the operations were consolidated here, at the George Mason-built factory on Amsterdam and Cass Avenue. Much of the building still stands and is used by Westcott Paper Co.*

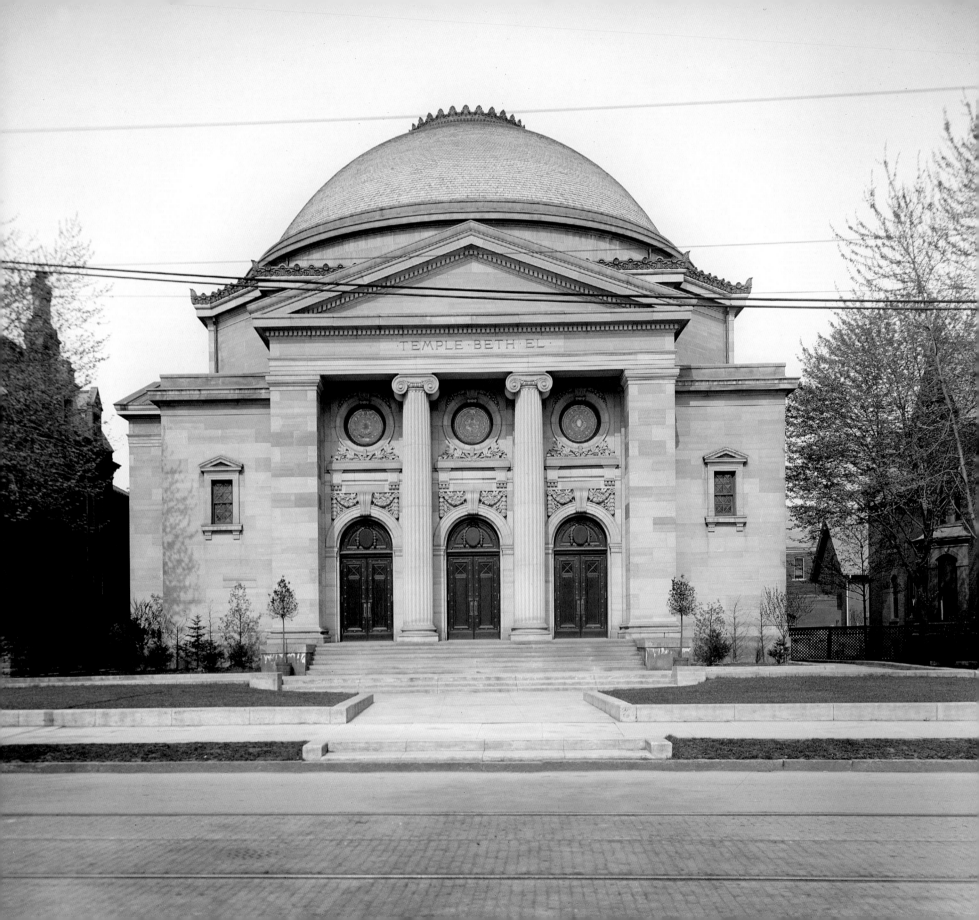

Temple Beth El MOVED 1922

Temple Beth El was the first Jewish congregation in Detroit. At the time the congregation was founded, 1850, Detroit's population of over 20,000 had only 60 Jews. This synagogue on Woodward Avenue and Eliot marks the congregation's sixth location and its third dedicated building.

When the congregation was first formed it met in homes of members or rented spaces. The congregation subsequently used two church buildings to meet, one on Rivard Street in 1861, and one on Washington and Clifford in 1867, where they remained until the new synagogue was opened in 1903.

The early congregation followed the path of Reform Judaism, allowing instrumental music in their services and a mixed choir. Orthodox adherents objected and 17 families left to form Congregation Shaarey Zedek. Congregation Beth El continued down the Reform path in the latter half of the 19th century, permitting men and women to sit together, using an American prayer book, and introducing Confirmation. Up until 1884, when the first American-trained rabbi, Louis Grossman took over, the sermons were given in German, the language of the founders.

The design of Temple Beth El is attributed to architect Albert Kahn, a member of the congregation, but project records show both George Mason and Kahn's name. Kahn had trained at Mason & Rice, but had left by 1896. After forming his own company with two others, in 1901 he was back on his own. He returned briefly to work with George Mason, who by this time had separated from Rice.

The architects followed the Beaux-Arts tradition, giving the building a Pantheon-like entry with domed roof. Kahn continued the Pantheon theme on a larger scale, when in 1922 the growing congregation moved farther north on Woodward to a Kahn-designed temple.

In 1924 the building was converted into the Bonstelle Playhouse by noted theater architect C. Howard Crane. Jessie Bonstelle, who began a stock theater company there, hired him to make the interior of the building suitable for theater. When she died in 1932, it became the Detroit Civic Theater, and from 1936 to 1951 was a motion picture venue called the Mayfair Theater. The building underwent an unsought after renovation in 1936 when its front was removed to accommodate the widening of Woodward Avenue.

In 1951 Wayne State University leased the building for its theater company, then five years later bought it and restored the name to Bonstelle Theatre.

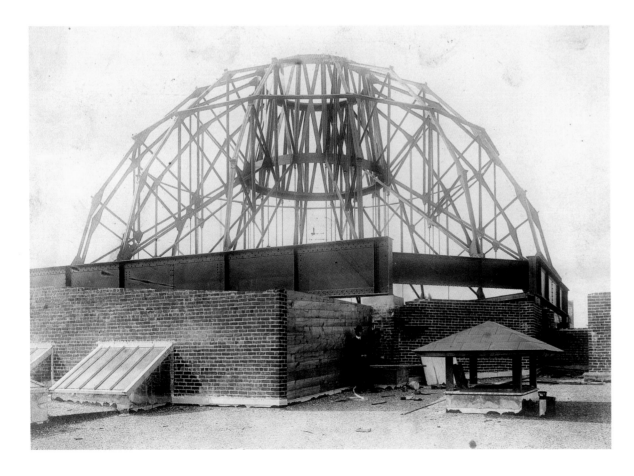

LEFT *This photograph reveals that the sculpture-like frame of the synagogue's dome was constructed apart from the building.*

OPPOSITE PAGE *The beautifully classic design of Temple Beth El was irreparably altered when the widening of Woodward Avenue, in 1936, caused it to lose the front colonnade. By that time it was being used as a theater.*

Hotel Cadillac RAZED 1923

When the Cadillac opened in 1888, it was considered a first rate hotel with all the embellishments and fine materials one would expect. Marble was everywhere, walls, floors, staircases and fountains, along with stained glass, and brass fittings. The man who built it, Daniel Scotten, was a multi-millionaire by today's standards

Daniel Scotten's tobaccos were "known from one end of the United States to the other." His company, the Hiawatha Tobacco Factory, made plug, chewing and smoking tobacco, shipping it as far away as Honolulu and London, and was in large part responsible for Detroit becoming a tobacco center in the mid-1800s. Having made a killing by filling up a warehouse with southern tobacco before the Civil War, he invested largely in real estate, and when he died, in 1899, his worth was pegged at around $700,000 or 19 million today.

The Hotel Cadillac began in 1888, on land owned by Scotten at Michigan between Washington and Shelby. It was built in two stages, the first part was a renovated business block that was then expanded in 1891 by razing the Antisdel Hotel next door. The seven-story Cadillac took up the entire block.

The gay nineties extolled public life, of which fancy hotels were a part. There was a musician's balcony above the entrance to the Cadillac, where an orchestra or band played every night. An early menu gave visitors to the restaurant a chance to try such unusual fare as "Boiled partridge with puree of celery," "Young pig with cranberry sauce," or "Opossum with fried bananas." The kitchen was enormous with cast iron stoves dedicated to specific tasks and the main dining room was said to have the largest mirrors in the country.

This was where U.S. presidents stayed when they came to Detroit: Benjamin Harrison, Grover Cleveland, William McKinley, Theodore Roosevelt and Howard Taft all made a stop at the Hotel Cadillac. A future celebrity, who would be better known than all those names, worked just around the corner in 1896. Hotel guests would gather around his unusual machine, the quadricycle, when he brought it out of his nearby garage on Bagley for trial runs.

When the Hotel Pontchartrain was built in 1907, the crowds who had once waited so eagerly for the opening of the Hotel Cadillac, flocked across Woodward to see the latest in hostelry. By 1915, the

Pontchartrain, whose time was nearing an end, was usurped by the Statler Hotel, up Washington Boulevard from the Cadillac.

Perhaps the most interesting part of the hotel's history is what happened next. Three brothers who were born in the Hotel Cadillac, Herbert, Frank and J. Burgess, Jr. Book, would go on to own the hotel, demolish it in 1923, and build another, the Book-Cadillac. They would eventually own 60 percent of the property on Washington Boulevard, and commission the Book Building and Book Tower, both designed by Louis Kamper, in an effort to create a shopping district along the boulevard.

RIGHT *Over 450 guests could dine in the elegantly appointed, second level dining room. The enormous mirrors at the end and side of the room amplify the columned space.*

BELOW LEFT *A sharp eye will notice the small, brass spittoons placed at strategic spots around the hotel lobby.*

BELOW *The striped awnings and gaily waving rooftop flags gave the Hotel Cadillac an air of insouciance, making it an inviting place to stay.*

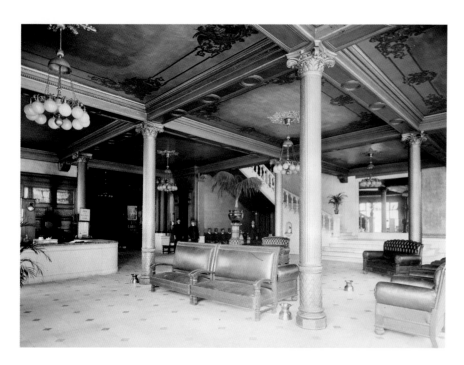

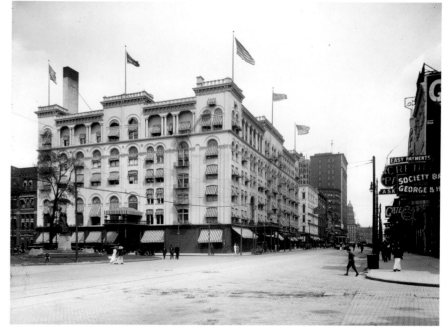

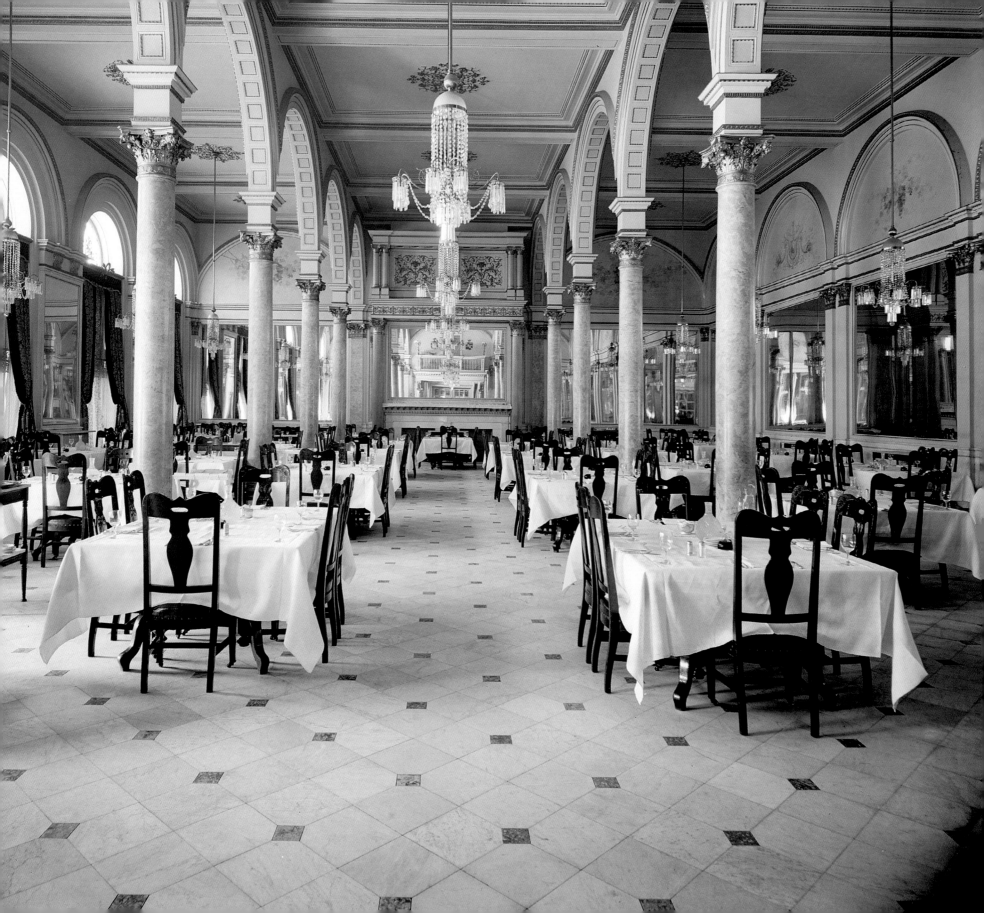

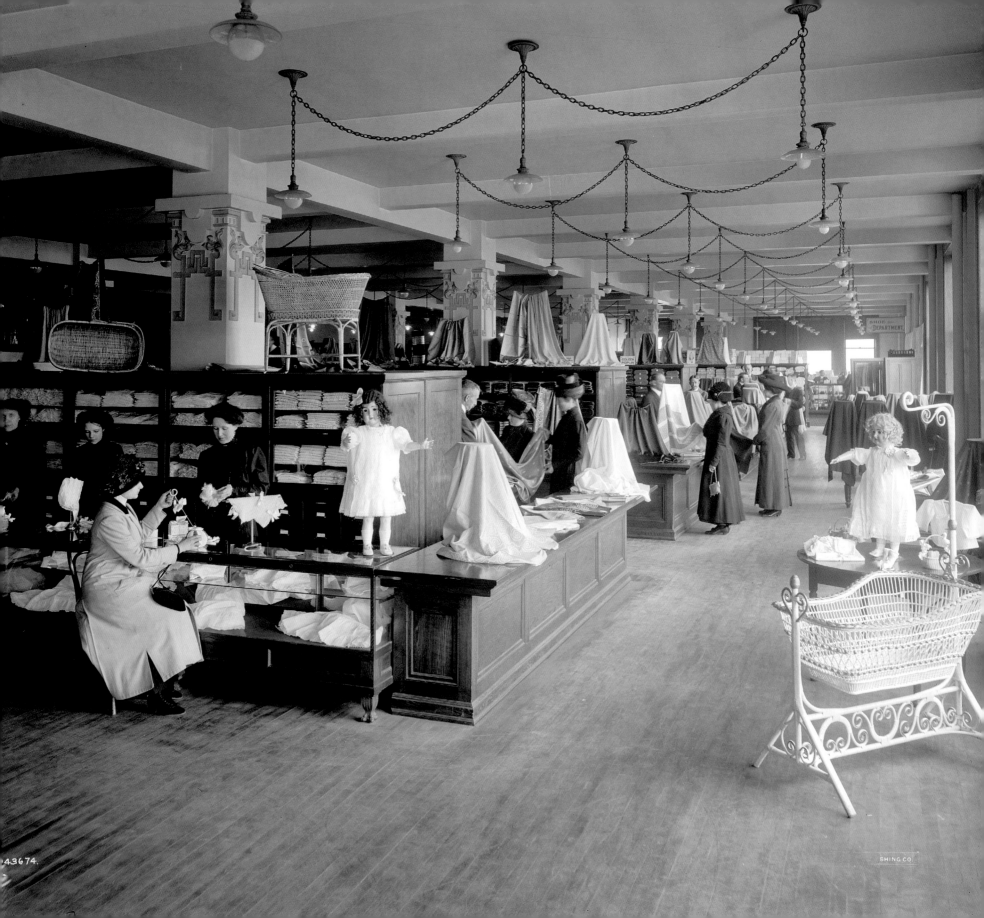

Elliott-Taylor-Woolfenden CLOSED 1925

It was a big risk to open a new store north of Grand Circus Park in 1911. The two separate stores had been in the heart of downtown, Taylor-Woolfenden at Woodward and State Street, W.H. Elliott at Woodward and Grand River Avenue. When they merged in 1909, the new company Elliott-Taylor-Woolfenden, at first established itself in the Elliott store location on Woodward and Grand River Avenue. But the owners decided a new building was in order, and in the process, set out to create a new shopping district for Detroit, roughly nine blocks north of downtown.

Joseph B. Woolfenden earned his retail experience in several places, starting in Kingston, Ontario, then in Detroit with a firm that was sold to Newcomb, Endicott & Company. He then went to Saginaw to join in a dry goods business there until a series of events led him back to Detroit and to starting a business with Frank D. Taylor, recently of Newcomb Endicott. The two decided on the order of the business name by a flip of a coin and Taylor-Woolfenden was born, open for business on October 1, 1880.

They had a new building, at the northwest corner of State and Woodward and the business prospered due in no small part to the extensive experience of the owners. Wanting to increase their operation even more, they merged with the competing dry goods company of W.H. Elliott in 1909.

William H. Elliott was a clerk in a dry goods store in nearby Amherstburg, Ontario, and came to Detroit in 1864. After working in dry goods with George Peck he opened his own store at 139 Woodward, also in 1880, then moved to the new, six-story building at Woodward and Grand River in 1895. When he died in 1901, Mrs. Elliott carried on the business.

Mrs. Elliott undertook the responsibility of building the new store at Woodward and Henry, in part, as a memorial to her late husband. Besides running his department store, William Elliott was director of several banks and a trustee of Harper Hospital.

The new store at Woodward and Henry had distinctions beyond its location. Because of its distance from downtown Detroit, it offered a "transfer auto" to bring shoppers to its store. It was also the only department store, in 1912, to have a lending library for its employees, one of the locations of the Detroit Public Library's extension service. The service was usually provided to factories, with the explicit purpose of promoting "mental uplift and widened horizon[s]" to the workers, according to Arthur Woodford's *Parnassus on Main Street*. Possibly the large number of women employees at the department store made the service a success there.

As reasons for its pioneering move, Elliott-Taylor-Woolfenden pointed to Detroit's population movement north of Grand Boulevard, and the need to alleviate the crush of retail trade in the "narrow confines" of the downtown district. A brochure describing the new store trumpeted its features: air "thoroughly washed of all impurities," "newer, softer, better lights," an information bureau with railroad and trolley time tables, telegram and post office, and a tea room and café on the sixth floor. No mention was made of the transportation service, added, no doubt, when business traffic did not meet expectations.

The back page of the brochure states, sadly in retrospect, "This will be a common remark after May 1st in Detroit—Meet me at Elliott-Taylor-Woolfenden, corner of Woodward and Henry. The new shopping district of Detroit."

Though the business "maintained the highest standards in its personnel, in the line of goods carried and in the treatment accorded patrons," it did not succeed in its location. Fyfe's Shoe Store, a major business in the city, built its new store at Woodward and Adams in 1918, six blocks south of Elliott-Taylor-Woolfenden, and managed to stay in business until 1971. The Fox Theater, which would have linked the two areas, did not open until 1928.

Mrs. Elliott sold her interest in the store in 1919. In 1924 it went into receivership and was sold to a Pontiac man, Sidney Netzorg, who claimed business would "continue as heretofore," but by 1925 it was out of business. The building itself was demolished in the early 1970s.

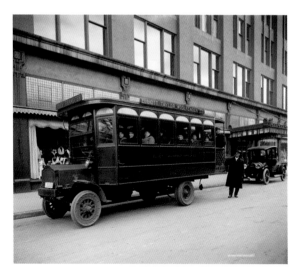

ABOVE *These determined-looking shoppers are taking advantage of an "auto transfer" service between the store, north of Grand Circus Park, and the downtown shopping district.*

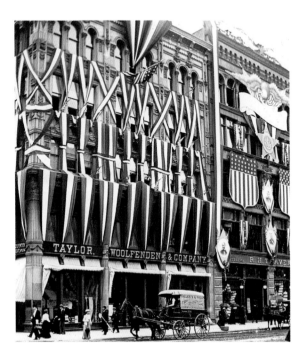

LEFT *This 1891 Jex Bardwell photograph of the Taylor-Woolfenden store on Woodward and State, captures the city's festive preparation for the Grand Army of the Republic reunion.*

OPPOSITE PAGE *Shopping is a leisurely affair in the early 20th century. The department store guide for the new E-T-W indicates that the second floor contains, among other things, clothes, infants' wear and shoes, as apparent in this photograph.*

Detroit Central High School MOVED OUT 1926

Detroit was without a high school for three years, between the fiery destruction of old Capitol High School, downtown Detroit, and the opening of Detroit Central High, a mile and a half north, at Cass and Warren Avenues, in 1896.

Malcolmson & Higginbotham, consultant architects for the Detroit Public School system, designed the building, which was thought to be one of their best school designs. Its buff colored limestone softened the appearance of the imposing Romanesque Revival structure. Built for up to 2,000 students, it contained 103 classrooms. Its cost of over a half million dollars was thought to be scandalous at the time.

Eight years after the high school opened it was fortunate enough to have as its principal David MacKenzie, a University of Michigan graduate who had previously served as superintendent of schools in Flint and Muskegon. It was he who began steering the school into the waters of higher education. In 1913 the introduction of a college level, pre-med curriculum helped the school become the first junior college in the state, as acknowledged by the state legislature in 1917.

Over time Central High went from a two-year junior college to a four-year, full degree institution, the College of the City of Detroit in 1923, all the while educating high school students. Besides the high school and university classes, students also attended extension courses for the University of Michigan and Detroit Teachers College. MacKenzie, whose house was also a Malcolmson & Higginbotham design, just blocks away from the school, was dean until his death in 1926.

By 1926, the high school students were all but crowded out of the building at Cass and Warren. A new Central High, at Tuxedo and Linwood became their home, one of Detroit's 11 fully occupied high schools. "Old" Detroit Central High School then became "Main Building," the cornerstone to the campus of Wayne University, its name until 1956 when it became Wayne State University.

LEFT *Taken from Warren and Cass avenues, empty streets make a traffic policeman's job boring. Today this building is known as Old Main, the focal point of the Wayne State University campus.*

RIGHT *This building served not only as the city's high school, but in 1900, a basement level space became the first branch of the Detroit Public Library. In 1921, the new main library would open a block away.*

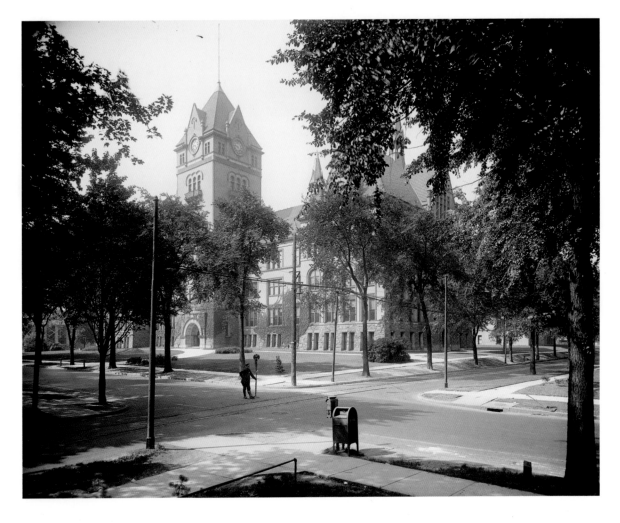

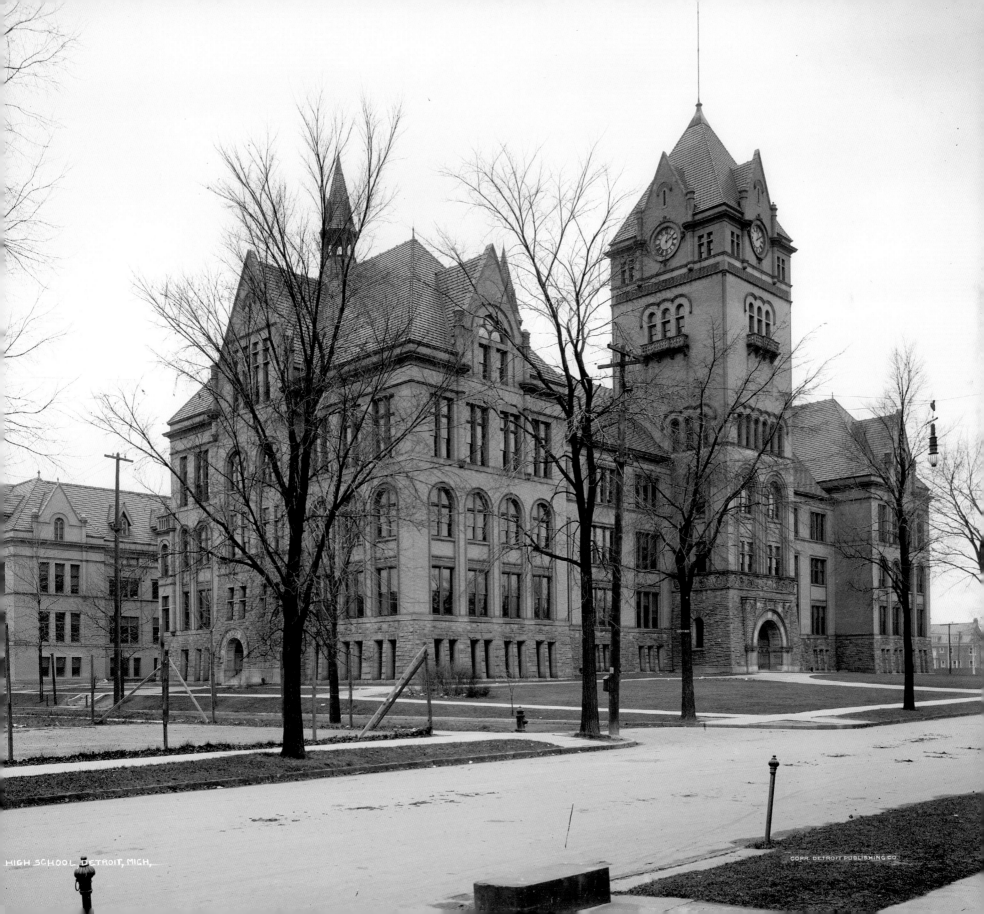

HIGH SCHOOL, DETROIT, MICH,

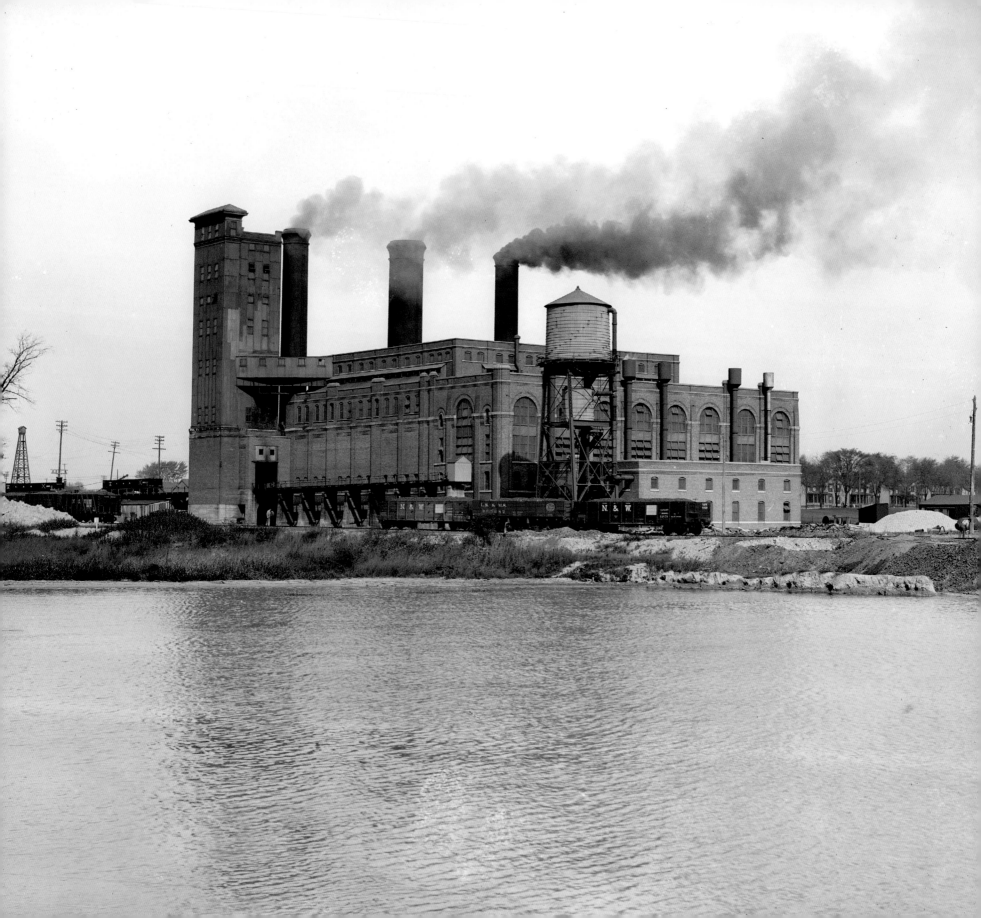

Edison Electric Plant PLANT NO.1 DISMANTLED 1928

Gas or electric? The choice wasn't easy. Gas lighting was cheaper and there was no electric wiring with its risk of shock or electrocution. The flame of the gas-lit lamp provided a warm, soft glow. But gas lamps came with an odor and created heat, particularly unwelcome in summer. Electric lighting was clean, that was its biggest draw at first. However, it could be unreliable; weather or other interference with the lines caused a break in service. And it cost more.

Electric lighting wasn't considered for the home until the incandescent bulb was perfected by Thomas Alva Edison around 1882. The Paris Exposition of 1881 allowed competing electrical companies and light bulb manufacturers to display their ideas and products. Edison, one of many inventors trying to come up with the right filament for the light bulb, put on the best show at the exposition, bringing a 220-ton dynamo to power his display.

Edison didn't invent the light bulb (though is credited for it), but a system for generating and distributing electricity. The light bulb was at one end of the system, a dynamo at a central station, with feeders and switches sending out this "mysterious and deadly force," at the other end.

At the turn of the 19th century there was fierce competition in Detroit as elsewhere among companies producing electric power. The Edison Illuminating Company was organized in 1886, when three-fifths of all Detroiters were still using oil lamps or candles to illuminate their homes, despite the availability of gas and electricity.

Detroit Illuminating operated two substations intended for distributing electricity. A plant was needed away from populated areas, with room for expansion, and on the river for access to condenser-cooling water. Detroit Illuminating bought out the remaining two electric companies and changed its name to Detroit Edison.

Delray, a village west of Detroit was chosen as the site for Detroit Edison's first power plant because of its location on the Detroit River and its access to railroad tracks entering and leaving Detroit. Work began on 30 acres of land in January 1903, directed by Westinghouse, Church, Kerr and Company. The power plant was described as "... to date, the largest industrial expenditure ever made at one time." It operated with two, 3,000 kilowatt steam turbines, built by the General Electric Company, beginning in August 1904. The plant opening allowed the company to convert their small steams plants in the city to substations. However Delray no.1 soon reached its full capacity and in the following two years, three more 3,000 kilowatt generators were added, making a total of five. Later the five turbines were replaced with four, each with 9,000 kilowatt capacity.

The second Delray plant began operating in 1908, and by 1913 had a total output of 93,000 kilowatts. Demand during 1913–14 equaled 75,000 kilowatts. When even more power was needed, a third Delray plant was added, built between the two older plants and the river. Delray no.1 was dismantled around 1928, when it was deemed economically unfeasible to update it.

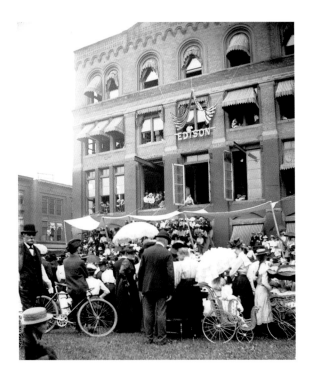

LEFT *Some unidentified celebration is taking place outside this office of the Edison Electric Light Company.*

OPPOSITE PAGE *Delray Power House no.1 was upgraded several times until the company concluded that further modernizations would be "economically unsound."*

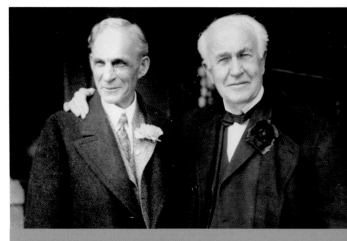

HENRY FORD AND THOMAS EDISON

The Edison Electric Co. had the same effect on people's lives as did the Ford Motor Company. Both made readily available a product that immeasurably changed the lives of people at the beginning of the 20th century. Henry Ford (pictured left) began working for Edison Illuminating as a mechanical engineer in September 1891 at the Willis Avenue and Woodward plant. In 1893 he was sent to the downtown station on Washington and made chief engineer there. He left Edison Illuminating in 1899 to take the plunge into the automotive business. But before that, company president Alex Dow introduced the 33-year old Ford to Thomas Edison (pictured right), initiating a lifelong friendship between the two. Ford's biggest tribute to Thomas Edison was The Edison Institute. The 14-acre museum was officially dedicated on October 21, 1929, the 50th anniversary of Edison's "invention" of the incandescent bulb. From this small beginning evolved the 90-acre Greenfield Village and the Henry Ford Museum. Ford reflected on his admiration for Edison in his book, *My Friend Mr. Edison*, "I admired the inventions of the man and also the man himself, but what hit my mind hardest was his gift for hard, continuous work."

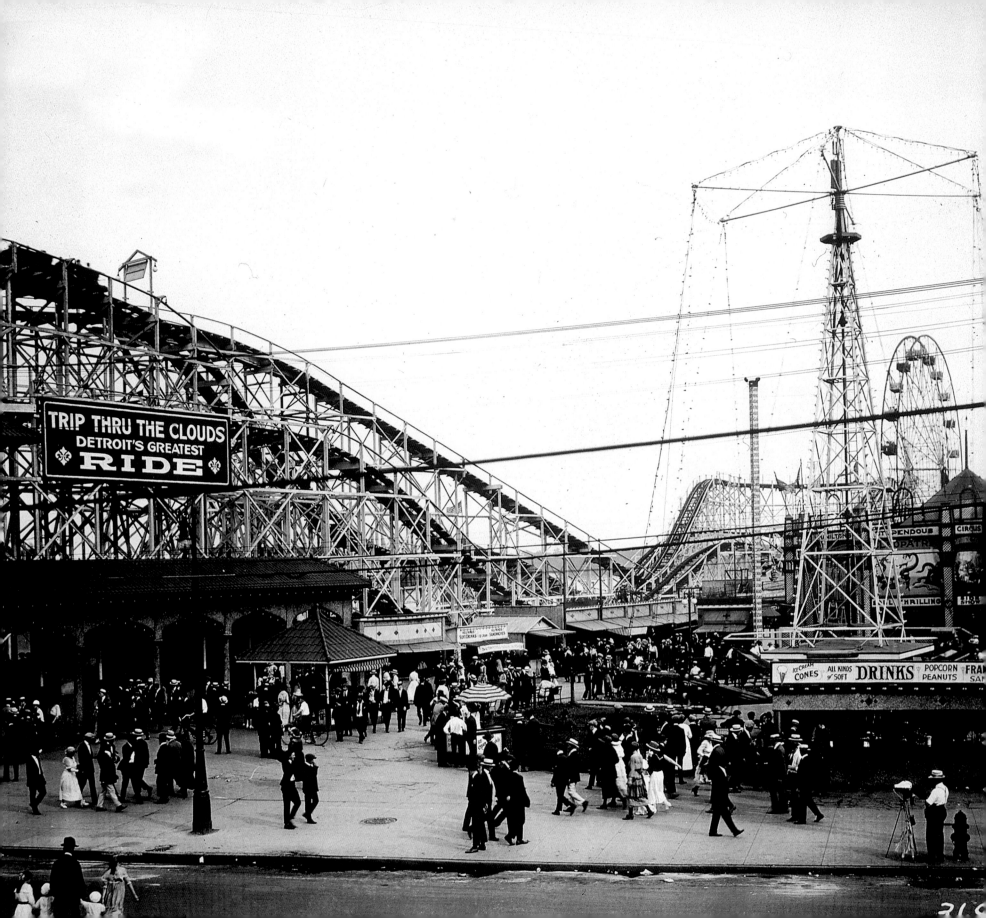

TRIP THRU THE CLOUDS
DETROIT'S GREATEST
RIDE

ICE CREAM CONES ALL KINDS OF SOFT DRINKS POPCORN PEANUTS

Electric Park RAZED 1929

The shore of the Detroit River, across from Belle Isle, was a popular place for amusement parks in the early 20th century. The parks existed on either side of the Belle Isle Bridge and were known by names like Riverview Park, Palace Gardens and Luna Park. Electric Park, with its 75,000 light bulbs, was the best known and longest running.

Opened in 1906 by Arthur Gaukler, it covered seven acres with such attractions as a roller coaster, an 85-foot Down and Out Tower slide, a 5,000 seat concert hall and the *Palais de Danse* Ballroom that extended over the river.

The dance halls attracted such big name bands as John Phillip Sousa's and local groups like Leroy Smith's Orchestra and the Floyd Hickman Orchestra. The *Palais de Danse*, called by one "the most beautiful ballroom in America," was built in 1912 by Charles Rosenzweig. It was preceded by Palace Gardens, also built by Rosenzweig, that burned in 1911. The Gardens, a stucco building with beer garden and dance bands, fronted on Jefferson Avenue at Field Street and ran to the river. Another ballroom called The Pier, operated by the Belle Isle Coliseum Company, was popular and lasted until 1928. In 1913 it offered "special Tango parties every Monday and Friday evening."

A 10 cent admission made the amusement park affordable to a variety of people, after all, part of the entertainment was experiencing the "great mixed mass of humanity." These parks had their critics, however, some calling them "the worst excess of a new form of mass-market commercial entertainment." A survey by Detroit's Young Men's Christian Association discovered in 1909 that a Sunday afternoon and evening found an average of 1,700 boys malingering in these "demoralizing" places. Still, few if any paid attention to the naysayers, and instead enjoyed the chance to escape to the riverside with its cooling breezes and brightly lit fun.

Edgewater and Eastwood Parks opened in 1927, drawing away some fun seekers, and Bob-Lo, though not as convenient, had been competing since Electric Park opened.

The park was condemned in 1927, the president of the Greater Detroit Committee claiming it a "maze of matchwood and gaudiness," that detracted from the beauty of Belle Isle. Electric Park closed in 1928 and demolition was completed in 1929. It was later replaced in 1936 by a public park named after Father Gabriel Richard, who among other things, wrote Detroit's motto: *Speramus meliora; resurget cineribus*: "We hope for better things; it will arise from the ashes."

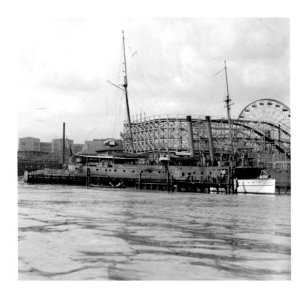

ABOVE *Taken from the Detroit River, this view of Electric Park, looking like "a maze of matchwood," makes a case for its condemnation.*

LEFT *The "Trip thru the Clouds" roller coaster was described as a "truly awesome ride," in a 1919 Detroit Convention & Tourist Bureau guide. The mile of track could handle six cars at once.*

RIGHT *Electric Park was located at the entrance to Belle Isle, at Jefferson and Grand Boulevard. People from all walks of life came to mingle and be entertained.*

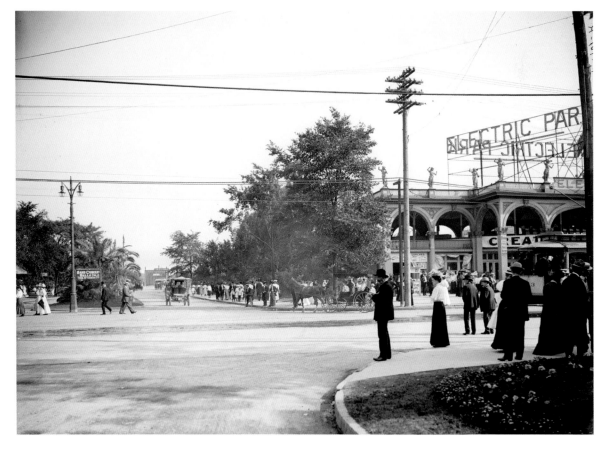

Centre Park Library RAZED 1929

At first the plan was to use the old City Hall for a public library building, putting it right in the hubbub of a busy downtown market area. When people realized that it would cost more to refurbish City Hall than to build a new library, another location needed to be found. In the meantime, the library opened on March 25, 1865 on the first floor of the old Capitol Building, used as a school since the state's capitol relocated from Detroit to Lansing in 1847. The state constitution, in 1835, provided funding for public libraries using penal fines, but the details and mechanisms of determining the city's share, and administering the funds took time to work out.

The Detroit Public Library opened with 5,000 volumes, at first for reference only, but quickly thereafter for circulation as well. It soon began its expansion. Rooms on the second floor of the Capitol were fitted up for use, then in 1870, an addition was built on the rear of the Capitol. Realizing that the library was going to keep growing, Common Council approved plans to make the old City Hall into a public library.

But public opinion dictated that a new, dedicated building, on another site was more practical and cost-efficient. A triangular plot of land called Centre Park was selected, and after more political back and forth, in 1873 the authorization was given to raise $150,000 for the building. The location, at Farmer, State and Farrar—the latter two streets later renamed Gratiot and Library—would put the new library, in 20 years time, directly behind the J.L. Hudson store.

Henry Chaney was chief librarian. As head of the high school, the responsibility for the library had naturally gone to him, and it was a responsibility he took very seriously. Along with the Library Committee, he toured other libraries, finding the Cincinnati Public Library a useful model. The Committee knew it wanted the library to be of brick, fireproof and have room for expansion. It also had specific recommendations for size, number and location of the rooms that were needed to conduct a library's business.

Brush & Smith were the architects of the French Empire building of brick, with wooden columns and pediment at the entrance. Funds had run out to follow the original plans that included a tower and broad sweep of steps, with a more decorative stone entrance. However, when the library opened in January 1877, it was the inside of the library that impressed visitors with a "grand architectural effect."

Ten wrought iron columns went from floor to ceiling. Each of the three floors above the ground floor had a decorative metal gallery for books, with iron spiral staircases and catwalks. The cast iron works were painted in colors of lavender and light brown, some were bronzed and gilded. The roof skylight was made of half inch thick stained glass.

In 1886 work was completed on a two-story addition on the rear of the building. The same year a telephone was installed, Sunday service began, and the Dewey Decimal system officially adopted.

When the new Main Library opened in 1921 at Woodward and Kirby, the Centre Park Library became the Downtown Annex. Though still used by library patrons, the book collection was small, and only part of the building was in use, making it inefficient to operate. In 1923, the library moved to temporary space in the old police headquarters at Randolph, Bates and Farmer and turned the Centre Park Library over to the Board of Education. The building was razed in 1929 and replaced two years later with a Downtown Branch Library, known today as the Rose & Robert Skillman Branch of the Detroit Public Library.

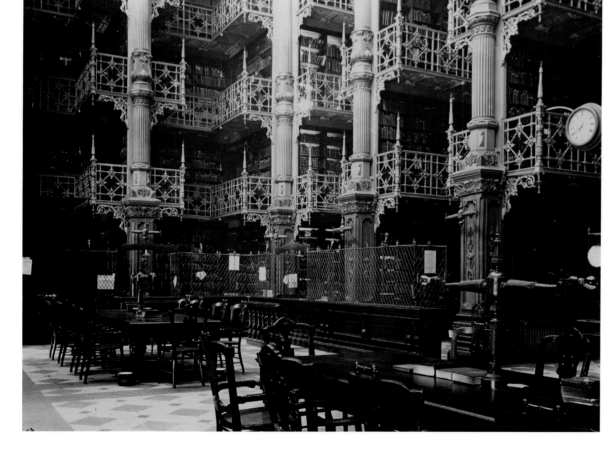

LEFT *In this "spider web of iron balconies and alcoves," the librarian sought to have "the books most in demand nearest the surface of the earth, to save the arduous labor of climbing stairs."*

RIGHT *The 1886 addition is visible at the rear of the library.*

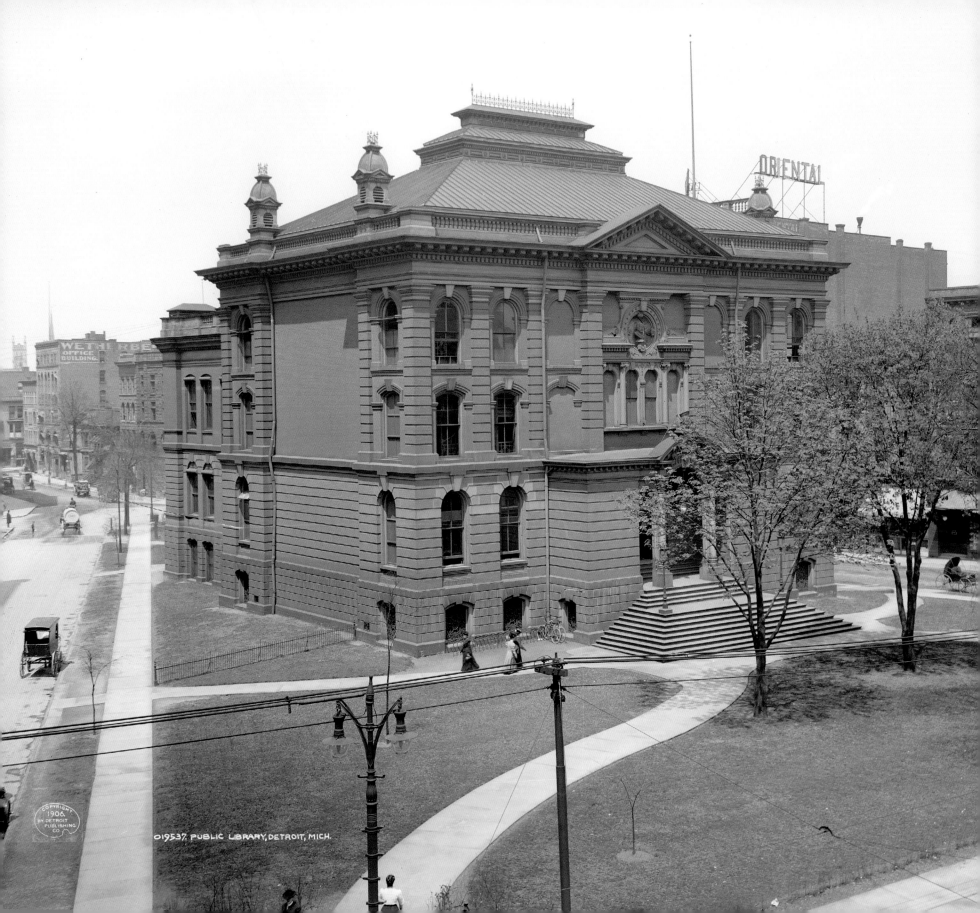

ORIENTAL

WETHERBE
OFFICE
BUILDING

COPYRIGHT
1906.
BY DETROIT
PUBLISHING
CO.

019537. PUBLIC LIBRARY, DETROIT, MICH.

Wayne Hotel and Pavilion DEMOLISHED 1931

The Wayne Hotel, opened in 1887, was a focal point of the Detroit dockside. Situated on the Detroit River, at Wayne and Third Street just west of downtown, it offered "two hundred large and airy rooms," from $2.50 to $3.50 a day. In 1898 the hotel announced the addition of its new steel pavilion containing a roof garden and sun roof, on the Detroit River side of the hotel. The Metropolitan Orchestra played every evening.

The 1909 Detroit Auto Show opened in the Wayne Hotel, after eight years but one of being hosted at the Light Guard Armory. It took over the Pavilion for five days in February. Two hundred cars were displayed by exhibitors and their employees wearing formal attire, a requirement. "Society Night" had a ticket price of $1.00. The show continued there for four more years before moving on to another venue.

The pavilion part of the hotel, known as Wayne Gardens, offered 30,000 square feet of space for the auto show, on two floors. Each year a contractor was hired and the hotel elaborately decorated, one year with over 5,000 lights, another with a goldfish-filled fountain and the next-to-last year with a rose bower. In 1912, the last year the auto show was at the Wayne, 62 manufacturers exhibited 73 brands of cars, trucks and motorcycles.

But the Wayne was more than a hotel and exhibition space. "Overlooking the Detroit River, with its immense display of merchant marine of the great lakes, makes it a most desirable resort," the hotel advertised. Indeed, it was right in the thick of things, with the Belle Isle ferry and ships leaving for Mackinac Island or Buffalo just outside the doorstep. The Michigan Central Railroad station was right next door. It couldn't have been better located.

And there was more. The hotel boasted one of the few mineral baths in the vicinity. A February 1915 *Detroit Free Press* article describes the drilling that would begin soon for a 500 to 600 foot deep sulfur well, and a 1,200 foot deep well aimed at striking the second salt strata. The owner had determined, by chemical analysis, that the water obtained for the baths would be superior to any other health facility in the country. As a result, the hotel was adding a two-story mineral bathhouse, to be followed by a six-story addition to the hotel.

The baths were patterned after those of Hot Springs, Arkansas and even managed by a gentleman from Hot Springs. There were to be 33 tubs, with cooling rooms and private rest and dressing rooms. The hotel manager, James R. Hayes, warranted that accommodations for women would be made. Several years after the baths had opened they were acknowledged to be "successful in the cure of many ailments."

The popularity of the hotel ("it was so popular that daily from morning on to midnight there was a procession of travelers registering at the counter, and the clerk could scarcely blot the name of one before another would be asking for a room") was seriously affected by the relocation of the Michigan Central Station at the end of 1913.

In 1918, "having decreased its business to the point of bankruptcy," the Wayne Hotel closed. The loss of business due to the relocation of the Michigan Central Station was devastating. According to a 1939 *Detroit News* feature, the Wayne Hotel was razed in 1931.

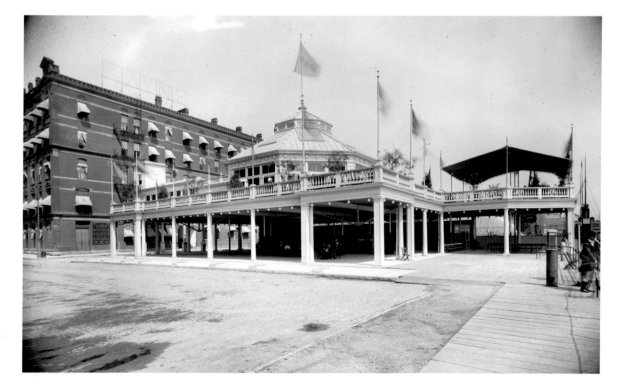

LEFT *With a roof garden and sun parlor, not to mention an excellent view of the Detroit River, the Pavilion added amenities to the Wayne Hotel that no other hotel could touch.*

RIGHT *The location of the Wayne Hotel was a traveler's dream. The ferry docks were just outside its door and the train station sat next to it. The Detroit Auto Show was held here from 1909 to 1912.*

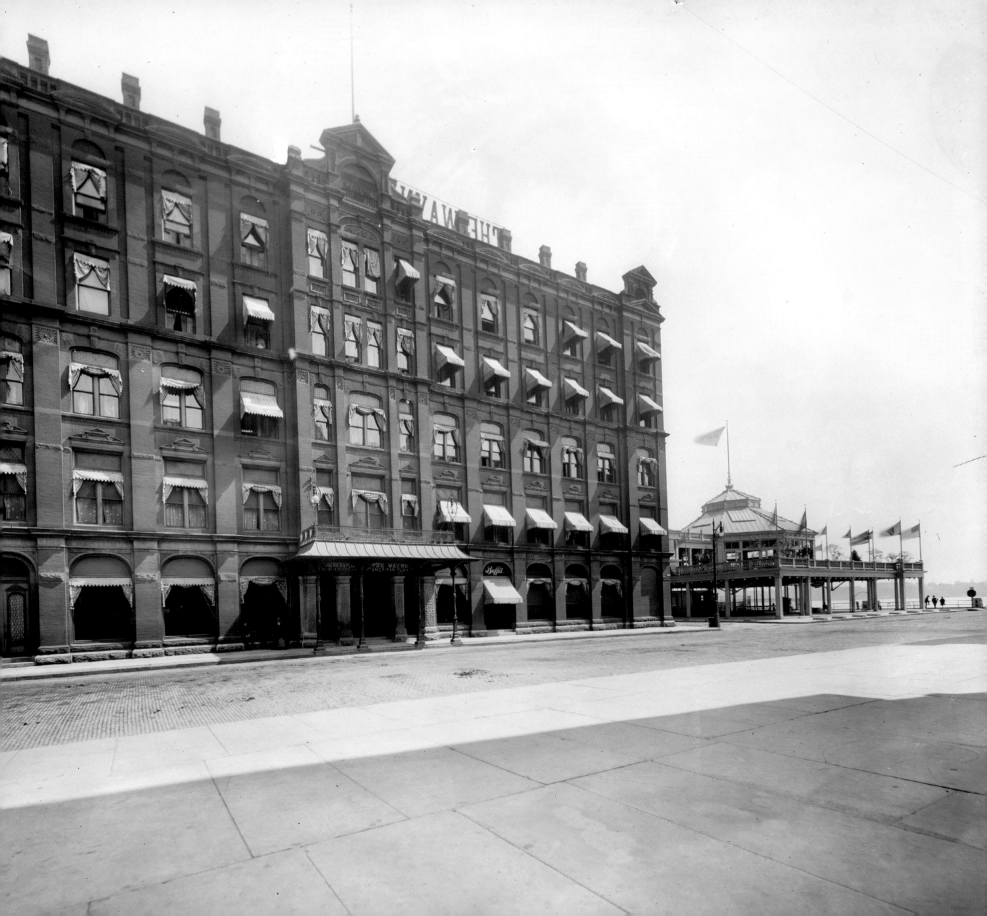

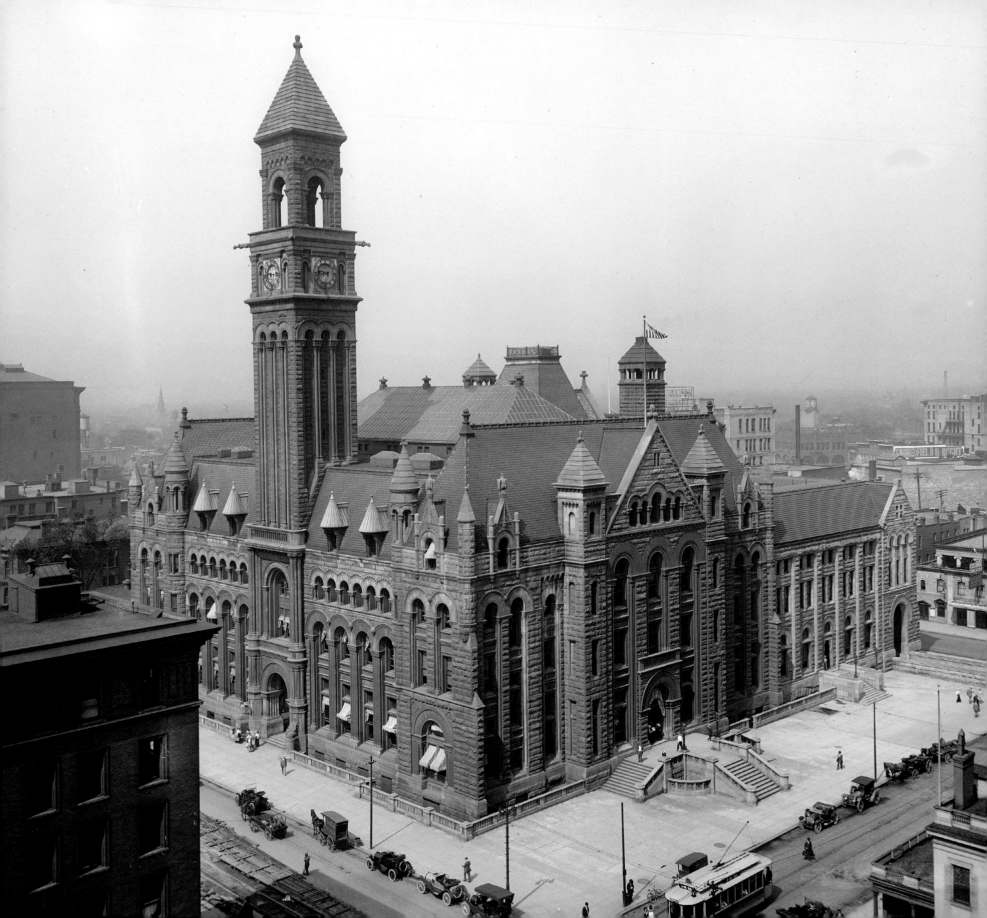

Federal Building / Old Post Office

DEMOLISHED 1931

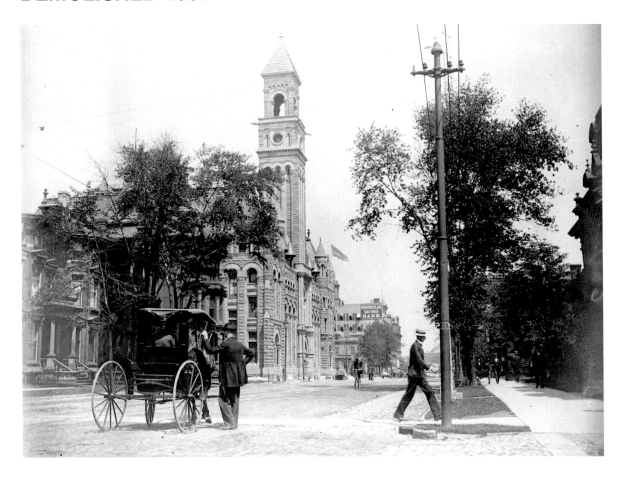

A number of locations were considered for this monumental building, including the spot where Capitol High School sat. The debate was whether to rebuild in the area where the U.S. Customs House and Post Office currently stood, at Griswold and Larned, or to seek a better location. Proponents of a new location argued for an entire block of space, so as not to outgrow the building. C.J. Whitney was easily persuaded to sell his Whitney's Grand Opera House, at the corner of Fort and Shelby, and the excavation for Detroit's second federal building began in 1890. The building was bounded by Fort, Shelby, Wayne and Lafayette.

Fifteen years later, Frederick Law Olmsted commented on the location and how isolated the Federal Building was from other civic buildings, specifically City Hall, two blocks away and the even farther County Building on Cadillac Square. He recommended demolishing the row of "happily unimportant" buildings on the north side of Fort Street and creating "a line of ornamental columns" to visually connect the Federal Building and City Hall. His advice was not taken.

A Philadelphia architect, James H. Windrim, designed the castle-like structure in the best Richardsonian tradition, similar to the distinctive Allegheny County Courthouse in Pittsburgh, built 10 years earlier. Henry Hobson Richardson died in 1886 but in 1888 a revival of his architectural style caused a number of substantial public buildings to be built with the trademark ashlar stonework, arched windows and entryways and conical-capped towers.

Officially it was the United States Customs House and Post Office Building, but everyone knew it simply as the Post Office, which took up the entire first floor. There was an observation deck on the roof's high point, outfitted with equipment for the National Weather Bureau (forerunner of the National Weather Service), but never used. Its 243-foot tower with clock provided another timepiece, besides the ones at nearby City Hall and Union Depot, that Detroiters could use to set their watches.

As predicted, the building was fast outgrown, some say before it was even fully occupied. It was enlarged by a three-story addition in 1915 but still remained overcrowded. In 1930, the federal government recognized Detroit's enormous population growth in the last three decades. Going from 15th in the U.S., at just over 205,000 in 1890, to fourth largest city in 1930, with over a million and a half people, it was designated the site of a new federal building and customs house. The old building was demolished in 1931 to make way for its larger replacement.

Before the 1897 building closed, students from architecture classes would visit the courtrooms to study their details. One of these courtrooms exists today in the new Federal Building. Judge Arthur Tuttle requested that the marble walls of his courtroom be removed and reinstalled in the new building. The transfer of the ornate room from one building to the other didn't come easily. The Treasury Department had to approve the move, then each piece of the courtroom had to be numbered, labeled, photographed and stored until the new building was ready. It took three months to put the pieces back together.

Hotel Ste. Claire TORN DOWN 1934

Called a "swanky showcase," this absolutely fireproof hotel was built on the Brush estate by William G. Thompson. Advertised as being in the heart of the city, it was steps from the Detroit Opera House and Campus Martius. Rooms were from $2.50 to $3.50, the higher-price indicating a room with bath. Promoting itself as being "the best equipped hotel in Detroit," the Ste. Claire had hot and cold running water, electric lighting, "the new Teleseeme call system and steam heat without charge." The proprietor, William P. Beyer, would gladly point out places of interest for the visitor new to the city, such as the Museum of Art, the public library one block away, Belle Isle Park, the garrison of Fort Wayne, and more.

As Beyer, who retired in 1909, remembered some years later, the hotel borrowed many ideas from the Waldorf and hired French waiters and chefs from New York City. In a *Detroit News* George Stark column he recalled that "Detroit millionaires drove in their carriages from Grosse Pointe to dinner." Grosse Pointe matrons hired away a number of the French waiters to butler for them.

At the time the eight-story hotel opened, in 1893, it eclipsed the Hotel Cadillac and Russell House as the social center of the city. Described as a "structure of rare beauty" its iron and steel framework was covered by stone and bright-colored brick. Inside, the floors, columns, staircases and wainscoting were marble with doors and woodwork of bird's eye maple. In the lobby, a mural by Detroit artist Robert Hopkin depicted a scene at Windmill Pointe, where the Detroit River opens into Lake St. Clair.

Designed by architect Henry George, the building also featured wrought iron window ornamentation, which, with the chateauesque style of the building's roofline gave the hotel a French flair. Located at the corner of Randolph and Monroe, the hotel was a few blocks from the city center, yet not far from the Wayne County Courthouse, whose politicians found the hotel's bar a ready hangout.

During the lean years of the Depression, the realty company, which had a long-term lease on the property, was unable to meet payments to the hotel's owner, the daughter of Mayor William G. Thompson. Over $76,000 was owed in back rent and taxes and when a court ruled against the company, the hotel closed in November 1933, evicting those living there, some for as long as 25 years. When no new lessee could be found, the owner sent in the wrecking ball and the building was demolished on January 3, 1934.

HOTEL STE. CLAIRE, DETROIT, MICH.

This is the Hotel where I am staying will

RIGHT *The Ste. Claire found favor with wealthy Grosse Pointers, perhaps for its emulation of New York's Waldorf Hotel. They even enticed some of the French waiters to work as butlers in their homes.*

LEFT *Just a couple of blocks from the Detroit Opera House and the city's early entertainment district, the Ste. Claire was a popular place for theater people to stay.*

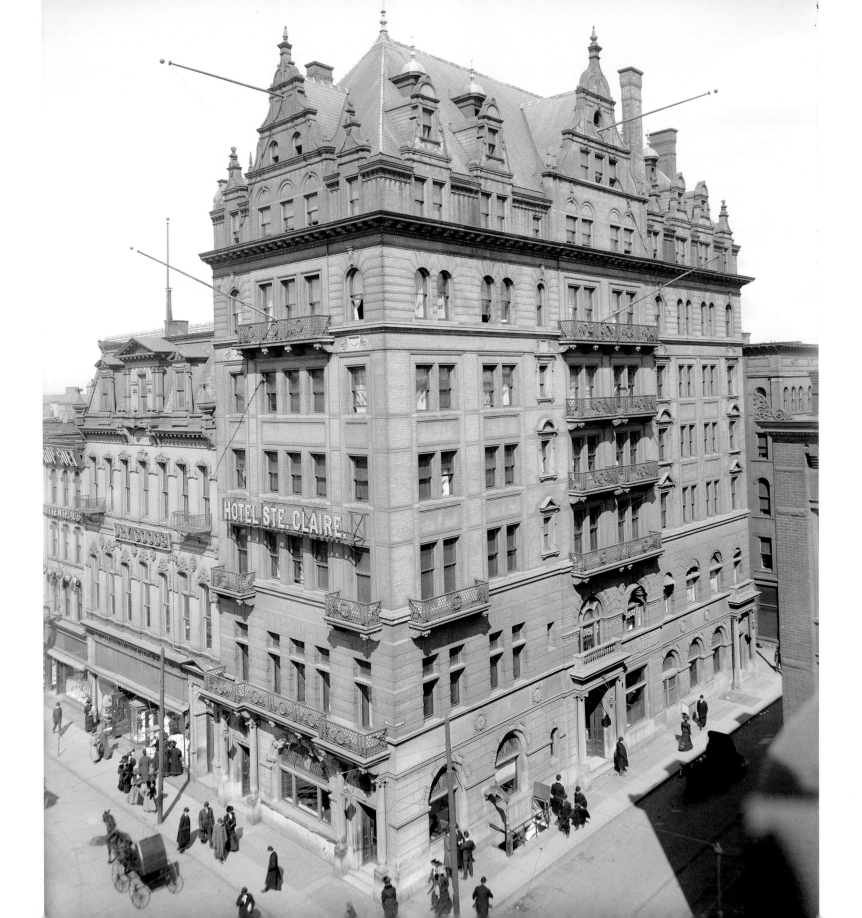

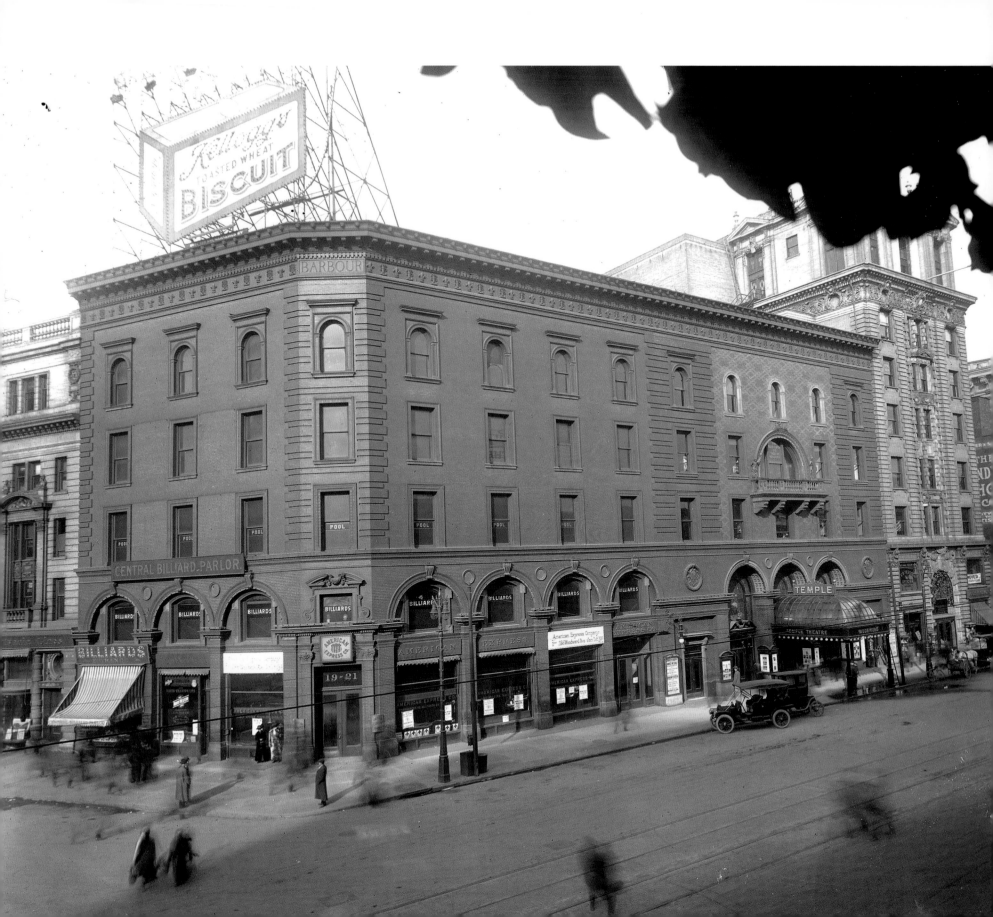

Temple Theatre RAZED 1935

The Temple Theatre, Detroit's best known vaudeville house, was around the corner from Detroit's legitimate theater, the Detroit Opera House. While the Opera House hosted Broadway plays and of course, opera, the Temple's fare was aimed at all classes of people, and had a high standard for providing only the best family entertainment.

The theater was in the Wonderland Building which shared an auditorium with the Temple. Both were owned by Enoch Wiggins. Opened on December 23, 1901, the Temple was one of the oldest and most successful theaters of its kind in the Midwest. Wiggins also built the Elks Temple, next door to the theater, and was known for his philanthropy. According to one source, he used box-office receipts to aid destitute families, with no publicity.

While the name acts performing at the November 6 opening might not be familiar, the Hawthorne sisters, Hall and Staley or the Cecilian Ladies' quartette, for example, some of the later names surely are.

Blind Tom, an African American savant and musical prodigy played at the Temple in his waning years, a few years before his death. A former slave, Thomas, "Blind Tom" Wiggins performed for years under the aegis of his former owner, then manager, for whom he made thousands of dollars. Considered a novelty act by some, Wiggins was a talented mimic also, and composed music as well as playing it. When vaudeville took hold he was "resurrected" and he appeared at the Temple for five days in March 1904.

Sophie Tucker, "The Last of the Red Hot Mamas," was on the Keith circuit, a vaudeville chain of acts represented by the B.F. Keith Company which eventually took over the Temple. She performed to a full house at the Temple in 1915.

The theater was renovated twice, once in 1908, when it was redone in an Italian Renaissance style at a cost of $20,000 and in 1915. For the second refurbishing, the old leather seats were replaced with plush, blue velvet ones, with seat numbers embroidered into the seat backs. The *Moving Picture World* article of August 7, 1915 on the "rejuvenation" described the new seats as "comfort personified." The lobby was retiled and new, blue carpeting laid on the first floor and stairways. In 14 years the theater was only closed five weeks.

One other 1915 act caused quite a stir in Detroit: Mae West: A reviewer called her "plainly vulgar," for her suggestive song, "And Then," which she apparently was allowed to sing at her Temple performance, despite the management's usual control of content. "The audience howled for more…" summed up their reaction.

Besides the theater marquee that drew attention to the on-stage performances, the top of the Temple building had an enormous electric sign that in 1908 was lit up with the slogan "Watch the Fords Go By."

In 1923 the B.F. Keith Company from Cleveland took over the Temple, investing $300,000 to remodel the theater to host Keith circuit productions. The theater was modeled after the Palace Theater in Cleveland. Keith and Albee was one of the more popular vaudeville chains and enforced strict rules about what could and could not be said or performed in an act. Anyone "found guilty of uttering anything sacrilegious or even suggestive … will be immediately closed and never again allowed in a theater where Mr. Keith is in authority." If you were locked out of the Keith circuit your chances of finding work elsewhere in vaudeville were slim.

The Keith circuit didn't last long however, as the city's most popular theater lost out to motion pictures. Campus Martius, which had been the city's live theater center until the early decades of the 20th century, was overshadowed by the movie palaces on Grand Circus Park.

The Temple, Comique, and other theaters turned into tawdry houses for low budget films while the popular Hollywood productions were shown in the more glamorous Michigan or Madison theaters. Vaudeville acts ceased at the Temple in 1928. It had a brief respite as a movie house, but the building was taken down in 1935.

LEFT *Calling itself "strictly a family theater," the Temple hosted such famous names as Fred and Adele Astaire, George Jessel, Jack Benny, and George Burns and Gracie Allen.*

RIGHT *The phrase "Their faces shall be wreathed with smiles; their hearts with mirth made lighter," carved above the box seats was an apt summary of vaudeville's intent.*

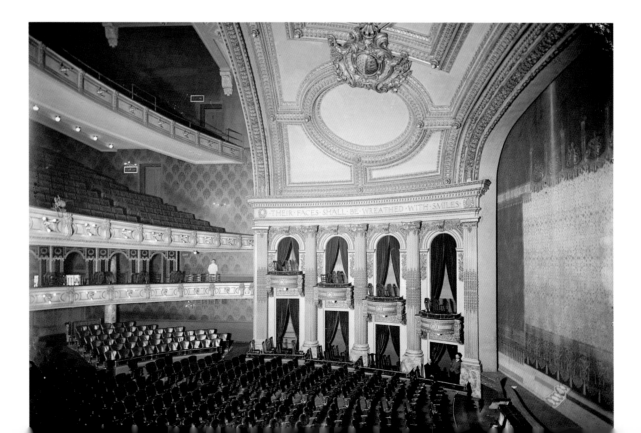

Detroit Creamery Headquarters CLOSED c. 1935

The name evokes times when milk, eggs, and dairy products were delivered right to one's doorstep. The Detroit Creamery was only one of a number of "creameries" or milk distributors in Detroit in the early to mid-20th century that had home delivery. Other familiar sounding names were Belle Isle Creamery, Brown's, Twin Pines, Brickley's, Eagle, United, Foremost, Sealtest, and Borden's.

Calling itself Detroit's largest and oldest creamery, the Detroit Creamery was incorporated in 1900. At one point it had 25 milk trucks, with glass-lined tanks, and 500 route salesmen, "all of [whom] must qualify as to being punctual, industrious and courteous to customers."

The company owned over 2,200 acres of land near Mt. Clemens, where one of their brands, Walker-Gordon milk, was produced. The 50,000 cows in their supply line had it pretty good. "Before each milking the cows must be washed and brushed and the tails and flanks are closely clipped for sanitary reasons."

Before there were bona fide companies collecting and distributing milk, there were milk peddlers. When people moved into cities away from their land and livestock, the only way to get fresh milk was from someone who had a cow. These independent vendors went door-to-door, their cans of milk loaded in a wagon, and anyone wanting to purchase some brought a container out to the wagon and the milk was ladled in. As one might imagine, high health and sanitary standards were not always maintained. Sometimes an unscrupulous peddler would add foreign substances, like chalk, to stretch the product.

City milk inspectors, responsible for the safety of the milk, were at first just policemen. Finally two doctors were put to the task and took milk samples to a laboratory to be tested. They also inspected places where milk was sold, and the milking parlors and living conditions of the animals.

When dairy factories started to be formed at the turn of the century, more regulation was put in place and the peddlers could not compete with the sheer size and distribution system of the milk companies.

The final blow came in 1916 when Michigan became the first state to require milk to be pasteurized.

Detroit Creamery's main dairy plant and stable for its delivery horses was at Grand River, Cass and Adams, two blocks west of Grand Circus Park. That building disappears from the city directory in 1935, though the company still had nine branch offices in Detroit at the time and stayed in business until 1958.

ABOVE *Workers at the Mt. Clemens farm made sure that every bottle of "certified milk" was capped and sealed.*

LEFT *By around 1924 motorized vehicles replaced the horse and wagon, and these drivers are poised to begin their delivery routes.*

RIGHT *The main plant was at Grand River, Cass and Adams; the Hotel Tuller is partially visible at the right edge of this circa 1906 photograph.*

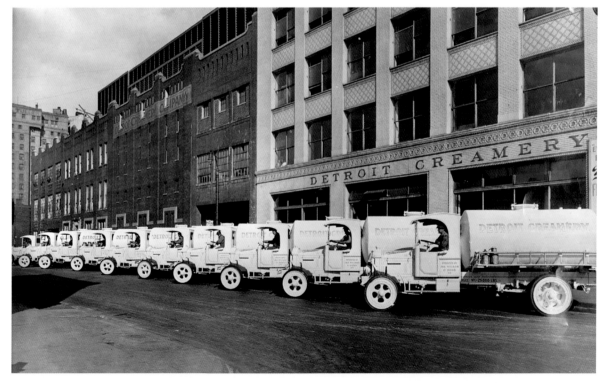

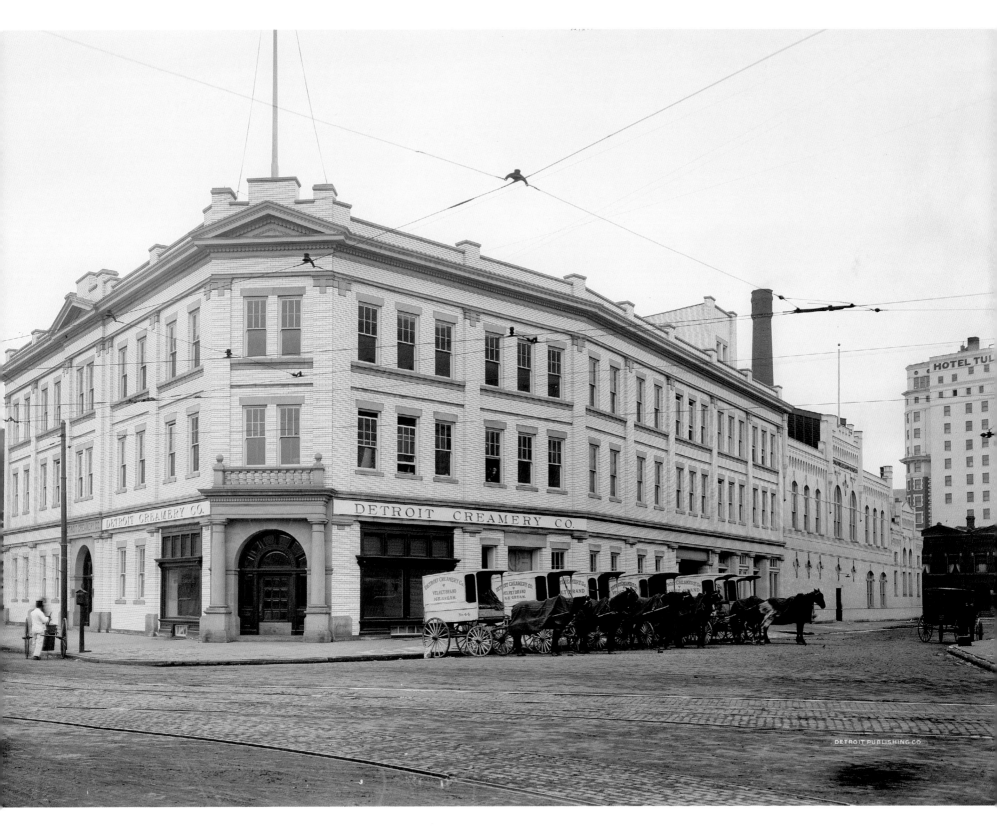

Tashmoo SANK 1936

Detroit was a city that began on the waterfront, did business on the waterfront, and took its pleasure on the waterfront. Large steamers full of gaily waving passengers capture the euphoria of setting sail on a summer's day. Some ships headed downriver to Bob-Lo Island or Sugar Island, others went in the opposite direction to Belle Isle or farther, on the two-hour trip to Tashmoo Park on Harsen's Island in the Saint Clair flats. At Tashmoo Park, the excursionists had baseball diamonds, picnic grounds and a dance pavilion to keep them entertained. What a relief it was to escape a steaming city full of clanging trolleys, street-dirtying horses, and later, the cacophony and fumes of the automobile. Poet George W. Osborne expressed it this way: "When the mercury denotes / Sultry summer heat, / Then the spacious ferry boats / Afford a cool retreat. / On a shady upper deck, / Joined by friends so merry, / Bless me! ain't it pleasant, / Riding on the ferry?"

From 1818, when *Walk-in-the-Water* sailed from Buffalo to Detroit, until 1991, when the last Bob-Lo boat sailed, these steamers plied the Detroit River and beyond, as ferries going to Windsor or Belle Isle, as larger boats like the *Tashmoo* or *Columbia*, going to amusement parks, or as the hotel-like *City of Detroit III*, making overnight trips to Buffalo and Cleveland. By 1922, according to Clarence Burton's *City of Detroit* history, there were more passenger steamers owned in Detroit, with more passenger capacity, than any port in the U.S. except New York.

The *Tashmoo*, an Indian name, was built by the Detroit Shipbuilding Company and launched in December 1899 from Wyandotte. The 300-foot long ship, the longest on the Detroit River, was designed by marine architect Frank E. Kirby and owned by White Star Lines. A brief notice in the *New York Times* announcing the launch repeated the claim that she was considered "the finest and fastest excursion steamer on either the lakes or the seacoast." In 1902 President Theodore Roosevelt, visiting Detroit to address the Spanish-American War Veterans Convention, took a sail with his entourage on the *Tashmoo*.

The Detroit Belle Isle and Windsor Ferry Co., created by a merger of the Detroit Ferry Co. and the Windsor Ferry Co., ran ferries every 20 minutes to Belle Isle from their docks at the foot of Woodward Avenue, "three squares" from the D&C dock. Hot days in the city were combated by a 10 cent ride on the ferry, back and forth all day long, accompanied by a picnic lunch. You might be lucky enough to have Harry P. Guy's band on board.

Other than private craft, the ferries were the only way of crossing the Detroit River to Windsor or to nearby Belle Isle Park. The first Belle Isle Bridge wasn't built until 1889, and a connection to Windsor, via the Ambassador Bridge, wasn't made until 1929. The last ferry to Windsor sailed July 18, 1938. After a fire destroyed the Belle Isle Bridge in 1915, the second one didn't open until 1923 (though a temporary one went up until then). Three weeks later, fire destroyed the Belle Isle ferry docks at the foot of Woodward, but the company was able to temporarily make use of the Walkerville Ferry Company docks at the end of Joseph Campau. Ferries to Belle Isle stopped operating in 1957.

The *Tashmoo*'s run came to a sad end when she ran aground on June 18, 1936 while carrying 1,400 passengers from an evening's entertainment on Sugar Island. The passengers safely disembarked in Amherstburg and were given passage back to Detroit. But the salvage company was unable to dislodge the ship without destroying it. Tashmoo Park stayed open until 1951, when the last steamer to serve it, *Put-in-Bay*, retired.

RIGHT *The designer of the* Tashmoo, *marine engineer Frank E. Kirby, was responsible for more than 150 ships on the Great Lakes.*

BELOW LEFT *Docked next to the* Tashmoo *is a smaller White Star Line ship, the* Owana, *which ran in the opposite direction, downriver to Toledo.*

BELOW *On September 21, 1902, President Theodore Roosevelt managed to squeeze in a ride on the* Tashmoo *while in town to address Spanish-American War veterans.*

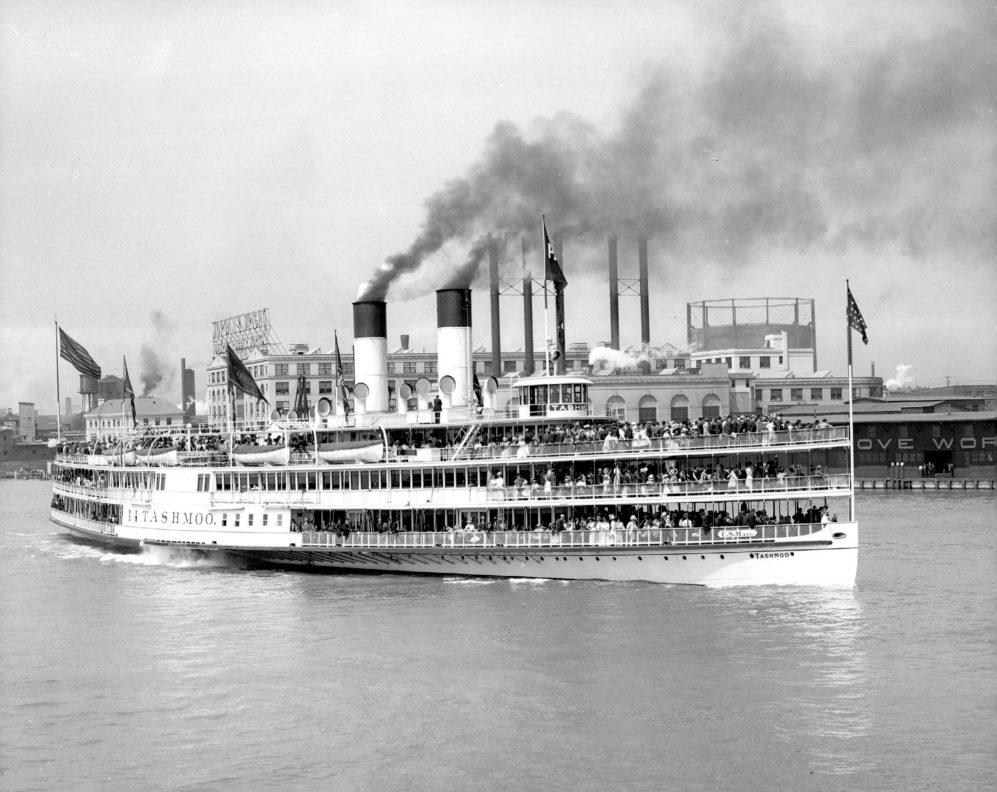

2639, STR. "TASHMOO," (PARKE DAVIS EXCURSION) DETROIT, MICH.

COPR. DETROIT PUBLISHING CO.

Fort Wayne CONVERTED INTO A MUSEUM 1949

Never a fighting fort, Fort Wayne sits a mile across the river from Canada, just west of downtown Detroit. Named after Revolutionary War General "Mad" Anthony Wayne, it was built during 1843–51 to stave off a possible Canadian or British invasion.

This was Detroit's third fort. The French built the first, Fort Pontchartrain in 1701, the second, Fort Lenoult, was built by the British, and later renamed Fort Shelby, after the U.S. won the French and Indian War. The star-shaped fortification on 96 acres had red cedar-faced earthen ramparts, which were replaced with 22-foot high, 7.5-foot thick brickwork in 1863. Britain's sympathy with the South led to fears of an attack from across the river.

The Fort served as a training ground for the Michigan First Infantry during the Civil War, mustering troops in and out of service and hosting wounded troops during their recovery.

The Fort was used as a garrison post until 1920. During the two world wars it became a depot for vehicles built in Detroit for the military, officially becoming a Motor Supply Depot in World War II. Two thousand civilian employees and more buildings were added to handle the influx of

vehicles. The Fort also housed Italian prisoners of war, many of whom remained in Detroit after the war ended.

Members of President Roosevelt's Civilian Conservation Corps lived at Fort Wayne during the 1930s and early 40s, and before that, homeless families struck by the Great Depression. In the 1950s and 60s Fort Wayne hosted anti-aircraft batteries and Nike missiles, and during the Korean and Vietnam Wars inductees were sworn in there. Those displaced by Detroit's 1967 riots found a temporary home at the fort.

What remains of the old fort today is the 1845 star fort, the original 1848 limestone barracks building and restored commanding officer's house, and the restored Spanish American War guard house. The troop barracks, built at the same time as the fort, is a building of five adjacent, independent sections, each with a mess on the ground floor, two floors of barrack rooms and an attic. The original officers' quarters, constructed inside the star, no longer exist. In the 1880s, wooden officers' homes in the Victorian style were built, and during the 1930s covered in brick by Works Progress Administration workers.

Beginning in 1948, the Army began gradually turning over the property to the City of Detroit and the City's Detroit Historical Museum began operating it as a military museum. The fort was deactivated by the Federal Government in 1967. Today the Detroit Recreation Department oversees the Fort, which, besides housing the Tuskegee Airmen's Museum, is used for reenactments and is open for tours.

JEX BARDWELL

Jex Bardwell was one of the first professional photographers in Detroit. Born and educated in England, Jex and his wife Emma showed up in Detroit around 1860. It was an exciting time to arrive in the big city. Troops would soon be mustering in Campus Martius and training at Fort Wayne and what more could a photographer want than to document history? Bardwell has been called, perhaps effusively, "Detroit's Matthew Brady," for his iconic images that document Detroit's role in the Civil War. But more than that, he provided hundreds of pictures of everyday life in Detroit at the end of the 19th century, from formal portraits of homes, to group portraits of clubs and organizations, to pictures of businesses and industries, to capturing the casual "man in the street," to following important events, like the 1891 gathering of the Grand Army of the Republic in Detroit. His business waned with the introduction of Kodak's Brownie camera in 1888, and he retired in 1893. He was revered as a teacher at the Detroit Museum of Art and presented technical papers at a number of conferences elsewhere. The Photographer's Association of America, along with the Masonic Temple in Detroit, helped support him in his later years, for though a prolific and gifted photographer, Bardwell was not a successful businessman. He died in 1902.

LEFT *This Jex Bardwell photograph presents the officers of the Second Michigan Infantry. It was taken near Fort Wayne in May 1861.*

OPPOSITE PAGE *Incorrectly labeled "officers quarters" by the photographer, this is one of four troop barracks built between 1890 and 1910.*

Belle Isle Skating Pavilion REMOVED 1949

It was difficult to say which season was more popular with Detroiters, winter or summer. Winters could be made quite agreeable by bundling up and strapping on a pair of ice skates. There were skating rinks scattered around the city, but a few turns around Lake Tacoma, by the skating pavilion on Belle Isle, was sure to restore a sense of well-being. Male skaters might break out in a sudden sprint just for the competitiveness of it, while women figure skaters showed the grace and elegance of the sport.

The skating pavilion was built in 1884, two years after the park opened. The building embraced architectural features of the Victorian Shingle style, in its wood covering, turreted towers and corner accents and the Romanesque style in its arched windows. A belvedere on top of the building provided ample room for observers. The building stood until the late 1940s; a new pavilion, the Flynn Memorial Recreational Building, designed by J. Robert F. Swanson, was completed in early 1950.

In the summer, skating gave way to canoeing and the canals were packed, particularly on the evenings when a band played in the pavilion over the water. The shoreline on these occasions was described by one as a "surging mass of humanity," the canals compared to those of Venice.

According to George Stark's memories, "The band stand was on a bridge that arched the grand canal. The crowds sat on benches or on the grass along the banks. The canal itself would be literally packed with canoes, gaily painted, and decorated with fancy pillows. Some carried a gramophone and provided its own music during intermissions. Applause was always long and enthusiastic, and it was amplified by the ringing of thousands of bicycle bells. …Harold Jarvis sang 'Beautiful Isle of Somewhere.'"

At first a rustic pavilion was built over the canal near the first casino, then in 1894 replaced by a classic marble-columned band pavilion. A variety of bands played on the pavilion, from the Detroit Opera House orchestra to concerts by Schmeman's Band that were simulcast on radio.

Canoes could be rented or a boat slip could be leased to dock a private canoe. A 17-foot long Old Town canoe was one of the largest on the canals, with Philippine mahogany interior and a white canvas skin on the exterior.

On the occasion of the city's July 1912 Cadillaqua, a combination city birthday and automobile celebration, the canals were even more glorious. A Venetian Night gala on Belle Isle featured canoeists gliding through the canals that were lit by thousands of electric lights. The *Detroit News* described it as "an hour in dreamland … [presenting] spectacles of a fairy night."

The band pavilion was removed in 1942. Canoes continued to fill the canals until the 1980s, when the canoe rental closed, effectively ending the sight of the elongated boats gliding on the Belle Isle waterways.

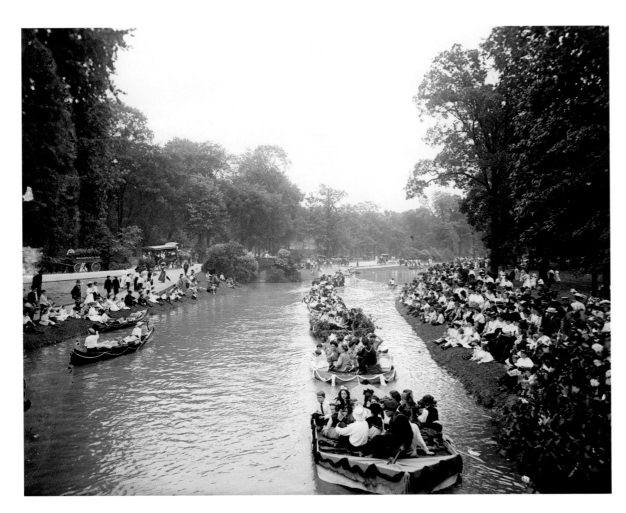

OPPOSITE PAGE *Having wobbly ankles was no barrier to ice skating on Lake Tacoma in front of the Belle Isle pavilion. The energetic sport took away some of winter's sting.*

LEFT *One of many water parades held on the Belle Isle canals, the costumed canoers indicate that this might be one held during Cadillaqua.*

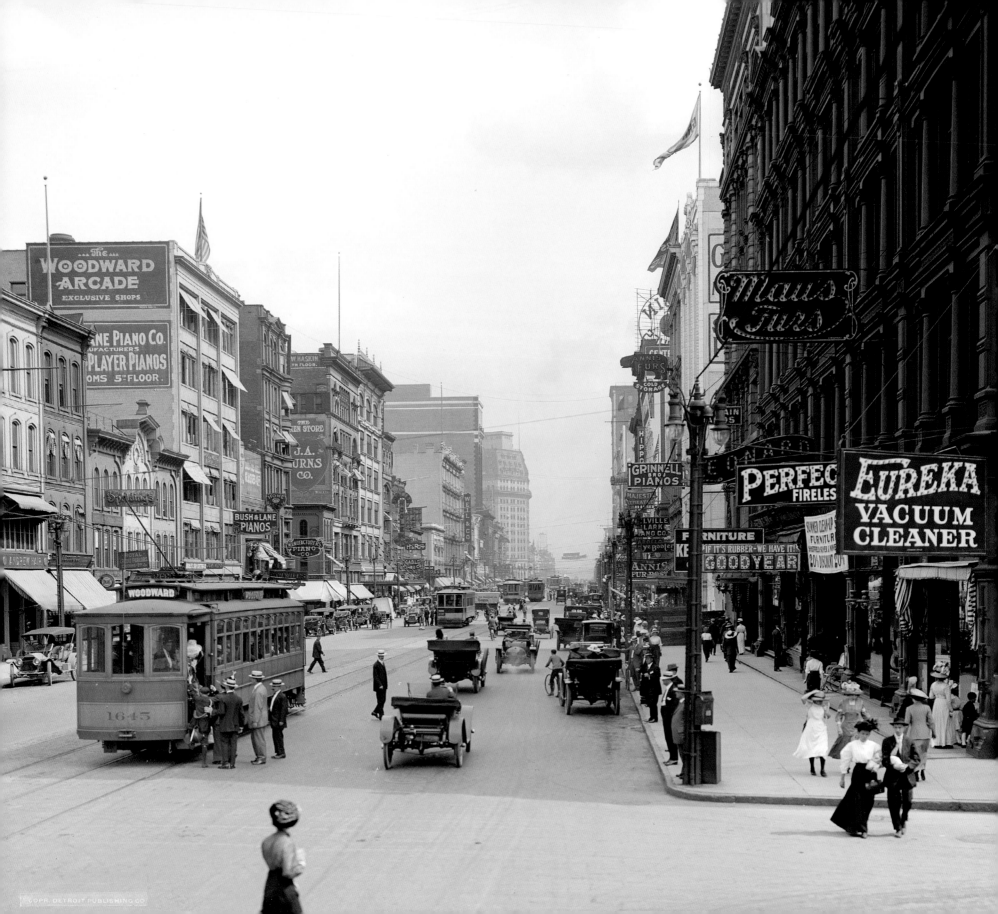

Streetcars DISCONTINUED 1956

The street car was more than transportation, it was also entertainment. By 1898, 35 years after the first horse-drawn street car traveled up Woodward Avenue, the streetcar was a modern convenience, marketed to the convention crowd. "Trolley parties, traversing 100 miles of beautiful boulevards, streets and avenues, reaching parks and lakeside resorts, are a feature of many conventions in Detroit," stated one promotional advertisement. Buffet cars further induced the visitor to "take a cruise over modern Detroit."

Detroit saw the first horse-drawn street cars in 1863, on Jefferson and Woodward Avenues, some 32 years after New York City and 29 years after New Orleans. The round trip was a little over two miles on Jefferson, taking 60 minutes, and a little over three miles on Woodward, taking 75 minutes. Travel at more than six miles an hour was speeding, and the fare was five cents. Gratiot and Michigan Avenue lines were added shortly afterward, and by 1866 there was an east-west line that ran outside the city limits from Elmwood Cemetery, on the east side, to Fort Wayne, on the west, a round trip of 11

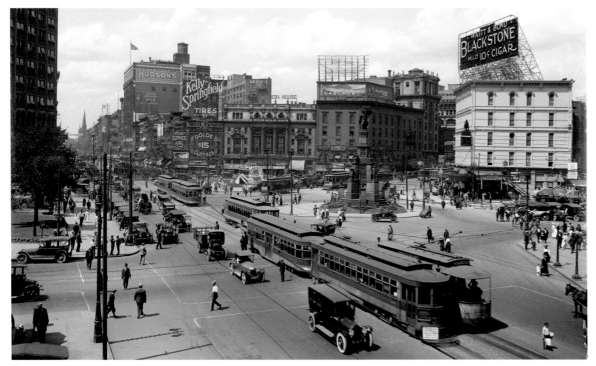

ABOVE *Streetcars pass along Woodward Avenue, with Woodward Avenue Baptist Church, St. John's Episcopal Church, and an electric light tower in the background.*

LEFT *All forms of transportation, from the horse-drawn dray, to motor-driven trucks and cars are cheek by jowl with the streetcar at this busy intersection of Campus Martius.*

OPPOSITE PAGE *A "wider, longer and faster" Kuhlman-built streetcar waits for passengers to board on Woodward Avenue, around 1915, when motorcars are starting to outnumber streetcars.*

miles, taking over two hours to complete. In the beginning, when a rider on a streetcar wanted to indicate a stop, he pulled on a leather strap that was attached to the driver's ankle.

It wasn't only conventioneers who "cruised" on the street cars. The open car carriages in summer were popular for cooling off. Kenneth Metcalf remembers, in his book, *Fun and Frolic in Early Detroit*: "People could ride as long as they pleased on one fare, and so they took joy rides for hours at a time. Groups of mothers and their children in various neighborhoods would ride all afternoon.

Their custom became a nuisance to regular riders who often complained about not being able to find a seat because these excursionists occupied them. The street car company then conceived the idea of turning this form of amusement into profit for the company … These caught on instantly and it was soon not unusual to see one of these special street cars crowded with merry makers, glide by at night."

The Detroit United Railway (D.U.R.), formed in 1901 by uniting several of the franchises, was flush with marketing ideas. According to the *Detroit News*, the company was one of the few in the country to operate a funeral car that would carry casket, mourners and guests to one of the city's large cemeteries. These plain, black cars ran from 1901 to 1917 and were in constant demand.

The D.U.R. could not keep up with the transportation needs of the city and in 1921 the municipality began constructing its own streetcar lines, purchasing the D.U.R. in 1922. That began the era of Detroit's Department of Street Railways (D.S.R.).

Around 1936 the D.S.R. began a campaign to convert "steel wheels to rubber tires," replacing the trolleys with coaches or buses. The last streetcar in Detroit ran on Woodward Avenue on April 8, 1956.

OPPOSITE PAGE *The loss of electric streetcars was much lamented when the Detroit Street Railways Department's "steel wheels to rubber tires" campaign succeeded in replacing them with gasoline-fed buses.*

BELOW *What not to do when a streetcar has the right of way. The Woodward destination sign on the trolley front says in small letters, "Safety First."*

HAZEN PINGREE

Hazen Pingree, a Civil War veteran who survived Andersonville prison, was elected Mayor of Detroit in 1889, the first of four times. Trained as a shoe leather cutter in his home state of Maine, he came to Detroit after the Civil War. By the time he was elected Mayor his shoe-making company was the second largest in the U.S. Pingree wanted better control over the privately owned utilities, to lower prices and improve service and sought to break the long-term franchises held by the street car companies in particular. He was successful in breaking the streetcar monopoly by refusing to sign an ordinance renewing a 30-year franchise for the Detroit City Railway. When Pingree handily won reelection on the basis of streetcar reform, he organized the Detroit Railway Company in 1895 with a three-cent fare. One of Pingree's more interesting ideas was his use of vacant land to grow food and provide work for the poor. In 1894 Pingree obtained the free use of 430 acres of land and the project was a roaring success, with a $14,000, retail value, harvest the first year. In the third year, the value doubled and exceeded the budget of the city's poor commission. In 1896, shortly after beginning his fourth term as mayor, he was elected governor of Michigan. He tried to serve both offices concurrently but the Michigan Supreme Court ordered him to pick one, so he resigned as mayor. The image below shows a bearded Pingree at the plough, breaking ground for Grand Boulevard, Detroit, in 1891.

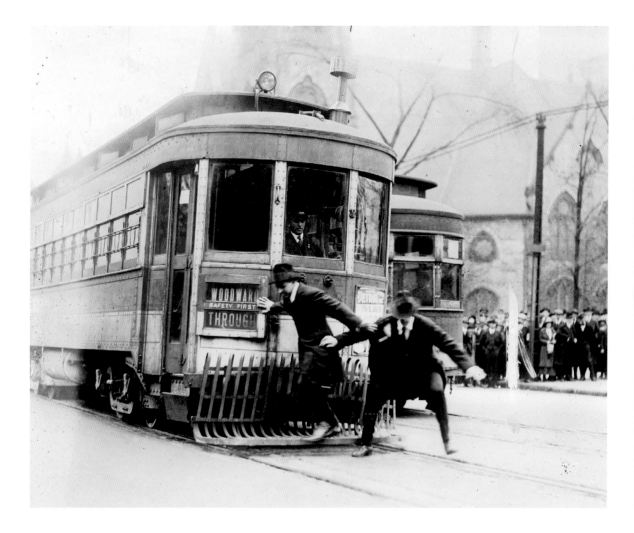

Hammond Building TORN DOWN 1956

This ten-story building was Detroit's first skyscraper. Completed in 1890, it bore the name of George H. Hammond, who made his fortune in meat packing, but who died before the office building was finished.

Detroit was becoming a big city, at over 200,000, the 15th most populous in the country. Its downtown warranted a substantial office building. However the inauguration of the building was anything but serious, as, to celebrate the opening, a high wire artist balanced his way on a wire strung between the top of the Hammond Building and City Hall.

It was the gay 90s. Hazen Pingree took office in January for what would be a six-year stint as Mayor, exercising the powers of city government over private concerns like never before. And in six years, Detroit would begin its odyssey as automobile capital of the world.

Hammond's death at the young age of 48 left behind a wife and eight children; it was left to Hammond's widow, Ellen Berry Hammond, to hire architect, Harry W.J. Edbrooke from Chicago. Edbrooke, whose father and uncles were architects, persuaded Mrs. Hammond to give him the job with a low bid.

Edbrooke did well for a young architect. There was a uniformity in the brick and glass rising from the street, though the traditional division of base, shaft and cap were retained. The brownstone base also maintained tradition with its Romanesque touches.

The building attracted tenants and sightseers alike. Members of notable families like the Joys and McMillans claimed office space there. Anyone riding a bicycle to work had to cart it down to the basement to store for the day; it was against management rules to have bicycles on the service elevator. After Henry B. Joy led a protest, management changed its policy and allowed the bicyclists to keep their machines on the first floor. Also, Tiger fans could look to the roof of the building to know if there was a home game. The team organization had an office in the Hammond building and flew a flag on the roof to signal a game at Bennett Park.

Occupying the southeast corner of Griswold and West Fort Street, across from City Hall, it made the gigantic structure seem less dominant.

However, the Hammond Building's claim to being Detroit's tallest building did not last long. In short order, a 12-story skyscraper went up nearby at Griswold and State in 1895, then a year later, the 14-story Majestic Building was constructed on the opposite side of City Hall. The Hammond Building was razed in 1956 to make room for the National Bank of Detroit building.

OPPOSITE PAGE *Looking down Griswold Street on the right, the Union Trust Building is next door to the Hammond Building. George Hammond's fortune was made thanks to William Davis's invention of the refrigerator car.*

BELOW *The Hammond Building is to the left of flag-draped City Hall in this image taken sometime after 1909. The tall white structure behind the Hammond is Daniel Burnham's Ford Building, still standing.*

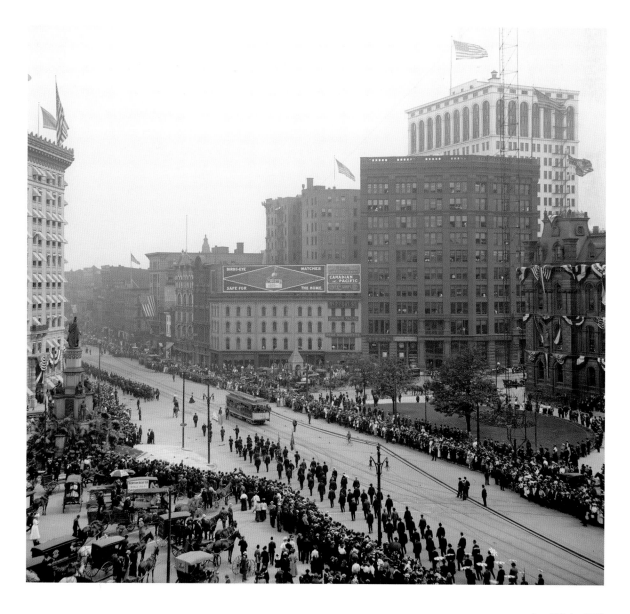

Packard Car Company CLOSED 1956

It was built to be indestructible. The Packard Motor Car Company factory was Albert Kahn's first automotive plant of reinforced concrete, though not his first building using that method. The Palms Apartment Building in Detroit and the University of Michigan Engineering Building in Ann Arbor allowed him to develop his ideas of creating a trussed beam to carry the weight of the building. Up until then, masonry walls had provided a building's support.

When Henry B. Joy bought a Packard car in New York and brought it home to Detroit, he convinced friends to invest in the Ohio Automobile Company which produced the car. Located in Warren, Ohio, the company was founded by brothers James and William Packard. Joy's investor friends were among the rich and famous of Detroit society: Truman Newberry; Russell A. Alger, Jr.; Phillip H. McMillan; Dexter M. Ferry, Jr.; Joseph Boyer; and Charles A. DuCharme. All were sons of Detroit industrialists and entrepreneurs, men who had contributed to Detroit's success as industrial hub of the country in the early 20th century.

In October 1902 the company name was changed to the Packard Motor Car Company with Henry Joy as president. With the Packard brothers now as minority owners, the company moved to Detroit in 1903.

It was Boyer who provided the link between Kahn and Henry Joy. In 1900 Kahn was the architect for Boyer's factory on Second Avenue where pneumatic hammers were made. Boyer introduced the two and the rest, as they say, is history. Joy hired Kahn to construct the buildings for the Packard factory on E. Grand Boulevard. The first of 10 buildings was completed in 1903.

But it was the tenth building that set the standard for the future of the automobile factory. The use of the "Kahn System of Reinforced Concrete," allowed for the light and airy design of the building with fewer columns and many windows. The concrete construction meant the building was fireproof and rustproof, and according to Kahn, the concrete strengthened with age.

The Packard car was also in a class by itself. A luxury car, it competed with the Pierce-Arrow and was driven by movie stars, presidents, and world leaders. During the 1920s and 1930s, it outsold Cadillac and Lincoln.

In 1954 Packard bought the Studebaker Company, changed its name to Studebaker-Packard Corp. and built the last Packard at the iconic factory. Two years later the Packard plant closed and production moved to South Bend, Ind. The last Packard produced in Detroit was at a plant on Conner in 1956. Studebaker continued to make Packards (in name only) for two more years, then the name died.

The mammoth complex, some 40 buildings covering 35 acres, has had various occupants over the years, some legitimate, the majority squatters and scavengers. Although Detroit City Council approved demolition of the complex on April 4, 2011, legal and environmental squabbles continue to halt any action.

LEFT *Not only quality but luxury was a hallmark of Packard. This glimpse into the 35-acre, 40-building Packard complex gives a clue to the vacant hulk that remains today.*

RIGHT *Factory buildings full of light and with more floor space followed Albert and Julius Kahn's employment of the trussed beam system to carry a building's weight.*

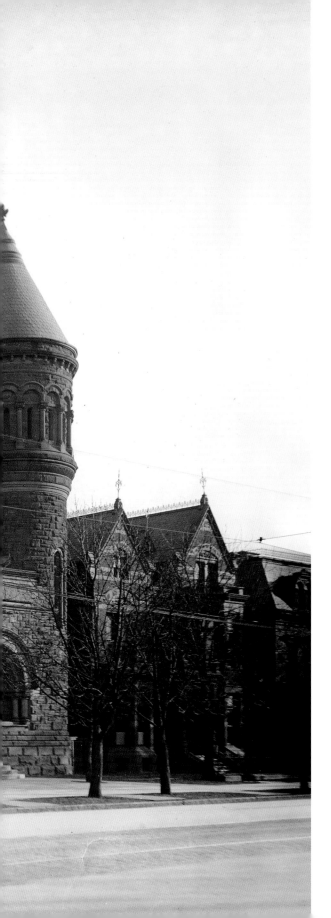

Detroit Museum of Art RAZED 1960

The success of the 1883 Art Loan Exhibition meant that Detroit was ready for a bona fide art museum. For the exhibition, $50,000 was pledged, $1,000 each, by 50 movers and shakers in Detroit that included such illustrious citizens as James E. Scripps, owner of the *Detroit News*, Russell A. Alger, soon-to-be governor of Michigan, Dexter M. Ferry, founder of the Ferry Seed Company, James A. Joy, railway magnate, and James McMillan, who six years later would be elected to the U.S. Senate. Many exhibited work from their private art collections.

The exhibition was held from September 1 to November 10 in a structure built for the purpose on Larned between Bates and Randolph Street. Over 130,000 people came to see a collection of nearly 5,000 works of art. The wealthy citizens of Detroit who contributed to the success of this event thought Detroit was ready for a permanent art museum. As fundraising began, led by Thomas W. Palmer, a bill was passed in the state legislature to provide for the establishment of an art museum, and the Detroit Museum of Art was legally founded in 1885.

A piece of property at Jefferson Avenue and Hastings Street was donated, an architect selected, James Balfour of Hamilton, Ontario, and work begun. The Museum opened on September 1, 1888, five years after the prophetic Art Loan Exhibition. Now that the building was completed, a formidable sandstone structure with arches, towers and a broad porch, a collection was needed. Two galleries, the first floor for sculpture, the second for two-dimensional works, were waiting to be filled.

Two men were instrumental in creating the first collections of the Detroit Museum of Art. James E. Scripps had an avid interest in art. Acknowledging that the country was just now realizing the importance of the fine arts he said: "Why might not Detroit aspire to the honor, and become the Florence or the Munich of this continent?"

He sprang into action. In a two-year tour of Europe he purchased between $75,000–$80,000 (around two million dollars today) worth of paintings, from Spanish, Flemish, Italian and Dutch schools of work. All were donated to the Art Museum and a gallery was named in Scripps' honor. The other major donor was pharmacist Frederick Stearns who turned over a 16,000 art object collection from the Far East.

Three additions to the building were made over the years. The value of the Museum's collections, including oriental art, a department of Egyptian and classical art, and paintings ranging from the 15th century onward, was over half a million dollars.

An arts commission, established in 1919 by the city charter, started making plans for a move to a larger building, and in 1927 the Detroit Institute of Arts, as it was renamed, opened in its current location in midtown Detroit. The old Detroit Museum of Art, after housing offices for two government operations, was torn down in 1960 to make way for Interstate 75.

LEFT *This solid, castle-like building followed the Richardsonian movement of creating monumental public buildings and presents an imposing place for what was then the serious business of art.*

RIGHT *Though Detroit has not become the Florence or Munich of North America, as James E. Scripps wished, a foundation for a notable art collection began here.*

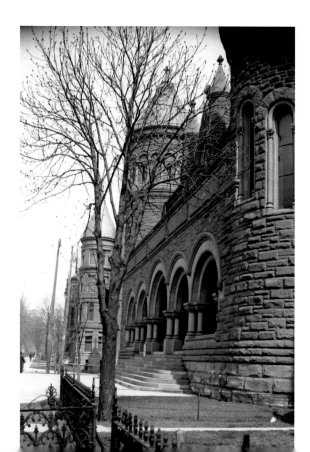

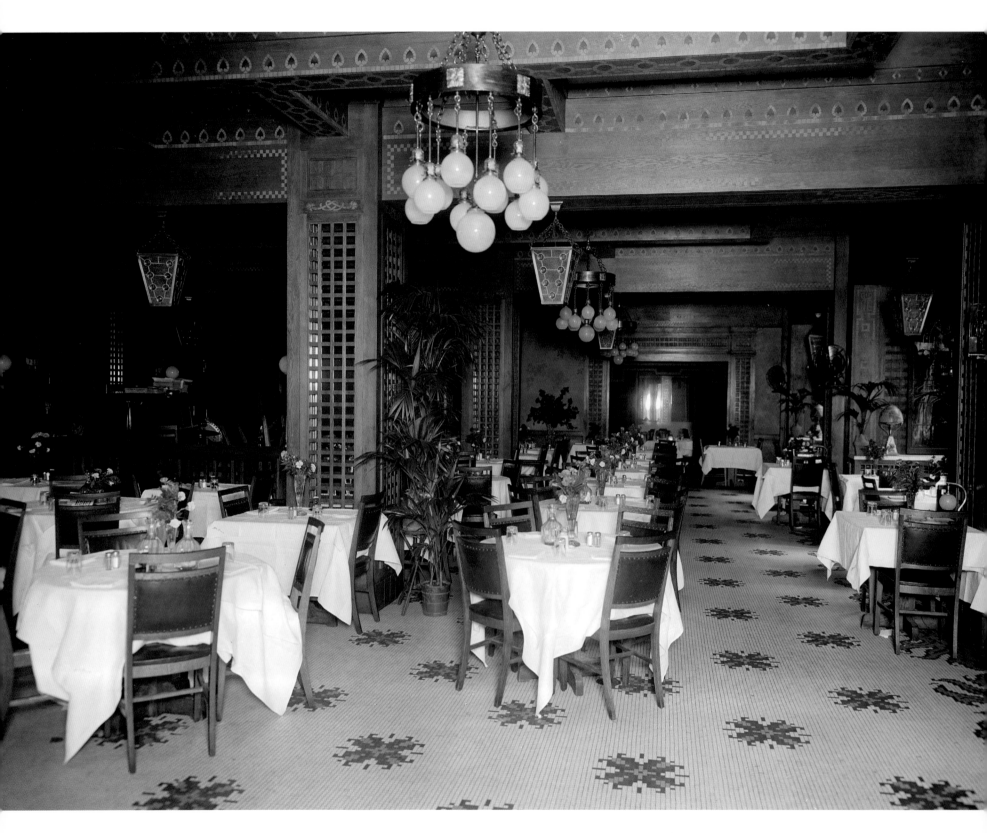

Griswold House Hotel DEMOLISHED 1961

Originally it was a hotel with a barn, where farmers and drovers could shelter and feed their animals while doing the same for themselves. Known as Goodman House, it was purchased in 1894 by Fred Postal, who came to Detroit after running a little hotel in Evart, Mich. He immediately tore down the barn and added a seven-story annex to the four-story hotel, renaming it Griswold House, after the hotel of the same name that stood near City Hall, at Griswold and Congress, torn down in 1895.

The new Griswold House, at Grand River and Griswold, was thought to be too far north to maintain a business but Fred Postal proved everyone wrong. The charming proprietor was an adept hotelier, remembering the names of even one-time guests and making everyone feel welcome. As owner of the Washington American League Baseball Club, visiting baseball teams stayed at the Griswold, and would board a bus in front to ride out to what was then called Bennett Park.

One homage to Fred Postal noted that African American actor and comedian, Bert Williams, who in 1903 starred in the first African American musical on Broadway, was welcomed at the Griswold, when other establishments in Detroit turned him away. The ultimate host, Postal was said to have created quite a night life in his "glittering café" near Grand Circus Park.

In a 1909 hotel guide, the Griswold House advertised 200 rooms, 50 with baths, and rates from $1.00 to $2.50 per day, for the European plan (no meals) and $2.50 to $3.50 per day for the American plan. Visitors were encouraged to come to "the city where life is worth living."

In 1925 Strata and Davis, a real estate firm, ran the hotel for five years. After that, it became the 'new' Griswold House when taken over by Milner Hotels System. On August 24, 1940 the hotel was called a firetrap and closed. However, when World War II created a housing shortage, the building was brought up to code and opened again. After that it changed hands several more times, and closed its doors for good at the end of 1959. In July 1960 it was bought by a parking lot owner and sometime after January 1961 became "one of the latest items in downtown Detroit's tear-down program."

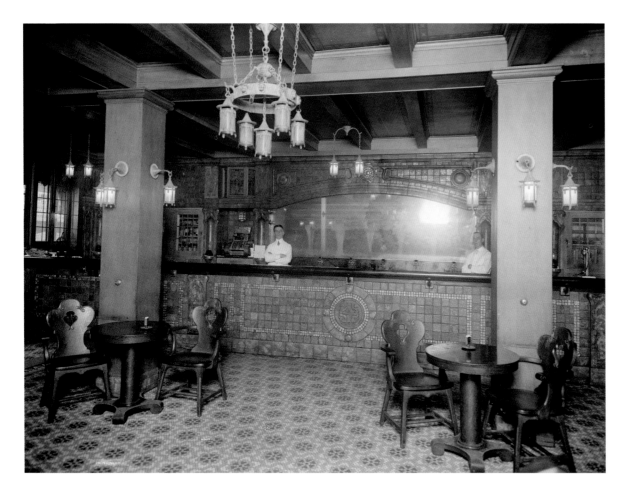

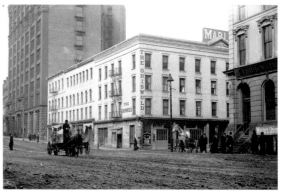

ABOVE *An early photograph of the first Griswold Hotel, at Griswold and Congress, leveled in 1895, for which the second hotel, farther up Griswold, was named.*

LEFT *A drink from the bar entitled a customer to walk into the grille and be served a piece of prime beef from a standing roast, sliced on the spot, at no additional charge.*

OPPOSITE PAGE *Despite its more homey appearance, dinner patrons who ate at the Griswold House's "glittering café" were said to be as sophisticated as any at the Hotel Pontchartrain or Cadillac.*

City Hall DEMOLISHED 1961

She was the grand dame of civic buildings. On the day this building opened, July 4, 1871, members of city government marched proudly from the old City Hall, on Cadillac Square, across Campus Martius and into the new seat of city and county government. The ornate building had several architectural styles, including French and Italian with a Georgian cupola topping the mansard roof. From the tower, as Silas Farmer called it, "…a magnificent view is afforded. The usually clean streets look cleaner still in the distance; the groves of shade-trees, the elegant residences, the river and its shipping, the Canadian shore and Belle Isle, all unite to form a panorama not often excelled."

James Anderson designed the building in 1861 but the circumstance of the Civil War caused plans to be put on hold and it wasn't until 1868 that the cornerstone was laid.

The architecture was enhanced by sculptures high above the ground. Complete when the building opened, they were by Detroit artist Julius Melchers. He created female representations of Commerce, Art, Justice and Industry, arranged around the base of the cupola. Ten years later, one of Detroit's venerable citizens, Bela Hubbard, commissioned four more statues of significant figures from Detroit's past as a gift to the city. Architect John M. Donaldson completed the model for one, Father Jacques Marquette, but Melchers modeled the figures for Antoine de la Mothe Cadillac, Robert LaSalle and Father Gabriel Richard, and made the stone statues for all four. Closer to the ground, the larger than life statues graced the east and west sides of the second floor pavilion. These four statues were saved when City Hall was demolished and are on the campus of Wayne State University.

The building was a landmark. Near the base of the cupola, was a four-sided clock with dials eight feet in diameter, which when lit at night, could be seen for miles. But as skyscrapers grew up around it, the Dime and Penobscot buildings to the west, the National Bank of Detroit building to its south, City Hall became an anachronism; city leaders wanted a new, more modern home and a new one was built, just blocks away.

In September 1955 the mayor and city officials marched from the old building to the new City County Building, completing the circle. The behemoth lasted close to 100 years, but in the end was deemed too inefficient to maintain and was demolished in 1961.

RIGHT *City Hall was the "Heart of Detroit" in this circa 1915 photograph with the Federal Building apparent beyond the twin-towered Dime Building, behind and to the left of the city offices.*

LEFT *By this time, close to 1961, City Hall was viewed as an anachronism, as more contemporary buildings overshadowed its fussy facade.*

BELOW *In this mob of baseball fans next to City Hall all heads are turned toward the Detroit Free Press scoreboard during an October 6, 1908 Detroit-Chicago pennant game. The Tigers won the American League championship for the second time.*

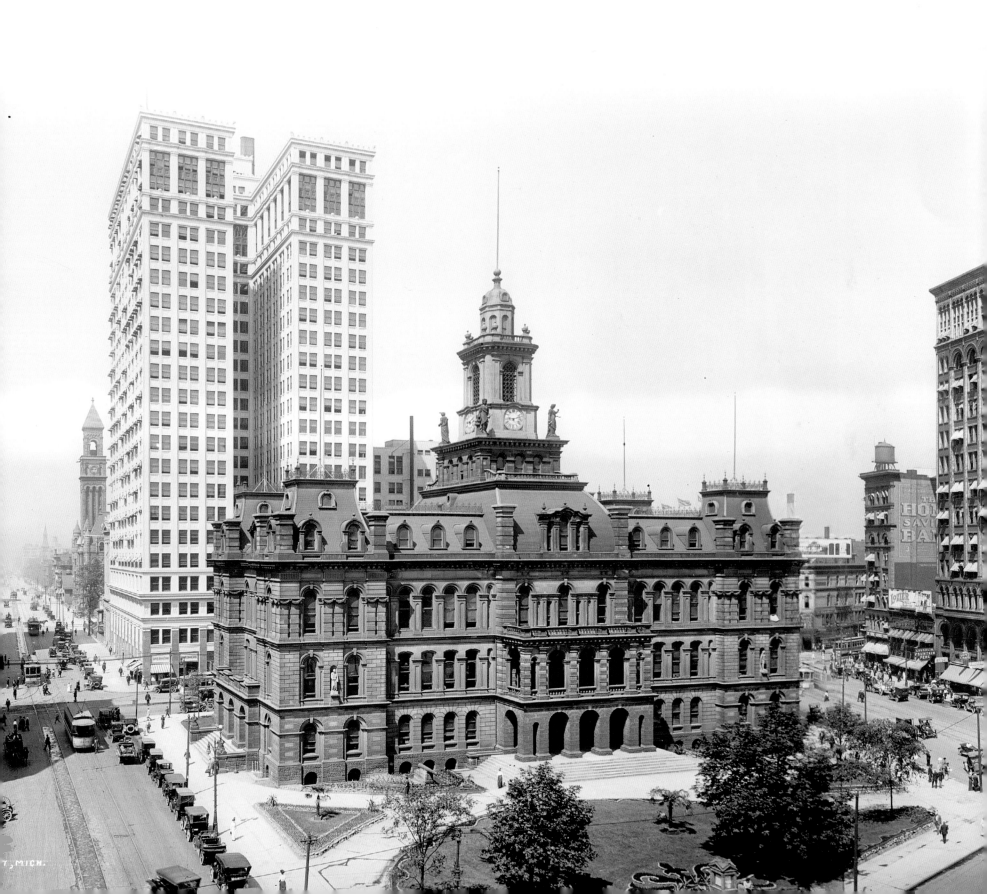

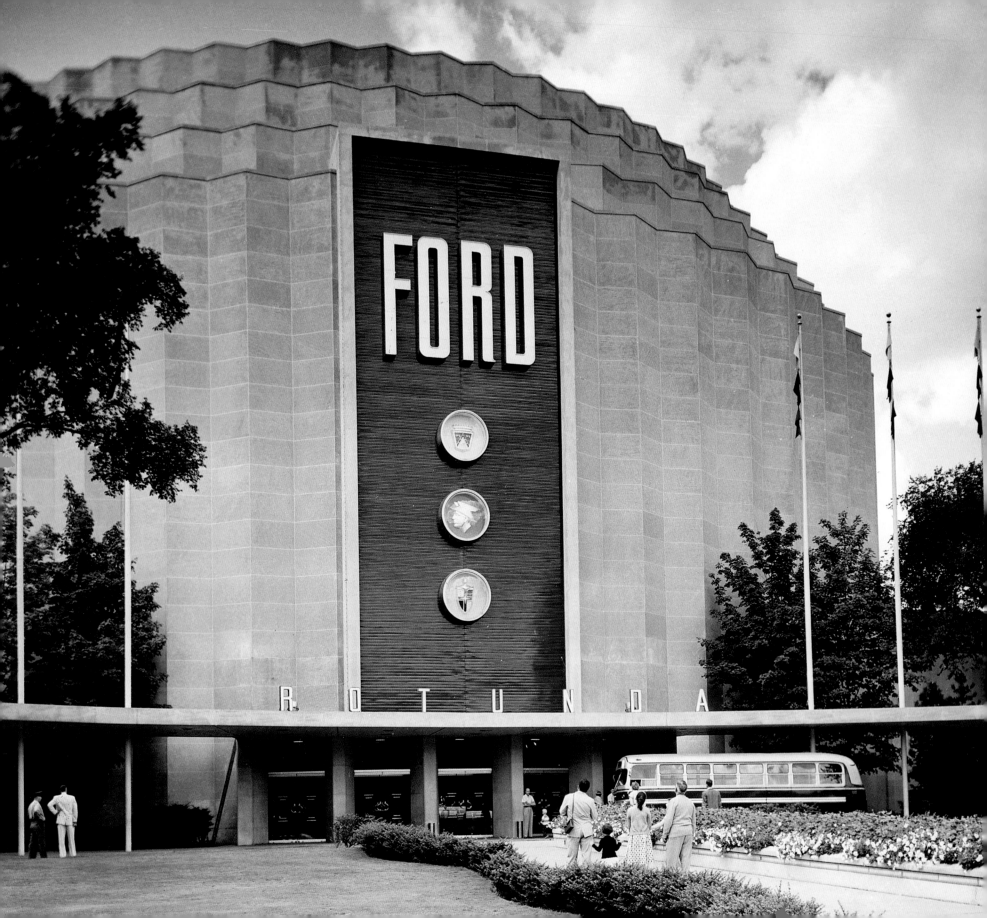

Ford Rotunda BURNED 1962

What was perhaps the Ford Rotunda's most unique feature became its downfall. On November 9, 1962, tar being applied to the building's geodesic dome caught fire. The fire spread quickly, causing 150-foot flames and black smoke that were visible for miles. Buckminster Fuller's creative solution for a roof for the formerly open rotunda was far ahead of the industry's ability to make that roof watertight. The rotunda of the building burned to the ground, and one of the two 110-foot wings, the south one, collapsed. Fortuitously, the north wing, which housed the Ford Archives was saved.

The Ford Rotunda was originally constructed for the Chicago World's Fair in 1933. Overlooking Lake Michigan, it was made of plaster board over a steel frame, and was not meant to be a permanent structure. Crowds of over 12 million people saw exhibits in the exposition building highlighting the Ford story. They could also see a 20-foot globe that illustrated the Ford presence around the world, travel the "Roads of the World" outside the Rotunda, and discover little known facts such as Ford's fascination with the soybean; half a bushel of the legume was used in every Ford vehicle, from the

base for the car paint, to plastic parts like door handles. The building also contained a photo-mural, to date the world's largest, that depicted the history of transportation. Because of the exposition's popularity, it was decided to relocate the Rotunda to Dearborn, to serve as the visitor center for the Ford Rouge plant factory tours.

Albert Kahn, who designed the World Fair prototype, was hired to redesign the Rotunda for its permanent location and architect Jen Jensen was responsible for landscaping the 13 and a half acres surrounding the building. The Rotunda, located on Schaefer Road, across from the Ford Administration Building, was faced with limestone to match the walls of the Ford headquarters. The north and south wings were added to the gear-shaped rotunda, which remained open to the sky until 1953. Because the 12-story building could not support a roof made of traditional materials, R. Buckminster Fuller was given the first commission for his geodesic dome, a lightweight aluminum and plastic structure weighing eight and half tons, and 93 feet in diameter. Covering a rotunda that was 112 feet, it illustrated Fuller's principle of "doing more with less." The spherical shape covered more interior space with less surface area, thus saving materials and cost.

However, the dome's strong point, its triangular structure, proved to also be its weak point. It was difficult to find a waterproof covering for the lightweight aluminum. While preparing for the Christmas Fantasy, perhaps the Rotunda's most beloved event and a memory for so many, the tar that was heated to spray on the dome caught fire. No one died or was seriously injured, but the Rotunda was gone.

R. BUCKMINSTER FULLER

"Bucky," as he was known, was a Henry Ford admirer, calling Ford "a great conceiver, ... Mr. Industry himself. His logistics were like conducting a great orchestra," Fuller said. He compared Ford's adaptation of the assembly line, "using tools to create tools," to the industrialization of the home industry and his own contribution to efficient, cost-effective structures. The geodesic dome was patented by Fuller on June 29, 1954, though he was not the original creator of the concept of the triangulated tension system. However, the dome was not perfect. Remembering the day in June 1953 when the Rotunda reopened after a refurbishing to celebrate Ford's 50th anniversary, textile designer Ruth Adler Schnee, who designed drapery and auditorium curtain fabric for the Rotunda, recalled in her Archives of American Art oral history: "It had been a very, very rainy day – it was just coming down in buckets, and the dome was leaking. The maintenance people had put up buckets everywhere to catch the water. The guests were drenched, and Bucky was totally unmoved by this. He said, "Well, the dome didn't collapse.""

LEFT *Reconstructed in Dearborn with a limestone facade, this building was originally a plasterboard structure meant to last only during the 1933 Chicago World's Fair, but the popularity of its exhibits gave it new life.*

BELOW *One purpose of the Rotunda was to serve as a visitor's center for tours of the Rouge plant, shown here in the far background. The Rotunda's facade matched that of the Ford Administration Building, left of the Rotunda*

BELOW RIGHT *This 20-foot globe showed onlookers the Ford Company's numerous locations around the world.*

Majestic Building TORN DOWN 1962

No one can mention the Majestic Building without pointing out that clothing merchant C.R. Mabley contracted to build it, but his company ran out of money and couldn't pay to complete it. At that point the capstone with an "M" was in place, so the building was named Majestic by the group organized to finish the project. Part of Mabley's cash flow problem might have been the result of the $700,000 price tag for the lot at Michigan and Woodward, almost 18 million dollars today.

Chicago skyscraper expert Daniel H. Burnham worked in conjunction with Detroit architects Mason & Rice to create this 14-story fireproof building in 1896. It topped the 12-story Chamber of Commerce Building, built one year earlier. Previously, the record for Detroit's tallest building had been held by the 10-story Hammond Building. Chicagoan Burnham was a logical choice for the job, the guiding hand behind the 1893 Chicago Exposition, and visionary of the "City Beautiful" movement. He and his partner John Root made their mark in 1886 with the construction of The Rookery, a prestigious, 11-story office building in downtown Chicago.

Designed in the Beaux Arts manner, the building lifted the eye upward with no horizontal breaks. The weight of the building was supported by steel and concrete, precursor to the steel frame skyscraper. Thirteen years later Burnham would create the Ford Building, which rose four stories higher than the Majestic.

The fittings were spectacular: Italian marble and mahogany. In the basement was a self-serve restaurant. The facade of the building was covered with terra cotta tile. On the roof an observatory used by the U.S. Weather Bureau was added in 1907, also open to the public for 10 cents. A view of 12 miles in all directions made it a Sunday afternoon destination for locals and a stopping place for tourists.

The Majestic received possibly its greatest attention in 1916 when Harry, "The Human Fly" Gardiner climbed the building in a publicity stunt for the *Detroit News*. It happened during the lunch hour and traffic on Woodward Avenue, in front of the building, was at a standstill, travelers and pedestrians stopping to gape upward as "The Fly" carefully crept up the building to the top.

The Majestic was demolished in 1962 to make room for the First Federal Building, known today as 1001 Woodward.

BELOW *In the foreground the Bagley Fountain, an 1887 Henry Hobson Richardson creation, stands across the City Hall landscape from the Majestic Building in this early 20th century image.*

RIGHT *Scarcely 20 years ago, from the time of this circa 1915 photograph, the Sanders Pavilion of Sweets occupied this prominent corner on Campus Martius, replaced in 1896 by the Majestic Building.*

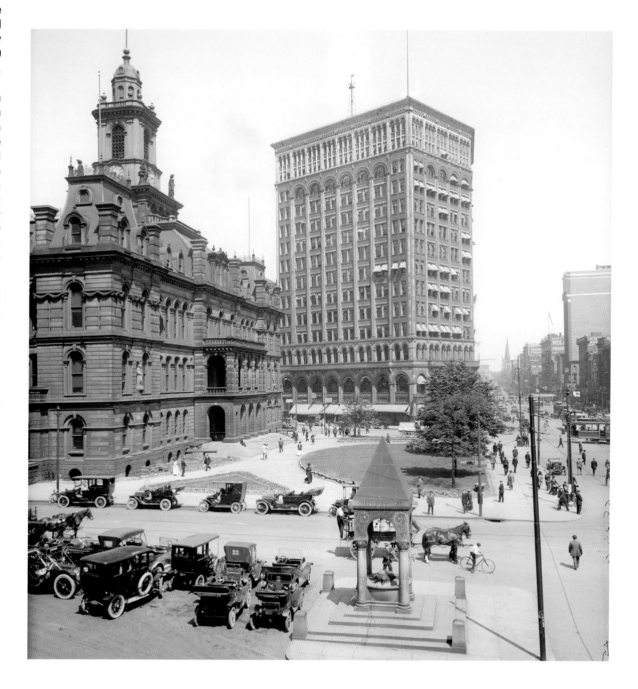

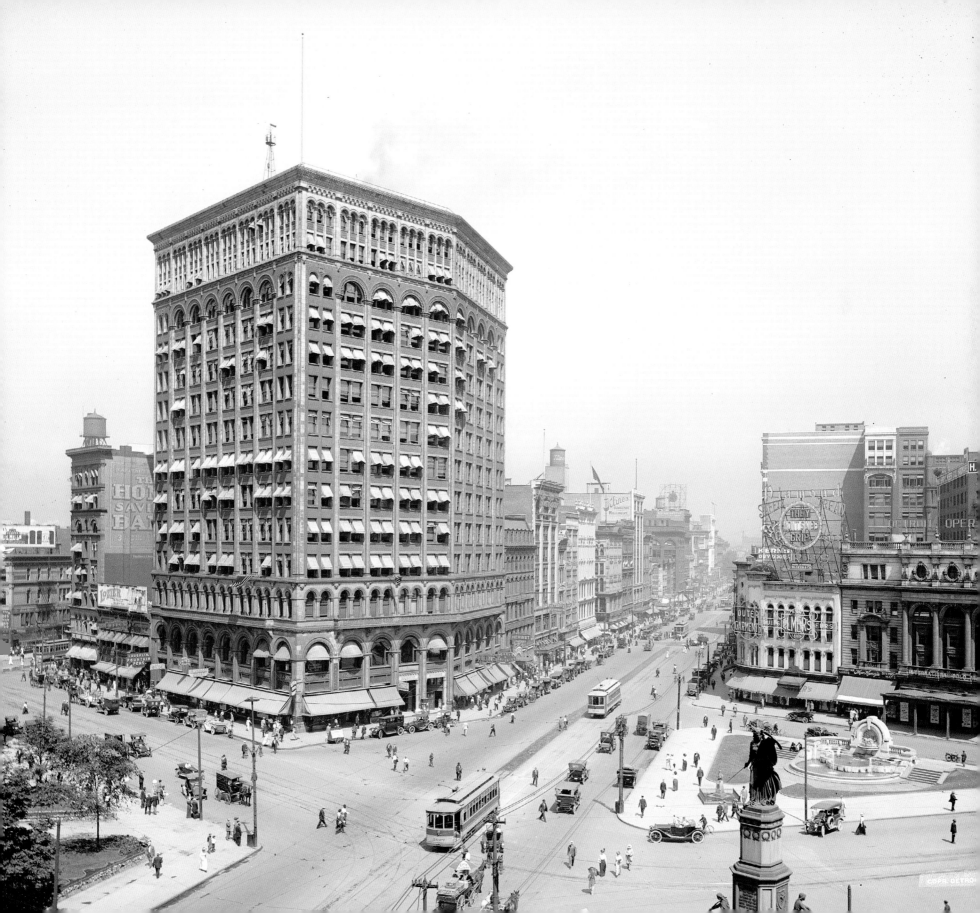

Water Works Park

PUMPING STATION RAZED 1962

It was a most exotic feature for a city park in the Midwest. This minaret-like tower was really a standpipe, and this beautiful park, situated between Jefferson Avenue and the Detroit River, east of downtown, had a utilitarian purpose. It began as the city's water supply in 1877, and still serves as such today. The 185-foot minaret, encasing the 124-foot standpipe, was designed by Detroit architect Joseph E. Sparks. Sparks's waterworks buildings were described as having the appearance of a "Franco-Italian villa" by W. Hawkins Ferry.

Along with the pressed brick "sleeve" to cover the standpipe, Sparks designed the pumping station, where according to the memories of *Detroit Free Press* editor, Neal Shine, "you could stand behind the polished brass railings and watch wheels bigger than a house turning the pumps that brought the water from the mouth of Lake St. Clair to every home in the city." There were other attractions on the 110 acres of waterfront: tennis courts, a baseball diamond, picnic area and swings, and a beautiful, shallow lagoon where children could sail their boats.

It was the tower though that caught people's eye and was featured on postcards of Detroit. There were 202 winding stairs that led to the top and a view of downtown Detroit four miles away.

Another feature, almost as popular, was a floral clock created by the first grounds superintendent Elbridge A. Scribner. He designed a water-driven mechanism to run the gears, and grew his own plants and flowers with which to create the face. It was placed just inside the park entrance.

In 1894 the entrance was enhanced by a grand piece of architecture, thanks to $250,000 left by Chauncey Hurlbut, a former president of the Board of Water Commissioners. The money was left to beautify the park and was also used by Scribner in his landscaping efforts.

Known as the Hurlbut Gate, the stone monument was 50 feet high and had staircases on either side leading to a 12-foot high terrace. It was designed by Herman Brede and Gustave Mueller, two classically trained architects who did not scrimp in their use of flourishes.

A library also resulted from the donation, though it was housed in a converted oil storage building. It was the first branch of the Detroit Public Library. Water Board employees, not librarians, staffed the library, Hurlbut's engineering and scientific books forming the first collection. In 1905 the Hurlbut Library was turned over to the Library Commission and run as a full time branch until World War II.

In 1912, the name was changed to Gladwin Park, after Major Henry Gladwin, commander of Fort Detroit who withstood Chief Pontiac's siege in 1763. No one called it that though, it was Water Works Park until the end. City Council approved razing the now unsafe standpipe in 1945. The park closed during World War I and II, then again in 1951. Seven acres along the Detroit River were reopened as a result of protests, then six more in 1961. Pumping station no. 1 was razed in 1962 and the park closed for good.

ABOVE *The floral clock was just inside the park entrance and its gears were driven by water. The beautifully landscaped setting by the Detroit River was a prime spot for picnickers.*

LEFT *The Hurlbut Gate provided a lofty, imposing entry to the park on Jefferson Avenue. The structure remains today, though the entrance is closed.*

OPPOSITE PAGE *A shallow pond in the park was ideal for children to sail boats and wade, while adults took in the view from the minaret's observation balcony.*

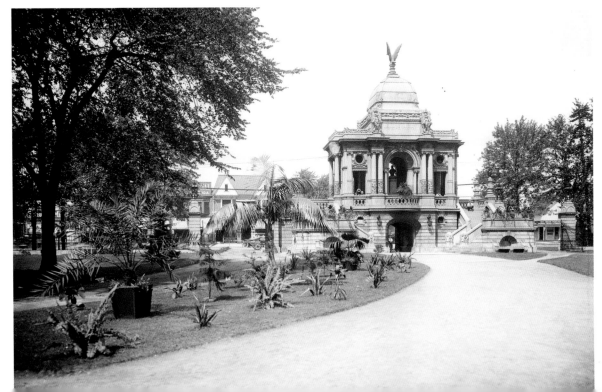

Goebel Brewing Co. TORN DOWN 1964

"**From the cypress** tanks of Goebel," was the slogan that aimed to set Goebel beer apart from its competitors, chief among them, Stroh's "fire-brewed" beer. Though the English and Irish were the first to brew beer in Detroit, by 1880 Germans made up over 20 percent of Detroit's population, and dominated the beer-making industry.

The Goebel company started in 1873 when August Goebel and Theodore Gorenflo, both German-born, opened a brewery that, in the 1880s, became the third-largest in Detroit, behind Kling and Voigt. In 1889 a British syndicate seeking not only a good investment but a way to limit competition, bought out Goebel, along with the Bavarian, Endriss and Mann breweries. August Goebel oversaw all four breweries, and by 1894 only Goebel remained in operation.

In 1897, a five-story brewhouse was built at the corner of Rivard and Maple. This tripled the capacity of the former plant, adding machinery "endowed with marvelous power [that] takes the place of human hands." In addition to their Pilsner and extra pale ale, Goebel offered a non-intoxicating "tonic," a malt beverage with healthful benefits.

Prohibition forced most breweries to close, although Stroh's continued to make "near beer," (less than 0.5% alcohol). When Prohibition ended, the Goebel company, whose property had been purchased by Walter Haass and used for various small industries, was newly incorporated and ready to brew again. By now, the only remaining Goebel connected with the business was August Goebel's grandson, Ted. E. Goebel. However, this didn't mean that the company wasn't ready to jump back into the competition. A real coup was about to occur.

Haass readied everything for the startup of the new business, including replacing the 1893 corner office building with a boiler and engine building. He then hired the former Stroh brewmaster, Otto Rosenbusch, who had retired from Stroh's in 1929 after a 35-year career there. The brewmaster was the key to the whole operation. In Germany, years of training, beginning in a boys' teen years could lead to the position responsible for masterminding the product that would make or break a brewery's reputation. It was Rosenbusch, along with Julius Stroh, who developed Stroh's "fire-brewing" technique, and who, during Prohibition, had brewed their "Temperance Beer." Rosenbusch worked at Goebel for only three years before retiring again, but his successor, Herman Zerweck, boosted Goebel's appeal by brewing a product similar to Budweiser.

Goebel beer sponsored the Detroit Lions and Detroit Tigers, and in the 1940s, had three breweries in Michigan. A west coast operation opened in 1950, called Golden West Brewing Company, but failed to survive. Goebel's healthy sales in the mid 1950s, placing them in the top 10 per cent of the industry, proved to be their peak.

A 45-day strike against Detroit brewers in 1958 allowed out of state breweries to gain a foothold in Michigan but was more harmful to Goebel than Stroh. In 1959 Goebel was forced to relinquish its Tigers' sponsorship, which Stroh readily took over. Goebel could not compete with Stroh's two million barrel a year production.

In 1964 Goebel beer closed the business. The Stroh Company, whose eight-story building overshadowed them a block away, bought the property, razed the buildings and built a parking lot. Yet the beer lived on. Stroh decided to continue the Goebel brand and it was produced until 2005, when the Pabst Brewing Company, who had acquired Stroh in 2000, stopped making the beer.

RIGHT *This 1897 brewhouse contained the latest in beer brewing equipment; the hop storage and malt house are on Rivard, to the right.*

BELOW LEFT *The corner-facing building is the office of the company, on Rivard and Maple Streets. It was razed in 1934 for a new boiler and engine building.*

BELOW *It was a beer-lover's dream to see beer called "pure food." Goebel did sell a healthy malt beverage, "nourishing, strengthening and exhilarating, but not intoxicating."*

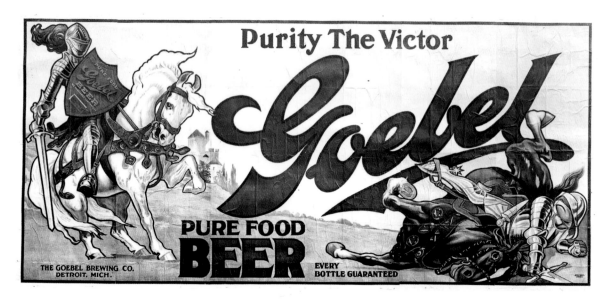

PURITY The Victor

Goebel

PURE FOOD BEER

THE GOEBEL BREWING CO. DETROIT, MICH.

EVERY BOTTLE GUARANTEED

Cass Tech OLD SCHOOL DEMOLISHED 1964

Cass Technical High School started as a vocational school to provide skilled employees for the city's burgeoning manufacturing companies. By the mid-20th century it was considered one of Detroit's premier high schools for an education in the arts.

The school began on the third floor of Cass School, formerly Cass Union School, in 1907. The technical school was an experiment devised by Benjamin F. Comfort, who was principal of the Webster School before being assigned to Cass. Familiar with the advent of the technical school in Germany, he set up a woodworking shop in the basement of Cass and the commercial and academic classes in the upper floor. If response warranted, a technical high school would be formed. Response was good: enrollment increased from 110 students in 1907 to 700 in 1909.

According to an article by Comfort in the *Detroit Journal of Education*, called "The founding of industrial and vocational training in Detroit," the idea had been tried in Detroit in 1888 but met with resistance from the trade unions, who feared that too many graduates of such a program would saturate the market.

The creation of the Cass Technical High School curriculum was systematically approached. Surveys were done to see which occupations needed trained employees, and what specific skills were needed. Courses in machine shop, mechanical drawing, mathematics, chemistry, pharmaceuticals, electrical and auto mechanics were identified. The students still had to complete core subjects including language, history, economics and mathematics as "the scientific and mechanical arts subjects have been grafted on so the relationship between the two has been welded into about a 'fifty-fifty' combination."

Cass School burned in 1909, though a new addition survived and Cass technical classes were continued there. The commercial courses were moved about a half mile away to the former Wilkins School. Money for a new building was approved by common council and the first dedicated building for Cass Technical High School was opened in 1912, on the site of the old Cass Union, at Second and Vernor.

In no less than three years the school was outgrown. In 1914 Henry Ford had instituted the $5 a day wage and job seekers poured into the city, disembarking in the new Michigan Central train station. The Dodge Brothers also started building cars that year. In a decade Detroit's population would more than double. It took effort to get funding approval for a new school, and then World War I delayed the project until 1922 when the new building opened.

The same architects who designed Central High School, Malcolmson & Higginbotham, were selected for Cass Tech, though the two schools bear no resemblance; the Romanesque Revival era was well over. The new building was on the opposite side of High street (now Vernor Highway) from the old, three-story Cass, in which the commercial school was reestablished and renamed the High School of Commerce. An arched walkway called the Victory Memorial Arch, dedicated to Detroit high school students who lost their lives in World War I, connected the two buildings. Teachers and students wouldn't have to contend with traffic and weather going from one building to another.

At some point, as early as 1940, the educational emphasis shifted. While Cass Tech still offered its array of vocational classes, it became known as a school for academically gifted students and any student who wanted to attend Cass Tech had to pass an exam. And the technical courses increased in diversity and complexity. In 1962 there were 23 curricula that included astronautics, graphic arts and electronics. Music and art became important parts of the coursework, but automotive technology remained.

In 1964, the original 1912 building was demolished to make way for the Fisher Freeway, the portion of Interstate-75 that passes through Detroit.

A school had stood on that site since 1861. With it went the memorial arch.

Albert Kahn & Associates built an addition to the west of the Malcolmson & Higginbotham building in 1985, and the total number of classrooms rose to 167. The school graduated a high rate of successful students across all disciplines, and names like Lily Tomlin, Harry Bertoia, Ron Carter, Alice Coltrane, John De Lorean, Diana Ross, Harlan Huckleby, Ruth Adler Schnee, plus many others, cemented its reputation. And yet, the school was deemed not adequate to the task of educating, and unsafe in some cases.

In 2001, plans were formulated for a five-story building on 18 acres of land next to the old school. When the new school was completed in 2005 the Cass Tech Alumni Association had ideas for using the old building, but the school board won out, claiming the structure was dangerous for passers-by and the building was demolished by the end of summer 2011.

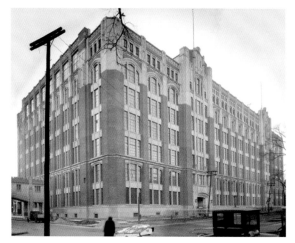

ABOVE *This Malcolmson & Higginbotham building opened in 1922, connected to the old building by the Victory Memorial Arch over Vernor Street, visible on the left. This building was finally demolished in 2011.*

LEFT *Students in an aero mechanics course during the 1940s take advantage of the school's reputation for excellence in technical education. By this time, art education was also a strength.*

OPPOSITE PAGE *This is the first Cass Technical High School, razed in 1964 for the Fisher Freeway construction.*

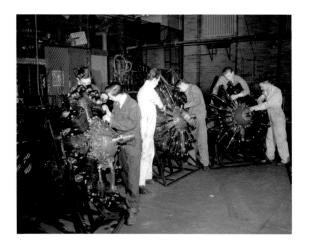

Detroit Opera House RAZED 1966

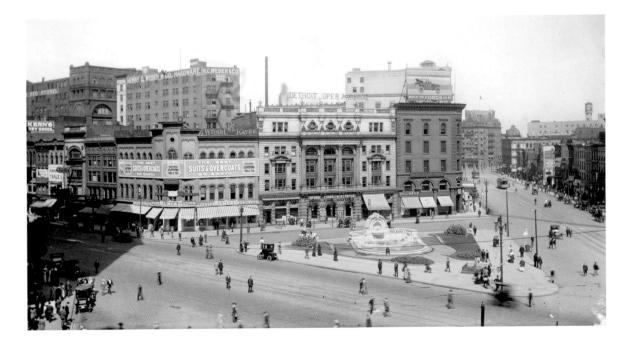

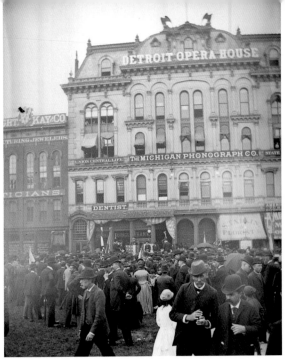

ABOVE *Barely discernible, a flag-draped speaker's stand in front of the Opera House explains the large crowd milling about at the city hub in this image from 1891.*

LEFT *This circa 1915 picture shows Mason & Rice's reconstructed Opera House. To its right around the corner is the Temple Theater, with the Hotel Ste. Claire in the background.*

RIGHT *The Carrere and Hastings designed Merrill Fountain graced the front of the Opera House from 1901 to 1926. Commissioned by Lizzie Palmer to honor her father Charles Merrill, the fountain now resides in Palmer Park.*

For 62 years the Detroit Opera House was the center of cultural life in Detroit. When it opened in 1869, Ulysses S. Grant had just been sworn in as president and, two months later, the first transcontinental railroad would be operational. Before it opened, musical and theatrical performances were held in places like the Young Men's Hall, Firemen's Hall or Merrill Hall, all on Jefferson Avenue, which in the mid-19th century was Detroit's business and entertainment district. The first performance in the new Opera House was *London Assurance*, with English actress Kate Reignolds playing "Lady Gay Spanker."

Opening reviews for the building were gushing: "Every figure, flower, stripe, cornice, and carpet caught some new beauty from the soft effulgence of light. Throughout the building there is nothing to suggest the idea of cheapness."

The Opera House, described as a "luxurious temple of art," was designed by father and son architects Sheldon and Mortimer Smith. Foreshadowing the adornments of the new City Hall that would open two years later, it too had niches filled with statues by Julius Melchers, these representing the various performing arts.

Many people know the Detroit Opera House as the first home of the J.L. Hudson Company, which opened on the ground floor in 1881. Before the Hudson store, Newcomb, Endicott & Company occupied the space. When their lease expired in 1879, they moved north on Woodward, in a building that 48 years later, would be gobbled up by the J.L. Hudson Company.

The stage and auditorium of the Opera House were on the second floor until the building was remodeled in 1887, moving them to the first floor. After the move, the auditorium was able to seat 2,100 people, 400 more than before. Bertram C. Whitney, son of competing theater owner C.J. Whitney, managed the theater from 1898 to 1918.

The Detroit Symphony Orchestra played its first subscription series concert in the Detroit Opera House on December 19, 1887. In 1910 the orchestra disbanded, but when they resumed on February 26, 1914, it was again at the Detroit Opera House; Weston Gales was music director.

The Opera House was witness to the first moving pictures in Detroit. In 1896 Thomas Edison demonstrated his Vitascope, an early film projector, and that same year an Eidoloscope, a copy of the Vitascope, was used to show several reels of film of a bullfight in Mexico.

On October 7, 1897 fire leveled the building, luckily waiting until an hour after the performance of *A Lady of Quality* had ended. Detroiter Fred S. Stone wrote the music for the production. After the fire, the Opera House was immediately rebuilt, reopening a year later on September 12. Architectural firm Mason & Rice reconstructed the building.

From 1919 to 1931 it was called the Shubert Opera House, then gutted to be the home for Sam's Discount Department Store, offering a basement and five floors of cut rate goods, an ignoble finish to a grand edifice. In 1966 the entire block was razed.

In 1988 Michigan Opera Theatre bought the nearby Capitol Theatre, remodeled it and opened it in 1996 as the Detroit Opera House.

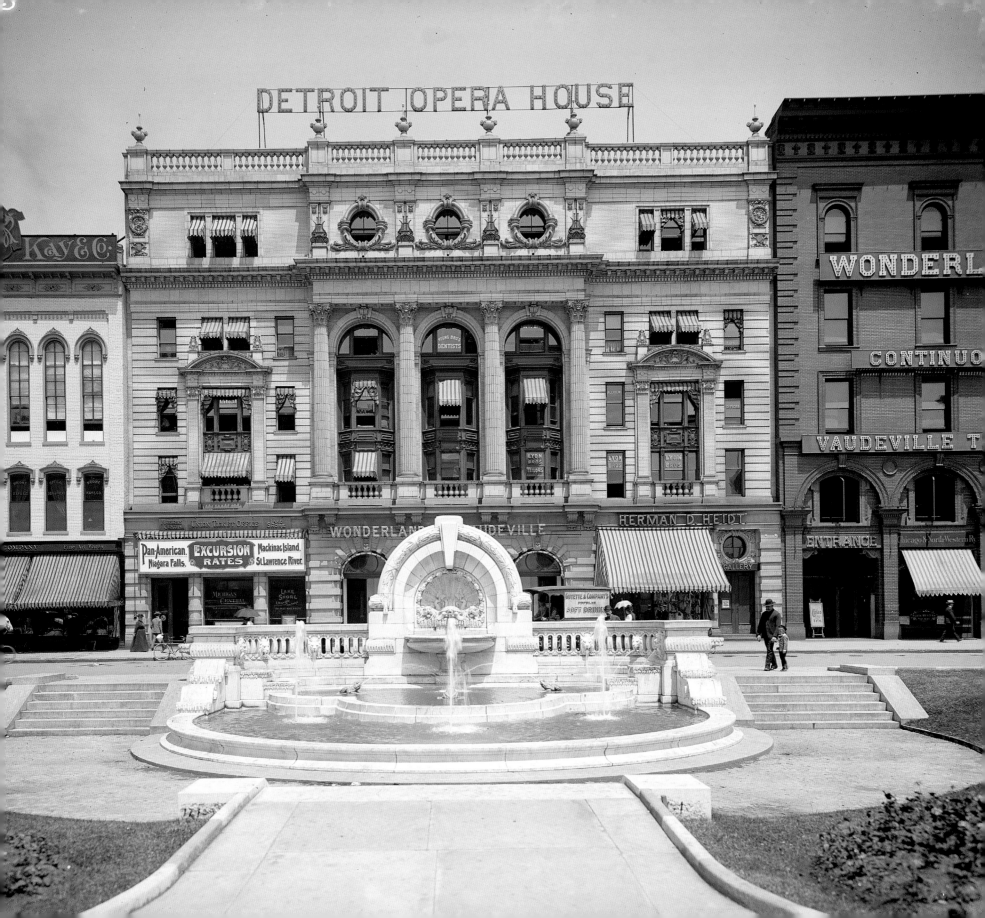

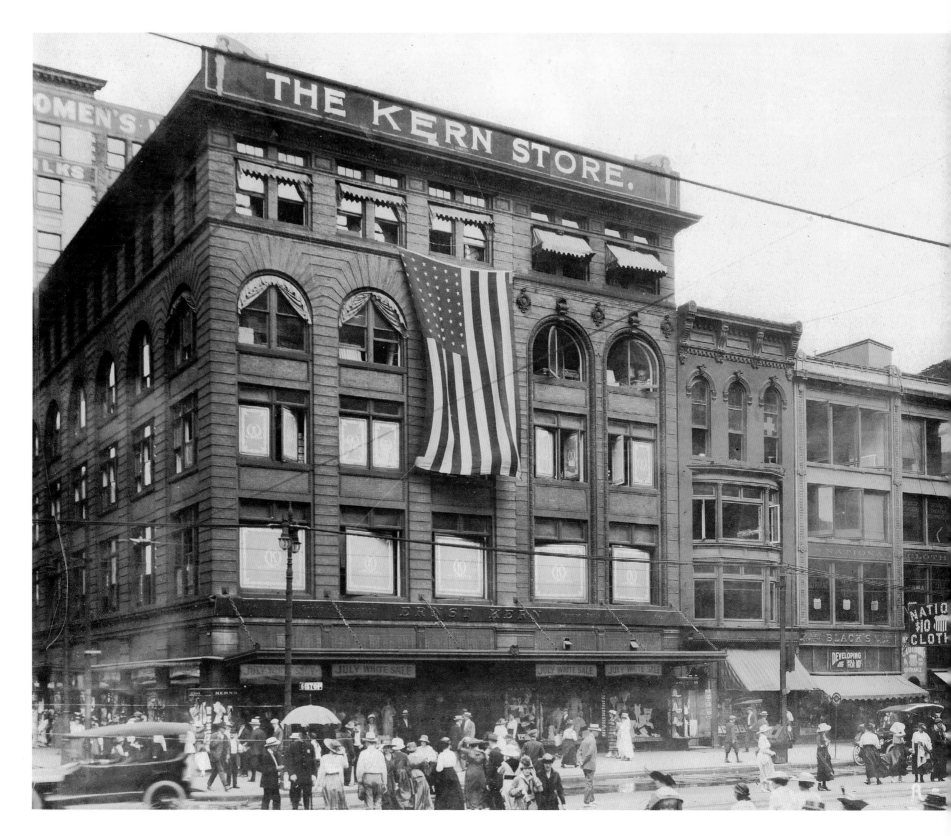

Kern's Department Store RAZED 1966

Though overshadowed by the J.L. Hudson Company, its neighbor to the north, the Ernest Kern Company, or Kern's as it came to be known, had its own personality. As one of three major Detroit department stores to continue into the 20th century, including Crowley-Milner and Hudson's, Kern's mark of distinction was its efforts to attract the business of the working woman.

The company began in 1883 on St. Antoine near Fort, moved to Randolph Street in 1887, then in 1897 came to its permanent location on Woodward at Gratiot. In 1919 the company, now run by Ernst's sons, Otto and Ernst, Jr., bought an adjoining building, and in 1929 a 10-story building was constructed at the same site.

Many have fond memories of Hudson's extravagant Christmas displays, but Kern's munificence in bringing 400 orphans to the store to see Santa and receive a candy and toy-stuffed stocking was just as noteworthy. Kern had other innovations including a "Floor for Youth," with scaled down furniture and fittings, a department created with input from parents, teachers and young people.

Their window displays announced more than the ordinary sales and holidays. Special window displays were prepared for: a 1923 field meet for public schools at Belle Isle; the 1927 inaugural game of the Detroit Cougars in Olympia, their new hockey stadium; and a promotion of traffic safety, that claimed Detroit to be third in the nation in auto deaths.

In 1956 Kern's joined with *Charm* magazine in highlighting the 400,000 working women in Detroit. As a possible consequence, they offered Kern's Desk Set program, aimed at attracting working and career women to the store. It featured special events and shopping assistance, and made it easier for women to get store accounts. Unfortunately, this successful program (over 4,000 women enrolled), was not presented until 1958, one year before the store closed.

In 1957 Kern's was sold to Sattler's a Buffalo department store. Said Otto Kern, "I didn't want the added responsibility of outlying stores and they seem to have become a necessity." When the store was sold it was estimated that Kern's had sold half a billion dollars worth of goods. What began as an enterprise specializing in imported fabrics, laces and ribbons grew from two store clerks to 1,000 employees.

What people remember about Kern's is its clock, visible on Woodward since 1933. After the store was sold in 1957, then closed in 1959, the building was torn down in 1966. The clock was removed to storage and in 1980 restored to its spot at the corner of Gratiot and Woodward. It was removed once again, in 1998, for the construction of the Compuware building at that location, then put back in place in 2003.

LEFT *"Meet me by the Kern's clock" was a common phrase for over 30 years. In this Christmastime photo sometime in the late 1940s, the shopping crowds have not yet reached their peak.*

OPPOSITE PAGE *It's the July white sale at the Ernest Kern store, which explains the U.S. flag on the building front in this 1919 image.*

Scripps Branch Library DEMOLISHED 1966

When George Booth married James E. Scripps's daughter Ellen, in 1887, his father-in-law built the newlyweds a home on the west side of Trumbull Avenue, across from his own. Scripps was founder of the *Evening News* (later the *Detroit News*). In 1905 Scripps donated property adjoining the Booth estate to the city, along with $50,000 for the city's beautification, designating that the 15 lots on Grand River between Trumbull and Commonwealth be used as a park, and as a site for a branch library. That same year, Scripps had retired as president of the Library Commission, on which he served for five years.

The Library Commission, no doubt with Scripps's influence, had already identified that area for its next branch, so the city gave the property to the Commission. When James Scripps died in May 1906, the Booth house and property, next door to the deeded land, were added to the donation. The Library Commission's allocation of $14,000 for a new branch would now be spent on making the Booth home suitable for a library. The $50,000 designated for city beautification would be used for the upkeep of the grounds around the library, to be called Scripps Park.

Built in 1888 by Mason & Rice, the Booth house was almost doubled in size to accommodate a children's room and a reference room; the second floor was adapted for use as an auditorium. The Scripps Branch Library was opened for service on July 3, 1909, the second Library Commission-owned branch.

Scripps's own house was a Tudor mansion built in 1879. In 1898 he added an octagonal library to his home, modeled after the Westminster Abbey chapter house. In 1926, James' son, William E. Scripps, made a gift to the Library of the octagonal annex, along with its private art and book collection. The 800-ton tower was freed from its foundation, moved across Trumbull and attached to the Scripps Branch Library in 1927.

The branch building was abandoned as a library in 1959 and demolished in 1966. The Gothic library tower was razed sometime later, after a valiant but failed attempt by George Booth's son, Henry Scripps Booth, to save the structure.

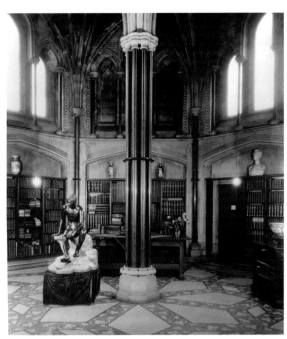

ABOVE *The octagonal chapter house, here still part of James Scripps's home, was moved across the street to be attached to the library.*

LEFT *This ornate entrance leads to Scripps Park, land donated by James Scripps, and the site for the Scripps Branch Library, seen in the distance.*

RIGHT *George Booth's house, that was the foundation for the library, was next to the property donated by his father-in-law.*

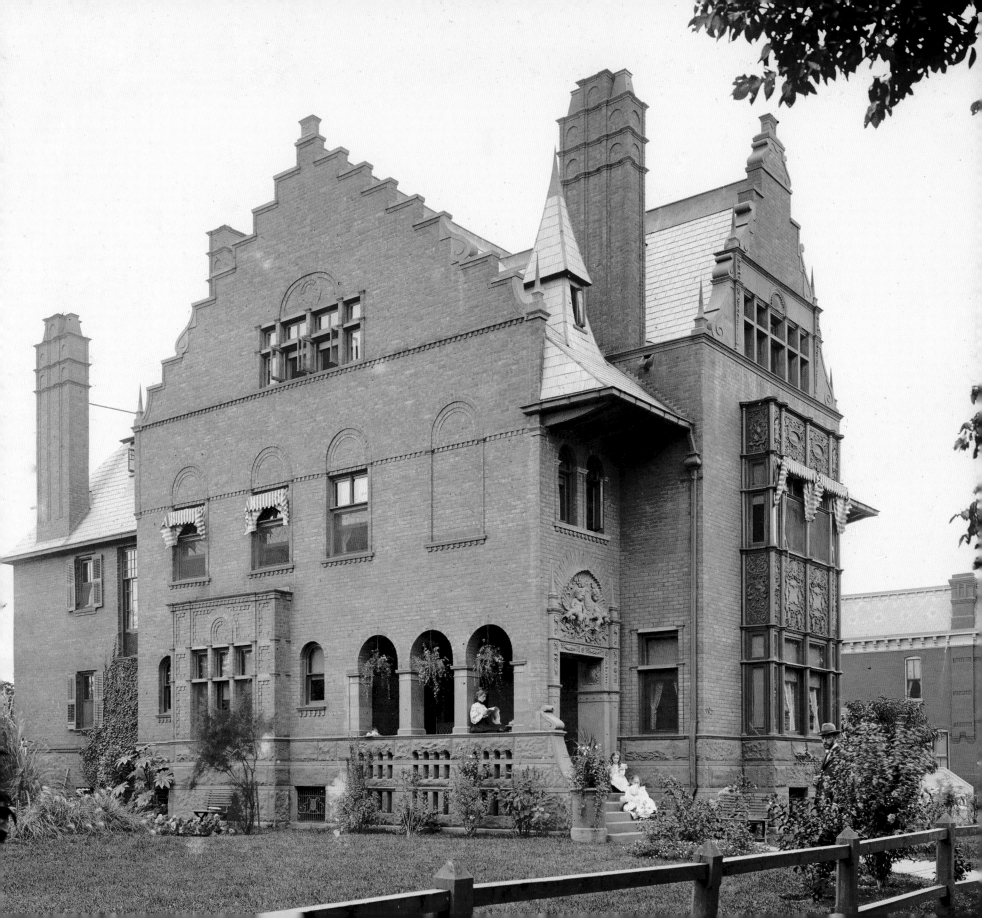

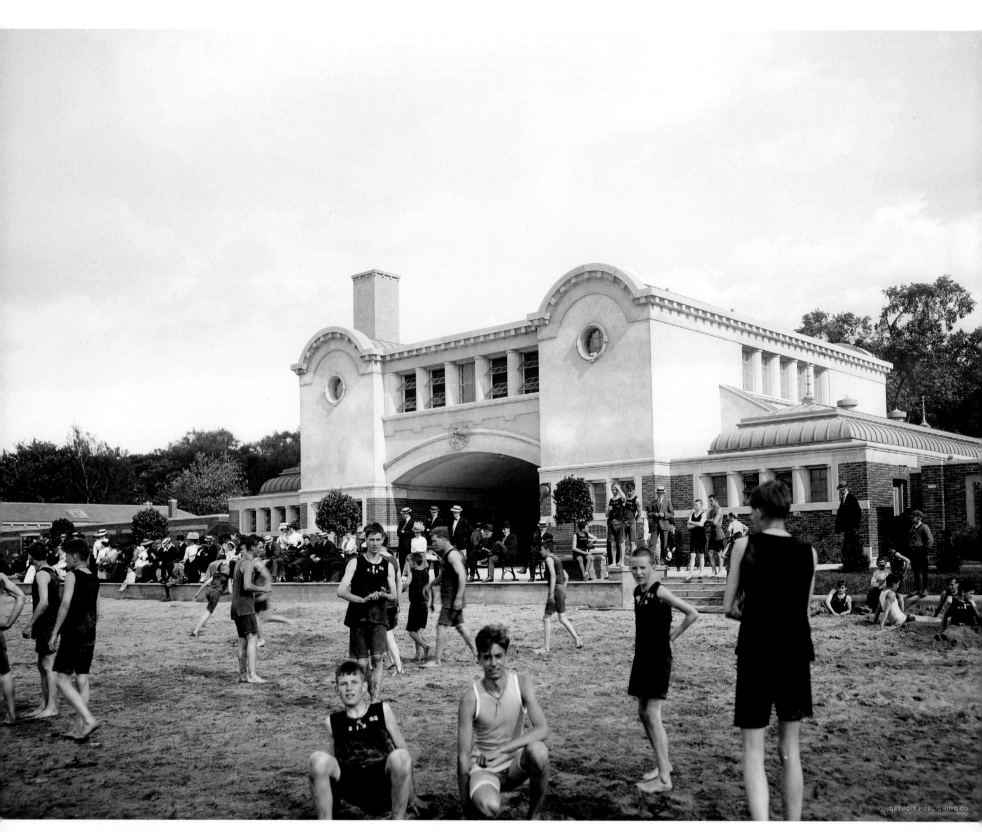

Belle Isle Bathhouse DEMOLISHED 1973

The first of three bathhouses on Belle Isle was opened in 1894. Located between the ferry dock and the bridge, at the west end of Belle Isle, it proved to be inadequate to the task and was followed 15 years later by a magnificent new structure. The second bathhouse opened in 1909 on the north side of the island.

After the new bathhouse opened, the first building was converted in 1911 to a nursery or "infants rest," as it was called. Mothers with children under six years of age were eligible to use the facility, which was staffed by a trained nurse. There were baby cribs and rocking chairs, plus means of heating and cooling milk for the infants. Outside, children had use of a beach with recreational facilities, so that sick children could benefit from the fresh air.

The nursery was discontinued after 1920. Following several years as a clubhouse for the Detroit Rowing Club, the old bathhouse was razed in 1964.

But the new bathhouse was something else. The 600 dressing rooms, barber shop, laundry facilities and night time swimming made possible by arc lights could accommodate 20,000 people a day. There was opposition at first to spending $65,000 on a new bathhouse, but 74,000 people flooded the building and beach the first year, showing that the decision was well-made. In 1921, bathhouse patronage topped 500,000.

The manager of the new bathhouse was Colonel James Cathcart, who strictly enforced all rules and regulations, earning him the nickname the "Belle Isle Czar." Women's bathing costumes must be no shorter than one inch above the knee, though they could forego flesh-colored stockings. Men had to cover their chests, until the "Czar" gave way to public pressure and in 1936 allowed trunks to replace the old-fashioned one-pieced suits for men.

The second bathhouse was closed to the public in the summer of 1967, to house people arrested in the Detroit riots. It was demolished in 1973 and replaced with an unadorned, brick and mason building.

ABOVE RIGHT *The first bathhouse was between the Belle Isle Bridge and the ferry dock, toward the west end of the island. After several other uses, this one was razed in 1964.*

LEFT AND RIGHT *The second bathhouse, opened in 1909, was an instant success. By 1921 there were traffic jams outside its entrance, and attendance reached well over 500,000.*

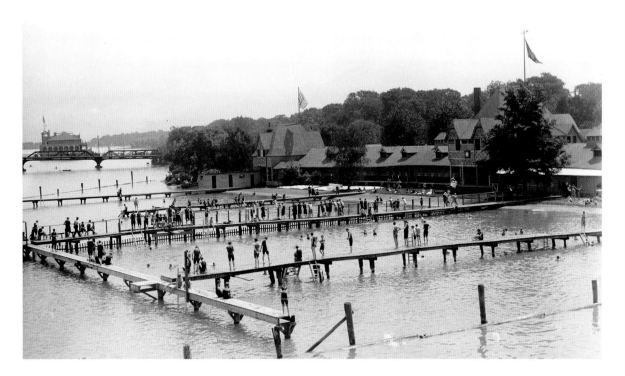

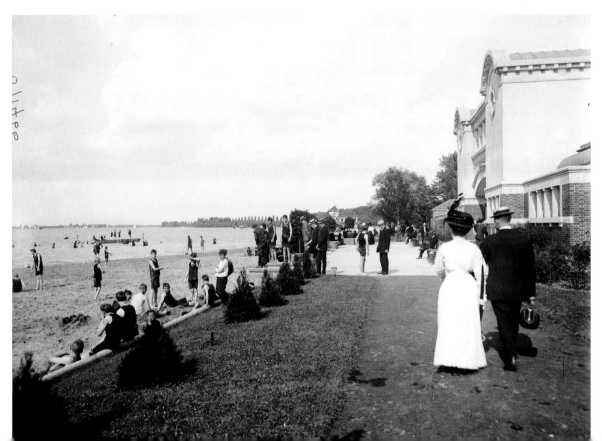

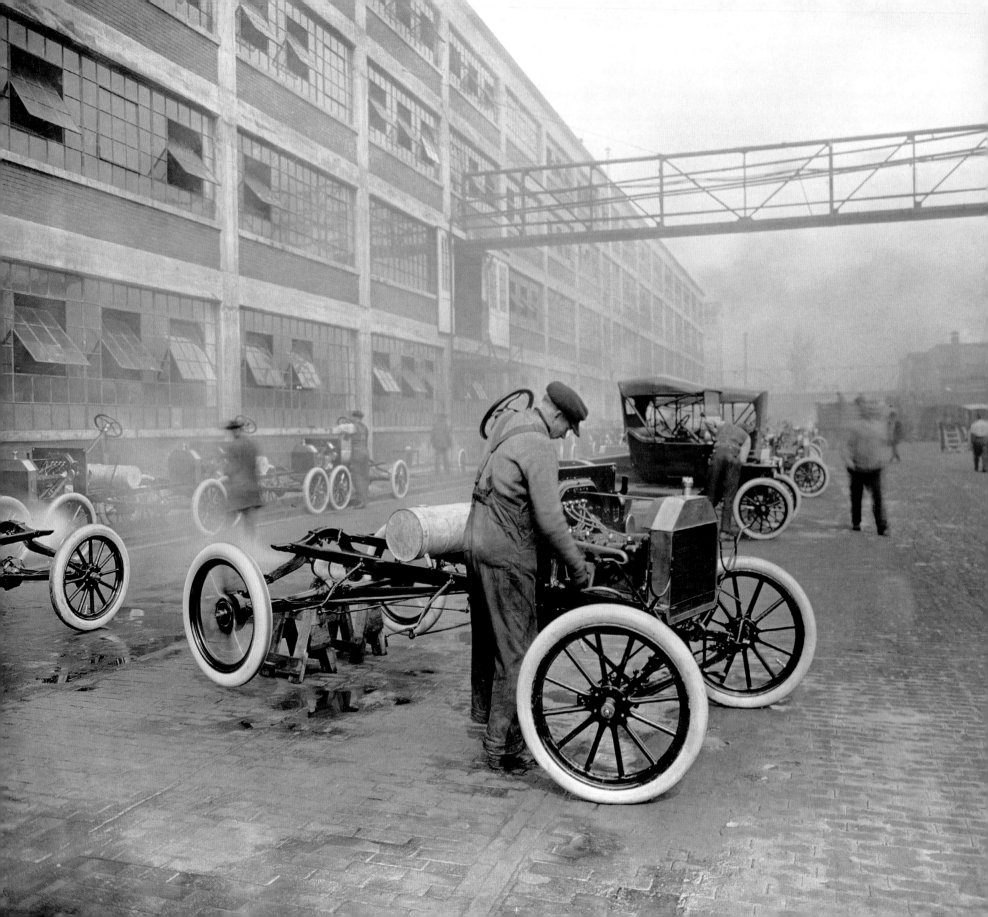

Ford Highland Park Plant PRODUCTION CEASED 1973

Henry Ford built cars in other locations before opening the Highland Park factory, but this was where it all began. Construction started in 1909, and the plant began operating on January 1, 1910.

The 230-acre plot of land was a former race course in a municipality that is surrounded by Detroit. Albert Kahn was selected as the architect, beginning a relationship with Henry Ford that would partially define his career. Kahn's reinforced concrete construction, first used in an automobile factory in the recently completed Packard plant, would find its full expression in this Ford complex.

It was dubbed the Crystal Palace for the light that flooded the factory floors. A glass roof and walls of windows gave Ford the light he wanted for his workers, not just for their well-being but for creating more light to work by, as more machines were added to maximize space.

The Ford Highland Park plant was history-making in many ways. Though the Model T was designed and first made at the Piquette factory, several miles south in Detroit, it was mass-produced here from 1910 to 1927 with the development and refinement of the assembly line. Instead of each car being built in its own location, with workers traveling from car to car performing their particular tasks, Ford introduced the assembly line in 1913, reducing the time it took to build a Model T from 728 minutes (12 hours) to 93 minutes.

Ford's assembly line workers were well rewarded, starting in 1914 when Ford initiated the $5.00 a day wage for an eight-hour day. The salary was double the going rate. Ford reasoned that something had to be done to inspire a more disciplined work force. And now the worker would be able to afford the product he made. Perhaps more than anything, this move cemented Henry Ford's place in history.

Ford's Sociological Department assisted workers in finding suitable housing, while immigrant workers could attend English classes. There was a fully equipped hospital at the plant, and the company even put their corporate lawyers at the disposal of workers who needed legal assistance.

The Highland Park plant grew as production of the Model T doubled each year through 1913. The population of Highland Park went from a little more than 4,000 residents in 1910 to over 46,000 by 1920. After 15 million Model Ts were made in this plant, production shifted to Ford's new factory complex, the Rouge. Starting in 1928 only trucks and tractors were built in Highland Park.

During the 1930s and 40s Ford leased parts of the property to outside firms and had some production of its own during World War II. It continued assembling tractors, trucks and postal vehicles until 1973, when truck production was moved to Romeo and all other production ceased. The site was designated a National Historic Landmark in 1978 and in 1980 sold to HFP Associates. According to a *Crain's Detroit Business* blog, the Woodward Avenue Action Association is negotiating to buy parts of the property from current owner, National Equity Corp., to be used as an automotive heritage welcome center.

OPPOSITE PAGE *Quality control took place outside the plant where all cars were tested, producing quite a lot of smoke in the process.*

LEFT *Workers during shift change appear suspicious of the photographer, giving him wary stares. The businesses down Manchester Street catered to the working man.*

BELOW *An unusual photograph of the Ford plant, with no workers visible, taken at the corner of Woodward Avenue and Manchester. The plant went into operation in early 1910.*

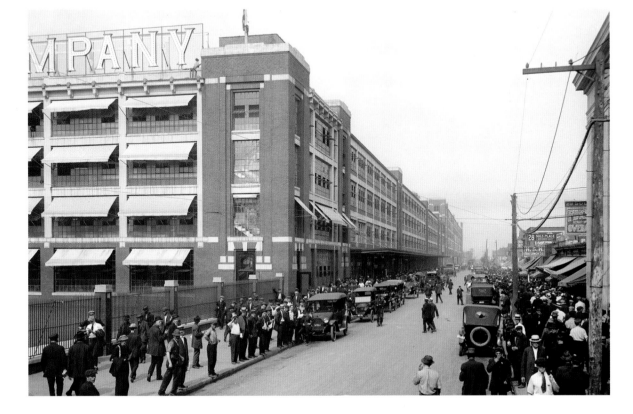

Union Station RAZED 1974

A union station was first tried in Indianapolis in 1853. When each railroad line had a separate station and set of tracks, transferring from one train to another was a real headache for the traveler, not to mention the cross hatch of tracks in the city center. So railway companies consolidated and began using the same station and the same set of tracks.

James Stewart and Company of St. Louis, an architectural and construction firm with experience building railroad terminals, built the station in the Richardsonian Romanesque style popular at the time. James F. Joy, attorney and president of the Detroit Union Depot Company, was involved in planning the new building which opened January 21, 1893.

The site selected for the station was opposite Fort Street Presbyterian Church, at Fort and Third Avenue. A number of residential property owners were forced to sell their homesteads to make way for the new station. The railroad put its approach above Fort Street on a 15-block long viaduct, which attained street level at 18th Street, to keep the remaining homeowners and businesses happy. A *Detroit Free Press* article trumpeted the new station as a sign of "unbounded faith in the future commercial importance of Detroit."

Fort Street was five blocks north of the riverfront where on Third Avenue, the Michigan Central Station was a hub for people coming into downtown, then heading elsewhere via ferry or street transportation. The Michigan Central station would relocate farther west in 1913.

In 1946 the station was remodeled to move offices and services from the first floor to the second, or remove them entirely, with the goal of making the main floor more commodious to travelers, according to *Railway Age*.

Kevin J. Holland's *Classic American Railroad Terminals*, says of the station: "In its prime, Fort Street Union Depot handled almost 30 trains each day. The station's wartime traffic peak occurred in 1944 when over 1.5 million travelers used its facilities."

One of the most recognized trains of the twentieth century, the Wabash Cannonball, had a route between St. Louis and Detroit's Union Depot. The celebrated train with its lush parlor coaches, elegant dining car and Pullman sleepers lasted until the station's close, though most of its amenities had long disappeared. The Cannonball last departed the station for St. Louis on April 30, 1971. With it went the last chance for the station's viability. Train travel was a thing of the past.

There was talk of using the building as a transportation museum or turning it into a restaurant, but vandals ruined the structure, making it unsafe, and with no buyers in sight, the owners decided it was too costly to repair and demolition became the easiest solution. One saving grace: the Detroit Historical Museum had time to salvage some of the architectural artifacts from the building.

RIGHT *Built 20 years before Michigan Central Station, Union Station took up a city block and added a second clock-tower to the city's skyline.*

BELOW *Excavation is taking place for the new station which would have a 15-block-long raised approach, to alleviate traffic problems and appease the home owners still in the area.*

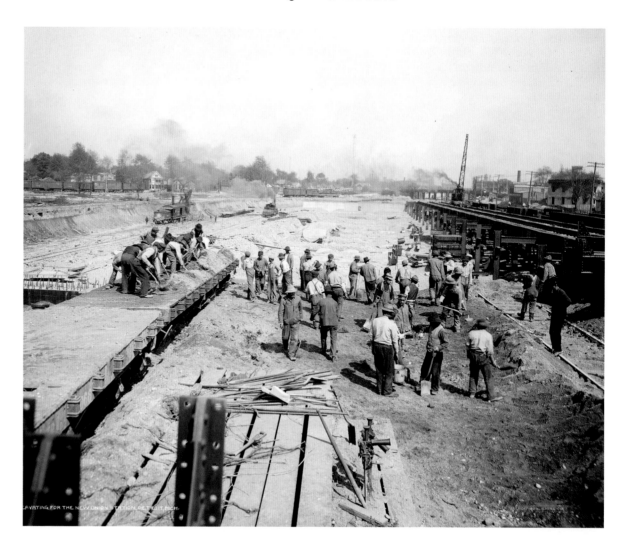

EXCAVATING FOR THE NEW UNION STATION, DETROIT, MICH.

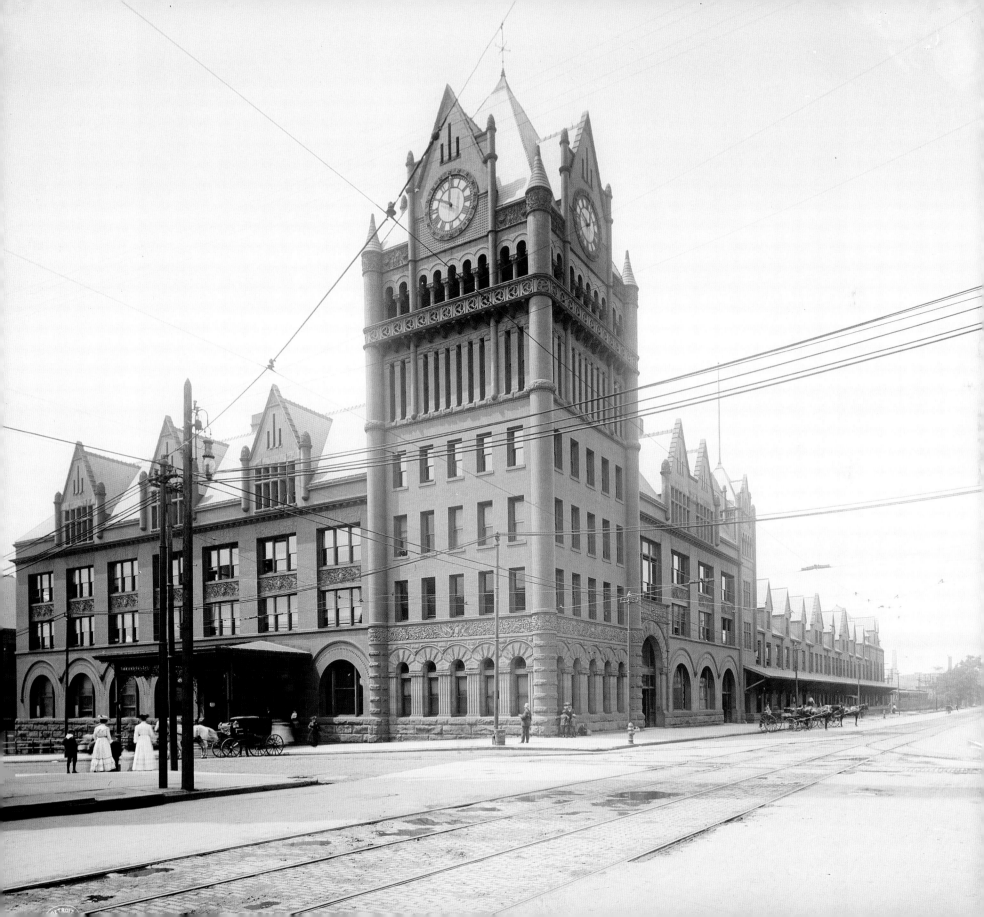

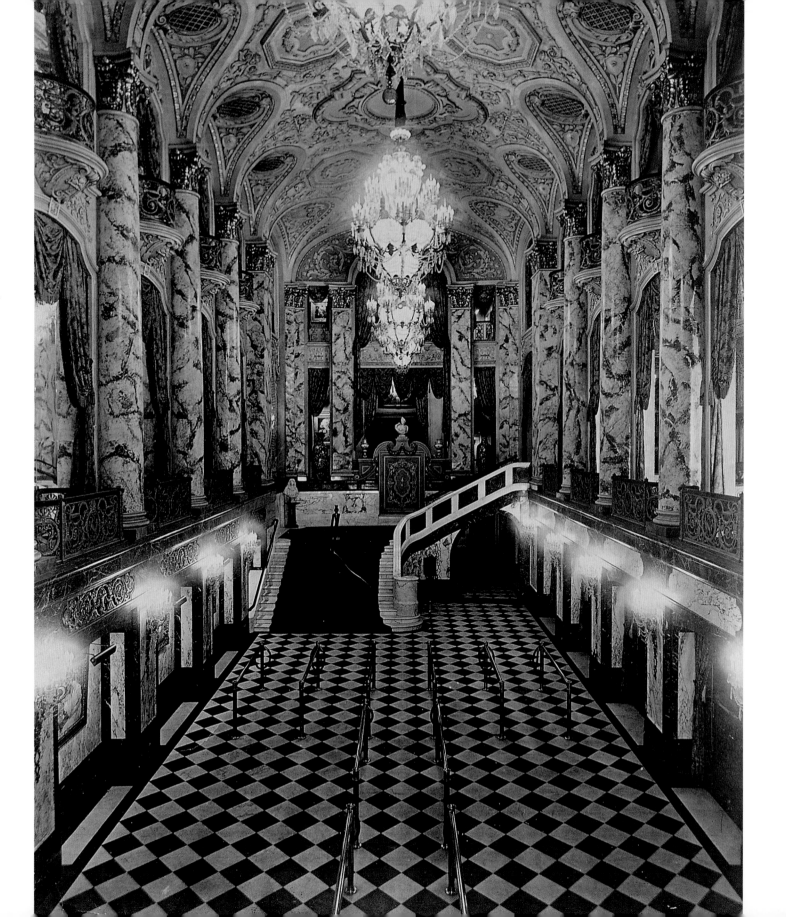

Michigan Theater CONVERTED TO PARKING GARAGE 1977

A five-story, domed lobby would cause first-time visitors to drop their jaws. Opulent, an overused word when it came to movie theaters of the 1920s, did not begin to describe the Michigan Theater.

It was designed by Chicago architects Cornelius W. and George L. Rapp, firm name Rapp and Rapp, and built beginning in 1925. The architects created a number of theater buildings throughout the country including Paramount theaters in various cities, New York City being one, and seven theaters in Chicago alone.

Detroiter John H. Kunsky, with Chicago partners Barney Balaban and Morris Katz, owned the Michigan, along with the Adams Theater around the corner on Grand Circus Park. The Michigan's 4,000 ton steel frame was constructed by Detroit firm Whitehead & Kales.

W. Hawkins Ferry, in his book *The Buildings of Detroit*, quoted a *Detroit Free Press* writer who waxed eloquent about the Michigan: "It is beyond the human dreams of loveliness," he said. "Entering it you pass into another world."

The theater opened on August 23, 1926, drawing crowds not for the movie, but to see what 3.5 million dollars would buy. Four thousand seats awaited the audience, who could view original art, sculpture and period furniture among the marble columns of the lobby and mezzanine. The lobby itself held 10-foot chandeliers.

Over 50 years, besides movies, the stage saw some of the most famous acts of the times: early on, Tracy and Duncan, vaudeville songsters, set a record by playing 98 consecutive weeks at the Michigan in 1929–31; Tommy Dorsey, playing there in 1942, had music stolen from his music stands by rambunctious teens during intermission; Sammy Davis, Jr. allegedly first met Frank Sinatra there when Sinatra was a vocalist for Dorsey; Billy Eckstine headlined Duke Ellington's orchestra, with Ella Fitzgerald billed later in the month, in 1951.

The Michigan was one of a chain of theaters owned by Kunsky, who would later change his name to King. In 1929 he and newly acquired partner, George Trendle, sold the chain for six million dollars to Paramount; it became United Detroit Theaters. They turned around and bought radio station WXYZ where Trendle was producer of "The Lone Ranger," first on radio, then on television.

Over the years, parts of the theater were dismantled: the "Michigan" sign over the marquee was deemed unsafe by the city and removed in 1952. The Wurlitzer pipe organ, last played in 1936, was sold to a private individual in Wisconsin in 1955. The office building adjoining the theater was the profitable part of the operation and when attendance declined, as television replaced movie-going for many, the Michigan was closed in 1967.

Nicholas George, owner of several local theaters, tried to save the aging beauty that same year and managed to keep her alive for three more years. Two other entrepreneurs, Sam Hadous, then later Steven Glantz, tried to make a go of it by turning the theater into first a supper club, then a rock venue, called the Michigan Palace. Concert-goers ruined the interior, smashing mirrors and ripping chairs and fixtures from their places, rendering the space useless once the business folded.

Tenants in the Michigan Building needed parking. The theater could not be torn down without affecting the integrity of its adjoining office space, so a decision was made to turn the theater into parking. The mezzanine, grand staircase and balcony were removed, other parts remain, including the lobby and proscenium arch. A three-level parking deck for 160 vehicles is the world's most beautiful garage.

OPPOSITE PAGE AND BELOW LEFT *Ten-foot chandeliers graced the lobby of this three and a half million dollar creation. Notice the 1926 ceiling is the same one that today watches over cars, instead of finely dressed movie goers.*

BELOW *Saved for posterity, but at what cost to its dignity? In 1977 the theater was converted to a parking garage, with many of its original features left intact.*

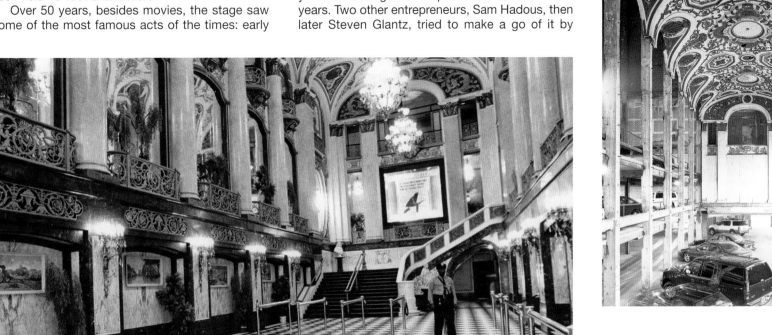

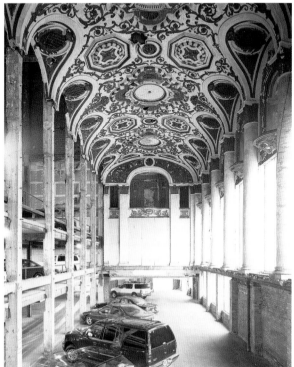

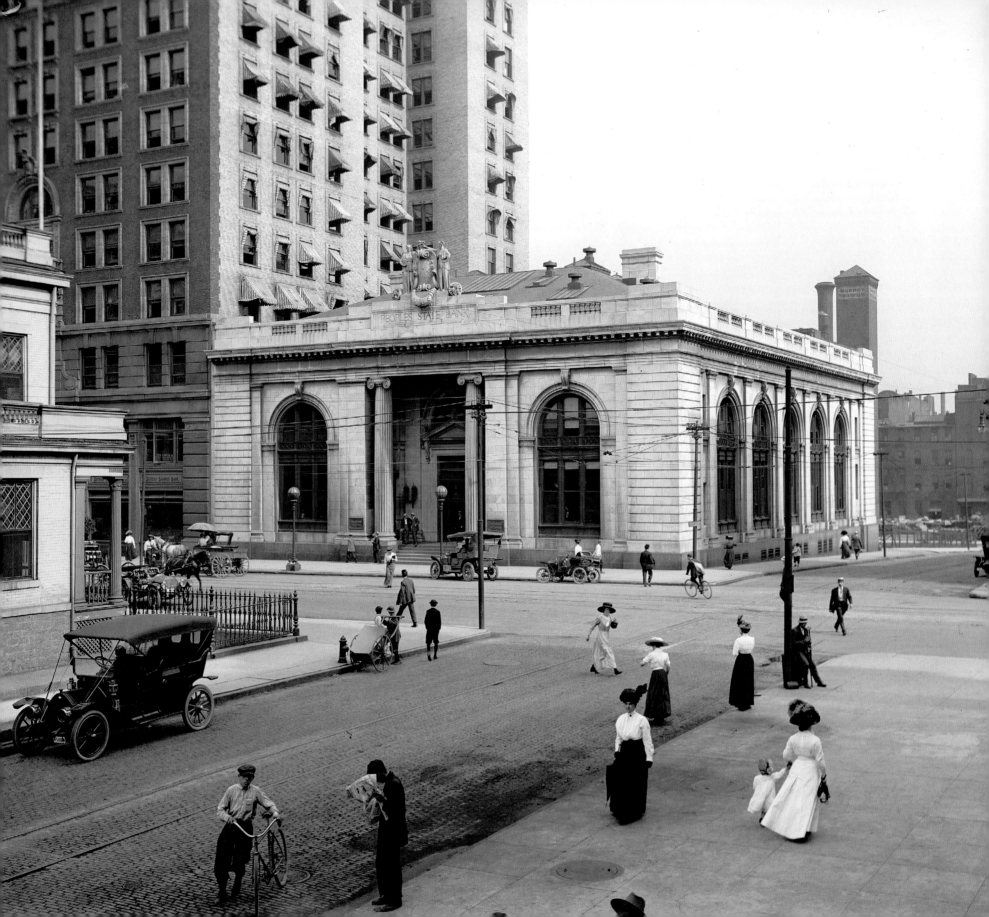

Peoples State Bank CLOSED 1979

Standing low amidst the surrounding skyscrapers, the elegant and classical Peoples State Bank is one of the few banks designed by the east coast architectural firm of McKim, Mead and White, and their only Detroit building. In 1900 local architects Donaldson and Meier carried out the execution of the plans featuring a marble facade and interior, with bronze windows and grillwork. Stanford White's son credits his father with a major part in the design of the two-story Beaux Arts building. The bank was enlarged in 1914 by Donaldson and Meier to extend to Congress Street.

The land, at W. Fort Street and Shelby, site of Fort Lernoult, was purchased by the State Savings Bank in 1898. When the foundation was dug for the bank, remains of an old well turned up various bits of military items.

The Peoples State Bank originated in 1871, and beginning in 1872, operated for a while as the Peoples Savings Bank. An 1871 state law created savings banks, which allowed "mechanics, clerks, servants, married women, and minor children" to open savings accounts. This was significant because previously women needed a husband's permission, and minor children that of a guardian, to make these bank transactions.

In 1907 the State Savings Bank merged with the Peoples Savings Bank, which then became again Peoples State Bank located in the new building at Fort and Shelby. In 1909 it purchased the United

States Savings Bank, and by 1922 was the largest bank in Michigan. It had 26 branches in Detroit and its vault held 9,000 individual boxes.

In 1927 another merger created the Peoples Wayne County Bank, which succumbed to the 1933 financial disaster.

In August of 1933 the Manufacturers National Bank was established there. Opened by Ford and run by his son Edsel until his death in 1943, Manufacturers National Bank was considered a rival bank to the General Motors' financed National Bank of Detroit.

In 1979 the building said goodbye to the bankers and hello to retail, becoming headquarters for Silver's, Inc., an office supply company, until Office Depot bought them out in 1994. In 1997 it was Britt's Café and in the following years provided office space to various concerns. The building, on the National Register of Historic Places, is currently unoccupied.

OPPOSITE PAGE *This is the bank before a 1914 addition extended the back portion to Congress Street. It later became home to Silver's office supply.*

BELOW LEFT AND BELOW *A skylight, and carved coffered ceiling in the central area, bronze grillwork and plenty of windows meant employees no doubt found the space agreeable.*

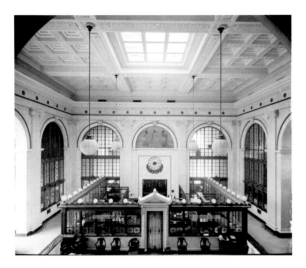

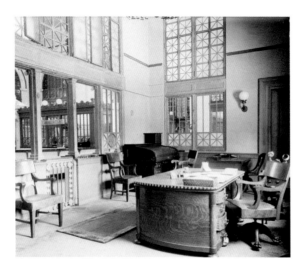

Pardridge & Blackwell Building RAZED 1980

Henry Blackwell learned the mercantile business in his home town of Limerick. He came to Detroit in 1892, after stopping two years in New York City. In 1901 he joined with William Pardridge to form Pardridge & Blackwell and they opened a store in the Majestic Building, in the space C.R. Mabley was to occupy. In 1906 they moved to a new, six-story building on the corner of Farmer and Gratiot, just to the east of the Kern's and Hudson's stores. Smith, Hinchman and Grylls was the architectural firm for the ornate and graceful white terra cotta faced building topped with giant electric heart signs containing the initials "P&B." Their ambitions were blunted, however, by a financial panic in 1907 which forced them to sell the business.

One of their creditors, Crowley Brothers, a wholesale house, along with one of Crowley's customers, William Milner of Toledo, reorganized the firm and incorporated it in 1908, though not changing the name to Crowley, Milner & Company until 1909. All three Crowley brothers, Joseph, William and Daniel, got their start in the dry goods business working for Burnham, Stoepel & Co., the eldest, Joseph becoming a partner. Daniel went on to work at Peninsular Stove Works, where he advanced to vice president and general manager.

Crowley's, as it was called, was the first store in Detroit with an escalator when they opened in 1908. Going between two floors it was later removed, but replaced in 1928 with one that connected all six floors, a record for the largest in Detroit. The wooden escalator was a memorable experience for many visiting the store.

The department store grew in stages. By 1917 it occupied the entire block, the original building topped by two more stories, then the whole structure expanded, making the claim to be the largest store in Michigan. A business on Library Street was purchased in 1920 and connected to the first building across the street by a tunnel. The city permitted the construction of a five-story bridge to link the buildings, done in 1925, making the site a landmark in downtown Detroit. That same year an 11-story structure completed the complex.

A popular feature of Crowley's was their twice a year Mill End Sales, for which people would stand in line. From an inside balcony, store employee, C.A. Lockhart would announce the sale items, then lead the customers through the store.

What were the differences among the large number of competing department stores? Some, like B. Siegel, specialized. Some offered services like delivery, mail order or credit and Crowley's was the first store of its size to give customers the option of time payments. Some, like Crowley's and Hudson's drew their success on sheer size and volume of sales, adding branch locations to their businesses. Crowley-Milner, in a 1932 brochure "Highlights of Detroit Industrial History," put out by the Detroit Insurance Agency, claimed its adaptation of the automobile industry principle of "high volume and low profits" to the retail trade "swept [it] ahead to unprecedented success."

That same year, in which thousands were unemployed in Detroit, the company held a contest in an effort to help the automobile manufacturers increase sales. Crowley displayed models of cars on the third floor of its Library Street building, and outside the building, exposing them to more than 1.5 million people who visited the store. From the more than 649,000 who entered the unspecified contest, 21 winners were chosen, each receiving a new car at the end of December. After being handed the keys to their new vehicles, the winners paraded them up Woodward.

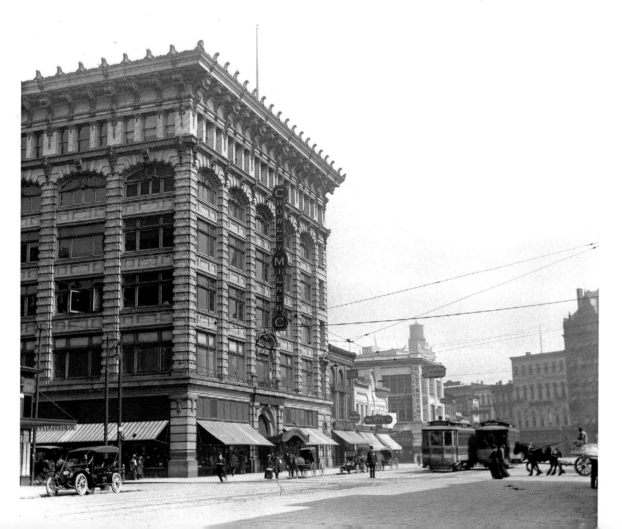

RIGHT *The ambitious opening of a new store proved disastrous for the two merchants and they were forced to sell their beautiful new building at Farmer and Gratiot.*

LEFT *By 1910 the building had extended a full block, to Monroe Street. Though giant hearts no longer topped the building, the company still promoted itself as being "in the heart of Detroit."*

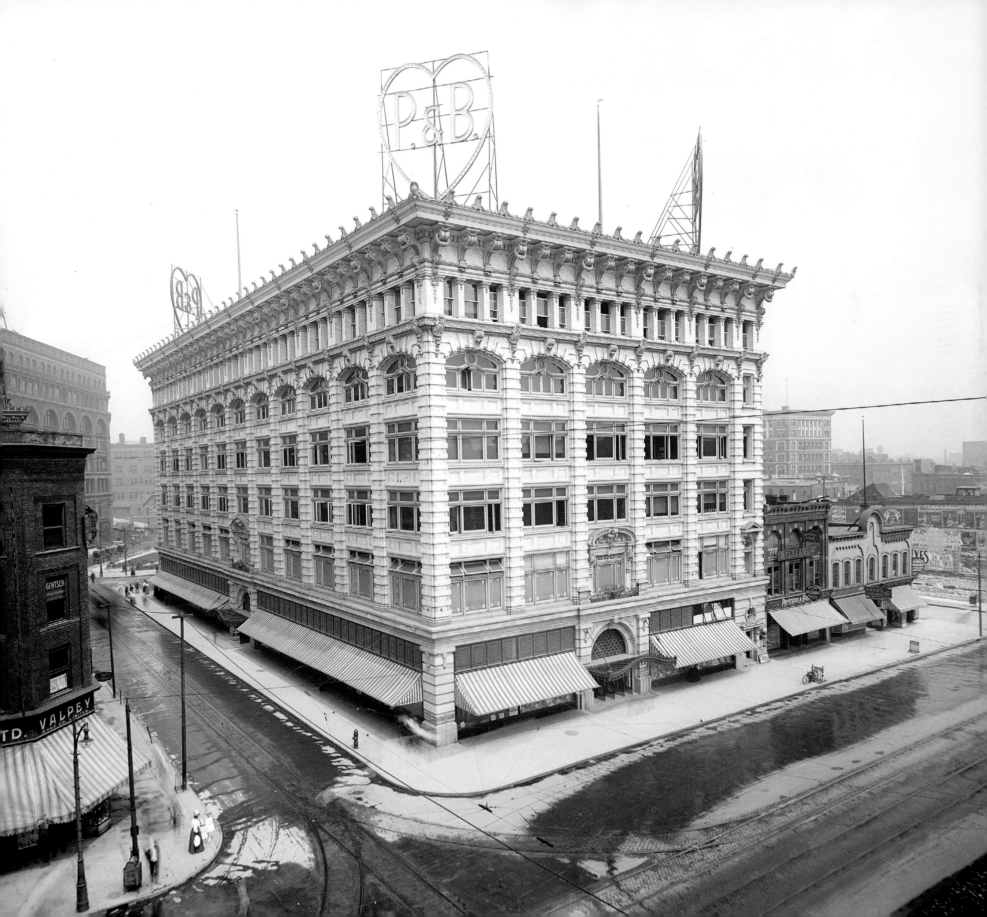

Between 1959 and 1975 Crowley's opened branch locations, but the decrease in downtown shoppers eventually forced the original store to close in 1977. "People moved away," said Crowley president Robert Winkel in a *Detroit Free Press* article at the time. No other use could be found for the building, and demolition began the same year it closed, though was not completed until the end of 1980.

LEFT *Customers received careful attention at a store that prided itself on its friendliness. In the 1940s, selling large appliances was strictly a man's job.*

RIGHT *An early Crowley employee remembered a day when 275,000 customers kept the staff so busy that they didn't have time to eat. By the 1940s that flow was somewhat staunched.*

BELOW RIGHT *A gentleman considers a purchase at one of the mahogany counters that, along with marble floors and other architectural details, made shopping at downtown department stores a pleasurable experience.*

BELOW *With several operator stations, no doubt business was brisk for telephone orders of merchandise. Crowley's was the first Detroit department store to offer the installment plan of payment.*

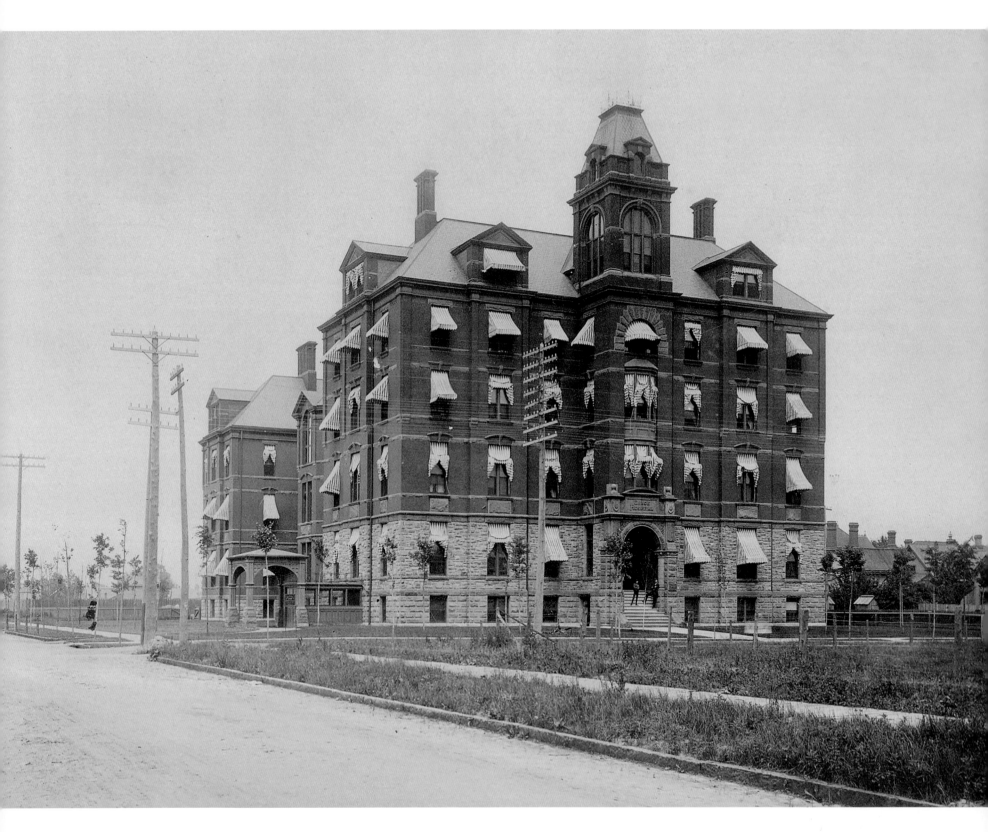

Grace Hospital DEMOLISHED 1980

Grace Hospital opened in 1888, 25 years after its venerable neighbor, Harper Hospital, was established. The architect was Gordon W. Lloyd who also designed the David Whitney house. The five-story building at John R and Willis was named after Grace McMillan, daughter of wealthy benefactor James McMillan. It was a homeopathic hospital, following a philosophy that substances causing an illness are used in diluted form to treat that illness. It remained dedicated to that philosophy until 1901, when doctors of the "regular" school of medicine were permitted to practice there.

A year later, in 1889, a nursing school was opened in a building next door. Pink-uniformed students took a two-year course to study subjects such as how to make bandages and dress wounds, and, under the supervision of the physician, how to properly give medicines to patients. The school survived until 1980, with over 7,000 graduates.

There were four other hospitals at the time, struggling to meet the needs of the close to 200,000 populace of Detroit. Grace Hospital offered 122 beds to the health-care community, vying for patients with its neighbor, Harper Hospital. Particularly fierce was the ambulance competition. The ambulance for each hospital tried to reach the scene of an accident first, in order to claim victims for its own hospital. Sometimes, if the victim rescued by a Grace Hospital ambulance, for

example, requested to go to Harper Hospital, he was left in the street and vice versa. Grace staff members would be on the lookout for the Harper ambulance, and race to send their own horse-drawn conveyance to the scene.

The origins of Harper Hospital are relevant, as in the 20th century Harper and Grace would merge as part of the Detroit Medical Center. Harper was built on land left by Walter Harper, a recluse from Philadelphia, and his servant, Nancy Martin. Before his death, Harper deeded an estate of nearly a thousand acres to trustees, for the purpose of building a hospital. Mrs. Martin, in addition to being Harper's housekeeper, had a stall in the market and sold produce. She invested what she earned in land, also leaving it to the trusteeship. Incorporated in 1863, Harper Hospital had to first meet the needs of the Civil War and a military hospital opened on Woodward to accommodate wounded soldiers. In 1866 Harper Hospital opened for civilian patients. A new hospital on John R opened on June 19, 1884.

Both Grace and Harper Hospitals grew over the years with additions made to their original buildings and branches added. In 1962 ground was broken for the Detroit Medical Center, which today incorporates Harper-Grace Hospitals, as well as buildings for Wayne State University's medical school. Children's Hospital and Hutzel Hospital are also located there. The old Harper Hospital building was demolished in 1977 and Grace in 1980.

OPPOSITE PAGE *Grace Hospital opened as a homeopathic facility, following a philosophy that the same substance that caused an illness be used, in diluted form, to treat it. In 1901 it joined the mainstream, or allopathic, school of practice.*

LEFT *Nurses who trained in a building next door to the hospital wore pink uniforms and were educated in a two-year program.*

THE DAY HOUDINI DIED

On November 27, 1906, a handcuffed Harry Houdini leaped from the Belle Isle Bridge 25 feet into the icy Detroit River, shouting "Goodbye" to the gathered crowd. Soon one hand appeared above the water, then the other. This was just one of the many stunts that he survived. However, in October of 1926 he was not so lucky. Prior to a performance in Montreal, before his scheduled appearance at the Garrick Theater in Detroit, Houdini spoke to a group of students. According to his *New York Times* obituary, Houdini was struck in the stomach by a student who responded to Houdini's remark that he could take any punch to the abdomen. Four blows were dealt. Though in pain, Houdini went on with the performance in Montreal. In Detroit, he performed at the Garrick Theater on October 24 with a 104 temperature and afterwards, was admitted to Grace Hospital. An attending physician, Dr. Charles Kennedy, called it a case of a ruptured appendix that poisoned his system. Nothing could be done. Houdini died on Halloween, October 31, 1926 at age 52 in room 401 at Grace Hospital. From the Hamilton Funeral Home on Cass Avenue his body was taken to New York, where his funeral was held on November 4, attended by over 2,000 people. He is buried in Queens.

Dodge Main Plant DEMOLISHED 1981

The Dodge brothers, Horace E. and John F., built Dodge cars at this plant for six years, between 1914 and 1920. In 1920 they both died tragically, John, age 55, of influenza at the beginning of the year, and Horace, age 52, of cirrhosis of the liver, at the year's end. The family managed the company for another five years before it was sold to a New York banking establishment for $146,000,000, the industry's largest financial transaction up to that point. Chrysler Corp. bought the company in 1928. The plant closed on January 4, 1980, and by 1981 it was gone, a victim of General Motor's Poletown development.

Horace and John Dodge were machinists, and, as it turned out, adept businessmen, whose company, Dodge Brothers, provided engines and transmissions to Henry Ford and Oldsmobile. They were also stockholders in the Ford Motor Company, and as Ford reaped profits, so did they. Having outgrown their plant at Monroe and Hastings Streets, in 1910 they decided to build a new factory and purchased land in Hamtramck, a township on the northern outskirts of Detroit. Following on the heels of Albert Kahn's recently completed Ford complex in Highland Park, the brothers enlisted Kahn to design the five million square foot factory on Joseph Campau Street. Kahn patterned the building complex after Ford's plant, only a few miles away. As the plant grew over the years, architects Smith, Hinchman and Grylls continued the reinforced concrete construction.

The Dodge brothers switched over to car manufacturing in 1914. Aware that Ford's dependence on the parts they provided could end at any time, they decided to make a mid-price car in their Hamtramck plant. Their reputations as solid mechanics and manufacturers stood them in good stead as they produced their first car in November 1914. As evidence, 13,000 dealers wanted to represent the new car. The Dodge brothers remained second in car sales, behind Ford, until the time of their deaths.

The plant had a free clinic and 24-hour medical staff, sponsored a company band, and provided life insurance for their employees. Dodge Brothers began hiring African American workers in 1919, shortly after Ford Motor Company, and women in 1920, though one can imagine that job selection was limited.

Their plant was the only one, besides Ford's

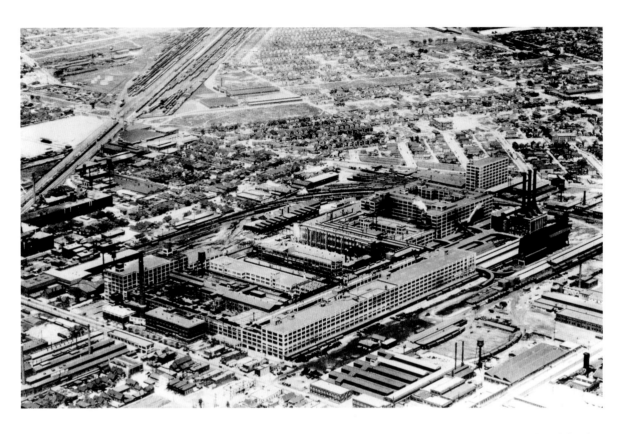

massive Rouge plant, to combine and integrate automobile manufacture and assembly. The location of the plant in Hamtramck increased the population there by 12-fold, most of it Polish or of other ethnic origin. The March 1937 strike at Dodge was seminal, the largest sit-down strike in U.S. history, that after a little over three weeks won the workers recognition from Chrysler. Chrysler would probably not have become part of the Detroit automobile triumvirate without the purchase of Dodge Brothers Motor Company.

When John Dodge died, thousands of Dodge workers lined up outside his Boston Boulevard home to pay their respects.

ABOVE *Looking northeast, this 1925 photograph shows the size of the complex in Highland Park when it was first sold.*

RIGHT *This glowing image of Dodge Main, identified as a 1943 WPA photograph, was taken when war work replaced automobile manufacturing.*

OPPOSITE PAGE *One of the prize jobs at the factory had to be testing the finished cars. This high-trestled track almost looks like an amusement ride.*

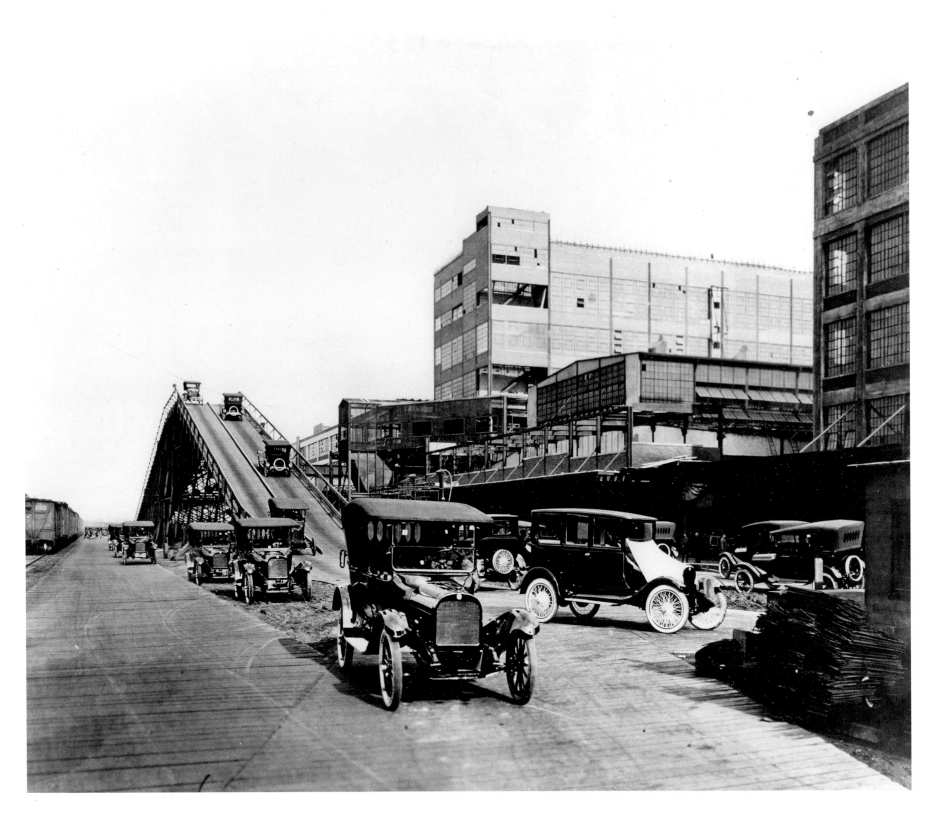

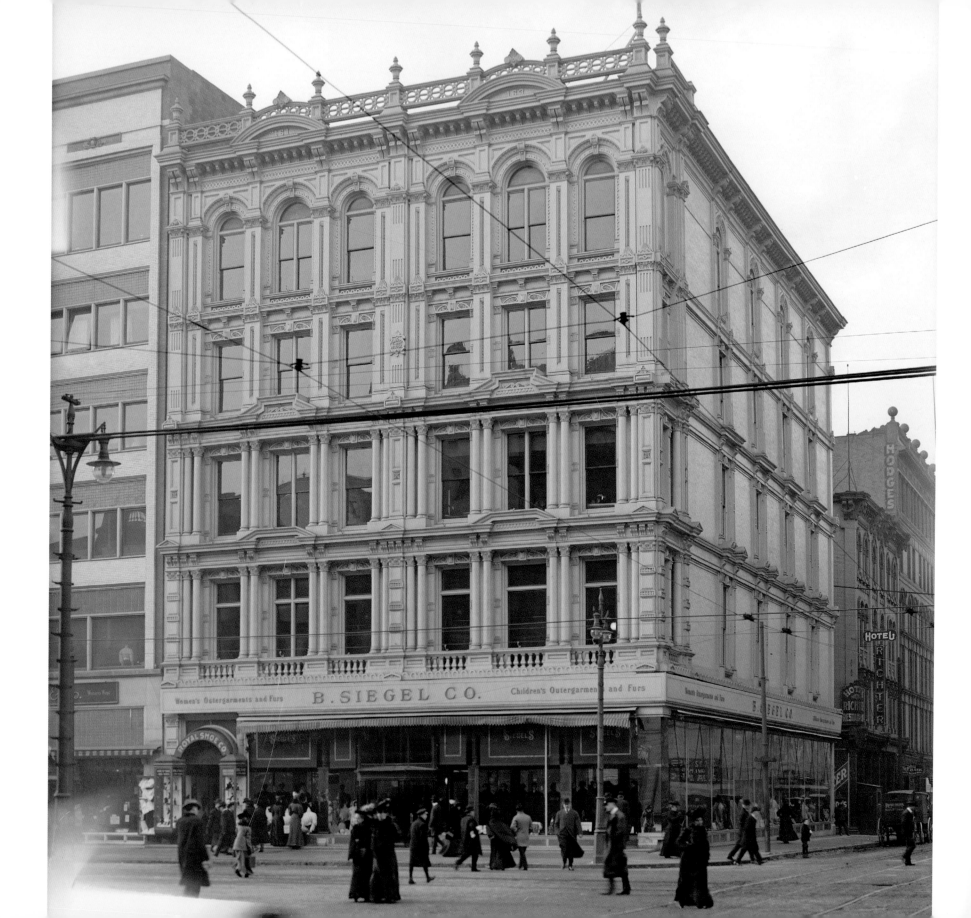

B. Siegel CLOSED 1985

Born in 1860 in Germany, Benjamin Siegel came to Detroit in 1881 from Selma, Alabama, where he began his career in merchandising. He first worked in Heyn's Bazaar on Woodward and, due to his skill in the merchandising business, was able to buy the store in 1895. He changed the name to the B. Siegel Company, and in 1904 moved the business to the southwest corner of Woodward and State Street.

His new store, occupying part of Parker's Block, was built in the second empire style, with a cast iron facade. The building, constructed in 1883, offered 42,000 square feet of space and was said to be the largest cloak store in the U.S. Later, it was increased to six floors, and the building next door was annexed to double the store size.

Siegel was credited with being a savvy businessman, always abreast of current fashion. Before opening his own store, he ran a Cloak Room in Heyn's Bazaar, advertising it in 1889 as the only exclusive cloak room in the city. His merchandise, promoting cloaks, suits and furs, was described as "upscale." Dress sizes were inaccurate in those days so an entire floor of the new store held fitting rooms, the top story devoted to an alteration and fur remodeling department with two hundred employees.

The display windows at B. Siegel's captured attention around the country in 1911, when, to celebrate George V's coronation, Siegel had copies made of the robes worn by the monarch, and exhibited them in the store windows.

Not only was Siegel *au courant* with the fashions, but in the latest delivery methods as well. His was the first store in the city to have motorized delivery service, and in 1915, had six vehicles, with the expectation of doubling that number within a year. An ad for the store in the 1922 *Social Secretary of Detroit* tells the prospective customer, "If you were to make a quest of the Orient and Occident for style suggestions which have inspired the present mode, you would be attempting what the fashion house of B. Siegel Co. has accomplished and have [sic] ready for your delectation."

The place "Where Fashion Reigns" sold exclusively women's fashions, specializing in furs, but eventually added children's clothing. There were seven B. Siegel stores by the end of World War II, including one on Seven Mile at Livernois, the "Avenue of Fashion." The Seven Mile store opened in 1949, making Siegel's "the first downtown specialty shop to introduce a full-sized shop in a neighborhood shopping district."

Benjamin Siegel lived in a 7,500 square foot classic Italian villa style house, designed by Albert Kahn, in the Boston Edison neighborhood. Others who lived in the well-to-do community were S.S. Kresge, who lived next door, Charles Fisher, of Fisher Body fame, Henry Ford, the Dodge brothers and clothing-store competitors Ernst Kern and Wolf Himelhoch.

Benjamin Siegel died in 1936, and the store remained under family management until its close. Despite its attempts to remain relevant, with updates over the years, the B. Siegel Company filed for bankruptcy in 1981 though remained in operation until 1985. A fire in 1990 destroyed the building and the space is now occupied by a parking garage.

LEFT *Gordon W. Lloyd was the architect for this "cast-iron grandiosity" that was later increased to six floors. Today it's a parking garage.*

RIGHT *The display windows always featured the latest fashions in Benjamin Siegel's stores.*

Olympia Stadium DEMOLISHED 1986

The famous theater architect, C. Howard Crane designed this five-level stadium as home for the new hockey team, the Detroit Cougars, who in 1930 became the Falcons, and in 1932, the Red Wings. When the first hockey game was played there on November 22, 1927, players skated on the largest indoor skating rink in the United States, 242 feet by 110 feet.

The red brick building was known as the "Old Red Barn" and was host not only to hockey, but basketball (the Detroit Pistons played there from 1957 to 1961), professional wrestling, boxing and big name concerts. Originally seating 11,563 people, it was expanded in 1965 to add 1,800 seats plus standing room capacity for over 3,000. The steep rise of the arena, with standing room at the top, meant fans were almost literally hanging from

the rafters. Add to that the fact that architect Crane had created another acoustical gem that would do justice to the roars of the fans

When the National Hockey League (NHL) expanded from Canada into the U.S. in the 1920s, the Detroit Cougars was the sixth team to be added, making Detroit one of the original six teams of the NHL. The Cougars took over the players of the defunct Victoria Cougars, of the World Hockey League, in 1926, and played their first year across the Detroit River in Windsor.

The Detroit Red Wings weren't the only ones to fill Olympia with screaming fans. The Beatles played their first Detroit engagement at the stadium in 1964, there were frequent boxing matches with name contenders like Joe Louis and Thomas Hearns, sports such as tennis, roller derbies, and

wrestling, plus ice shows, circuses and conventions. Besides the Beatles , Elvis Presley, the Rolling Stones, and Stevie Wonder, all the big names of the 1960s and 70s played Olympia.

A pivotal year came in 1935, with the Detroit Tigers, Detroit Lions and the Red Wings all at the top of their games, not to mention Joe Louis, giving rise to the nickname "City of Champions." The following year the Red Wings won their first Stanley Cup.

But the decade of the 1950s was not bad either, and no talk about Olympia is complete without mention of the great Gordy Howe and the Red Wings "Production Line": Howe, Sid Abel, and Ted Lindsay. The nickname "Production Line" refers not only to the threesome's scoring ability, but to Detroit's automobile industry. In that decade the team finished first seven consecutive times and won four Stanley Cups.

The Red Wings played their final game at Olympia on December 15, 1979. A declining neighborhood and a stretch of mediocre seasons led the team to accept the city of Detroit's offer of a new home on the riverfront, the Joe Louis Arena. After their move, Olympia remained empty until its demolition in 1986. A Michigan National Guard Armory now occupies the site.

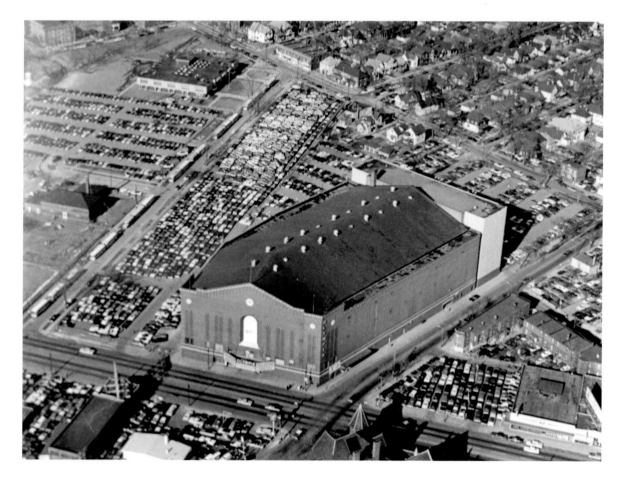

LEFT *The roof was raised, figuratively speaking, many a time when the Detroit Red Wings "Production Line" sent the puck screaming into the net.*

RIGHT *The Howard Crane-designed stadium was a venue for a variety of entertainment besides sporting events. The Beach Boys appearance at the stadium dates this photo to November 1964.*

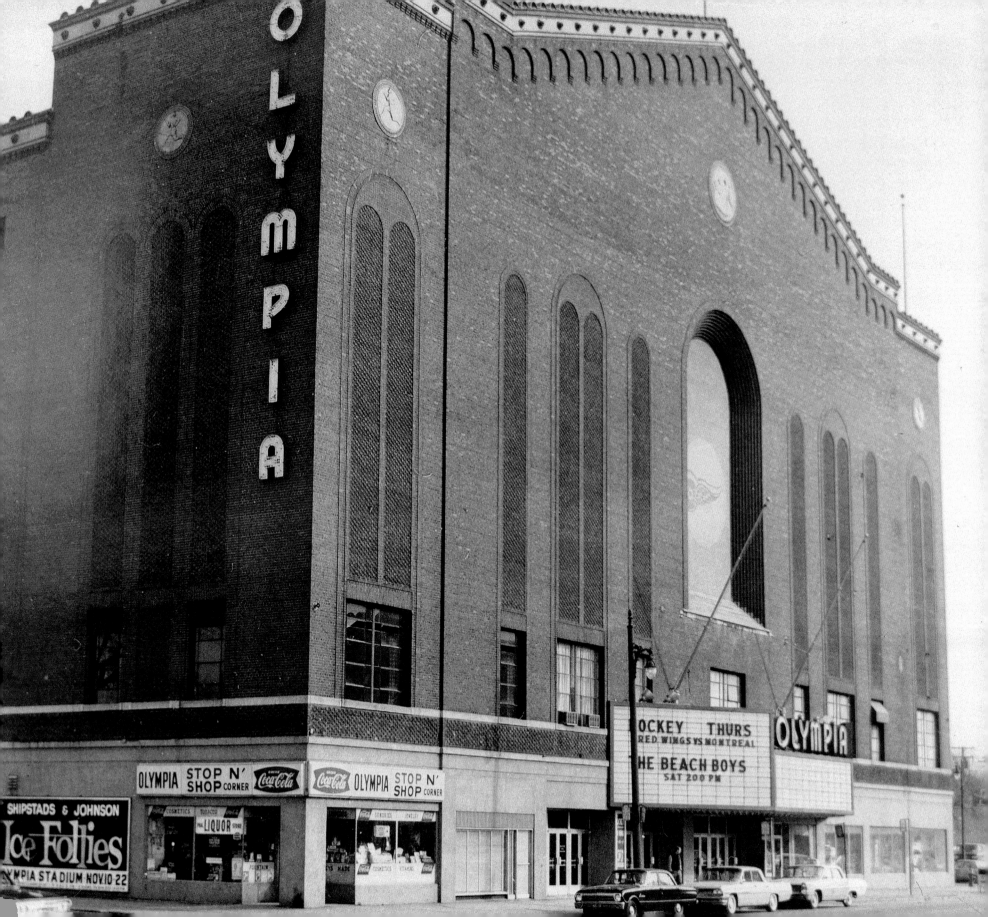

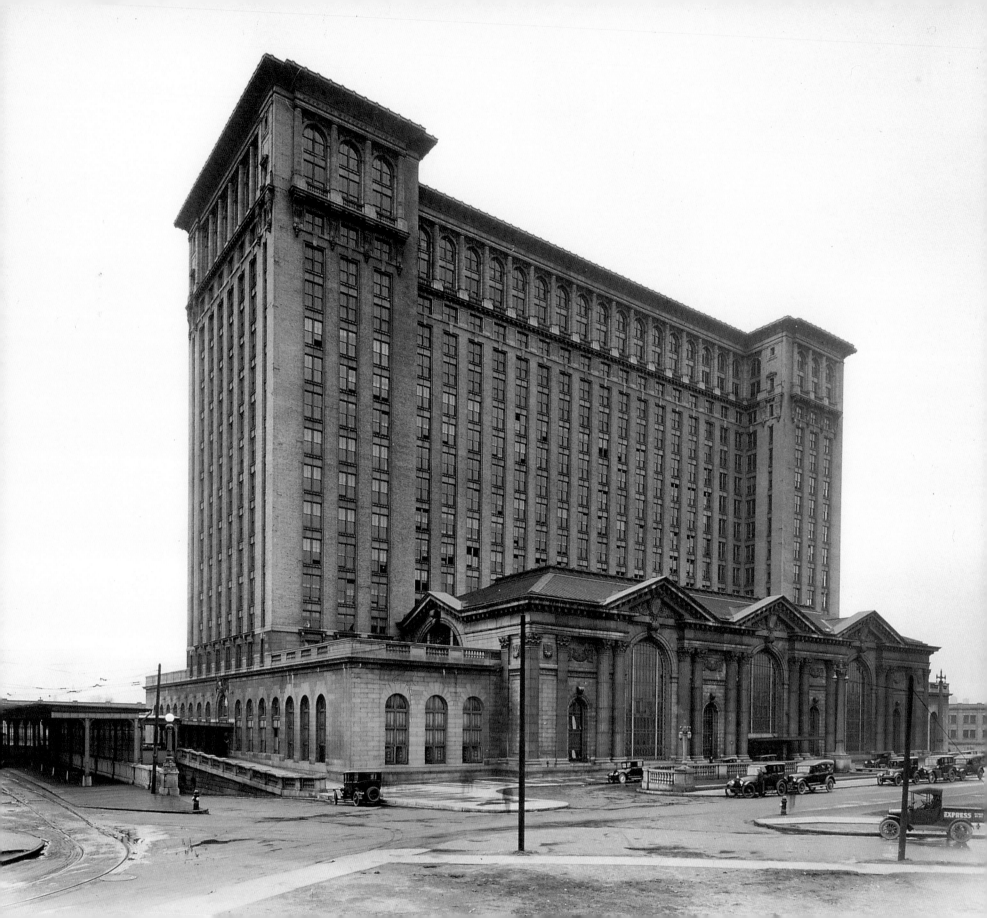

Michigan Central Railroad Station

TRAIN SERVICE DISCONTINUED 1988

For the millions who poured into Detroit in the early 20th century, the halls of the Michigan Central station were the first thing they saw. The marble columns and floors, vaulted ceilings, and gold-plated chandeliers were breathtaking. It was Grand Central Station on a smaller scale, but no less impressive. The same architects, Warren and Wetmore, and Reed and Stem had designed the New York City terminal a decade earlier.

This was the third depot for the Michigan Central railway line, which ran down Michigan Avenue to Griswold. The new station's location, about two miles from downtown Detroit, was chosen because rail yards for the railroad tunnel to Canada were there. When the previous depot on Third Street caught fire on December 26, 1913, the new depot was forced to open early, causing the plans for a grand opening to be cancelled.

Features of the new, two-story terminal included waiting rooms with leather-seated rocking chairs, potted palms, beamed ceilings and paneled walls reflecting the arts and crafts movement, a luxuriously appointed, white-table-clothed dining room with vaulted ceiling, and a main concourse illuminated by skylights.

A 16-story office tower connected to the back of the Beaux Arts building made it the tallest train station in the world. Roosevelt Park, added in front of the station in 1922, was surrounded by debate.

The Detroit City Plan and Improvement Commission sought the advice of Daniel H. Burnham, originator of the "City Beautiful" concept, and Edward H. Bennett to create an approach to the station. Burnham died shortly after committing to the project, which Bennett completed. His plan called for a boulevard to connect the station with

the area of the city that is now known as the Cultural Center. It was in keeping with Augustus Woodward's plan of a city of boulevards and parks, and with the City Beautiful's philosophy that cities should be planned with an eye toward incorporating classical architectural styles, which would soon be epitomized in the buildings of the Detroit Institute of Arts and the Detroit Public Library. But the boulevard didn't happen and 79 parcels of land were condemned to be appropriated for the park.

The building's owners changed over the years, from Michigan Central, to New York Central, to the Penn Central System to Amtrak. On January 5, 1988, the last train out of the station left for Chicago. Since then, several owners with grand plans have had no success in restoring or reinvigorating the classic building which stands gape-eyed to the skies. Scavengers have robbed it of everything precious and there are no tangible plans for its use.

OPPOSITE PAGE *"City Beautiful" philosophy purveyors, Burnham and Bennett, thought a wide boulevard should lead to the Detroit Institute of Arts. It didn't happen.*

LEFT *A portico on the station's side provided shelter for cars and their drivers.*

BELOW *In this undated image of the waiting room, leather-seated rocking chairs await the weary traveler.*

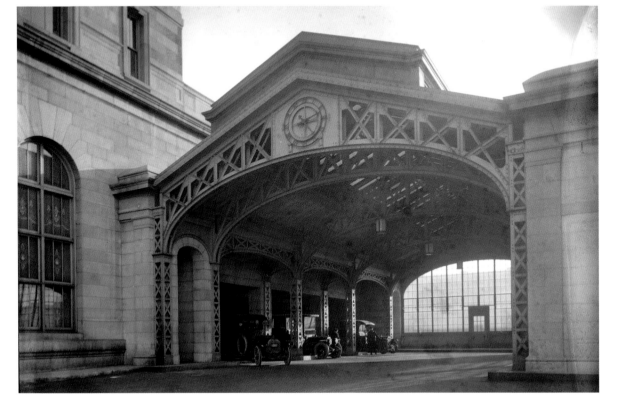

Frederick Stearns & Company

CONVERTED TO CONDOMINIUMS 1989

Frederick Stearns became interested in the retail drug trade at the early age of 15, when he apprenticed at a druggists' firm in Buffalo, N.Y. He pursued his trade there, becoming partner in another firm, before his marriage, and subsequent move to Detroit. Coming by way of Canada, he walked from Windsor to Detroit, across the frozen Detroit River, if historian Clarence Burton is to be believed.

In Detroit, he partnered with L.E. Higby in 1856 to open a business on Jefferson Avenue, later moving to the Merrill Block on Woodward Avenue, and finally farther north on Woodward to Larned. Stearns purchased Higby's share, and while managing the retail operations, set up a small laboratory to manufacture his own drugs. This was

the end of the business that really interested him. In Buffalo he had attended lectures at the University of Buffalo on the subject, and he continued to study and absorb any knowledge available to him.

At the time, many ailments were treated with patent medicines, a misnomer since most patented remedies were not officially patented. The sale and manufacture of these elixirs was a large industry, but unfortunately, few patients actually benefited, as the main ingredient was alcohol or small amounts of narcotics. Stearns, aware of the quackery inherent in such concoctions and the promises that came with them, did not sell patent medicines in his store, and sought to develop legitimate pharmaceutical products instead.

In 1876, calling it the "New Idea," Stearns started listing product ingredients on the label, including directions for usage. In 1878 Stearns used the term "New Idea" for the name of his monthly publication on pharmaceutical interests. These new preparations, also called "non-secret" medicines, were sold in retail drug stores worldwide, and a corps of 35 salesmen represented the firm. By this time Stearns needed more room for his pharmaceutical manufacture, so he sold his retail business and in 1882 incorporated Frederick Stearns & Company drug laboratories. Stearns retired from the business shortly after its incorporation, turning it over to his son, Frederick K. Stearns who by now had 15 years experience in the company.

Before the move to the new laboratories, Stearns made news by being the first Detroit business to install a telephone. A sign in his drugstore window at Woodward and Larned invited people to "come in and talk over the amazing new long distance telephone. Throw your voice almost 2 miles." The drugstore was connected to his laboratory on Fifth Street, a half mile west, by overhead wires.

The new building containing office, warehouse and manufacturing areas, built in 1899, was designed by William B. Stratton. It occupied an entire block on East Jefferson near Belle Isle, the largest in the world built for that purpose. In 1906 a nine-story tower was added, designed by Albert Kahn.

Stearns, Sr. turned his attention to his purposeful travels—traveling as a form of study, education and collecting. He eventually donated a sizable collection of Far Eastern art, gathered during his travels, to the Detroit Museum of Art. Musical instruments were another interest of his, and in 1890 he gave the University of Michigan over 2,000 instruments of all varieties. He died in 1907 and was eulogized for his philanthropic enterprises and holding "… higher aims than that of mere money-grubbing …"

In 1921, Frederick K. retired, passing along the management of the company to his son, Frederick Sweet Stearns. In that year the company had more than 2,000 employees on its payroll. The company was sold in 1944 to the Sterling Drug Company and in 1947 the 376,000 square foot building and all its belongings liquidated. The majority of the 600 employees were let go.

In 1989 the building was converted to lofts and is known as The Lofts at Rivertown.

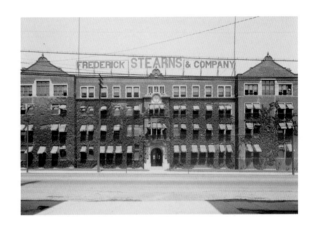

ABOVE *In 1899, this block-long building was the largest pharmaceutical laboratory in the world.*

LEFT *Memorial Hall in the company building reflected Frederick Stearns interest in art. He was a major donor to the Detroit Museum of Art, now the Detroit Institute of Arts.*

RIGHT *A telephone pole jutting into the Stearns sign spoils this shot of the beautiful building designed by William B. Stratton.*

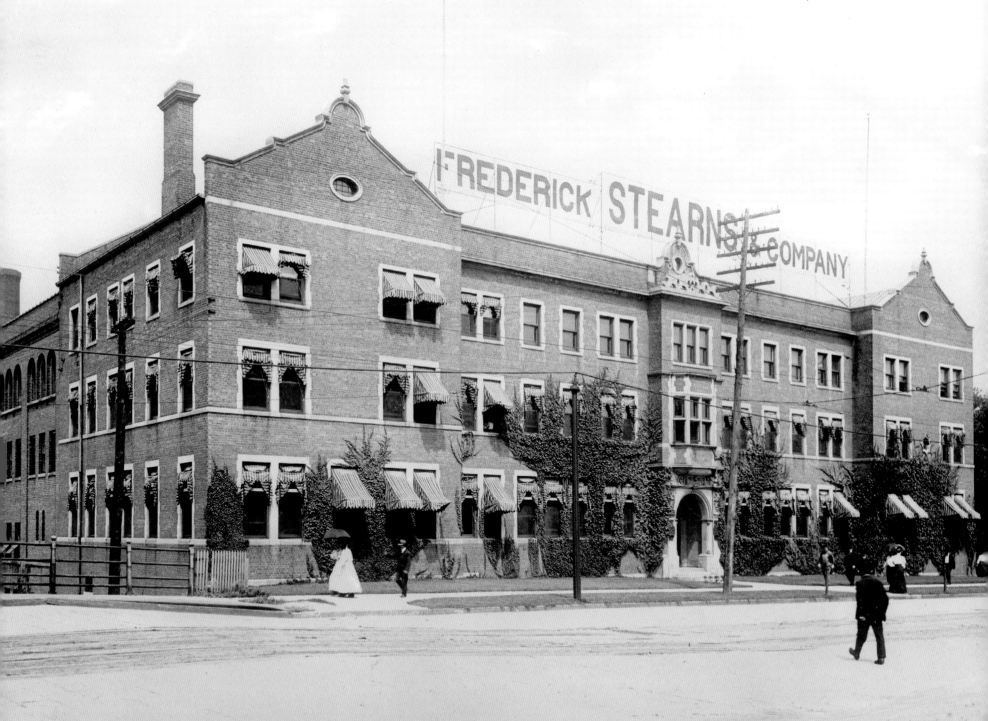

FREDERICK STEARNS & COMPANY

Tuller Hotel DEMOLISHED 1991

The Tuller Hotel, one of Detroit's oldest downtown hotels, opened in 1906, one year before the Pontchartrain, but unlike its neighbor the Statler, did not make it to the century mark. Located at the far west end of Grand Circus Park, it was built by Lew Tuller, who also put up the Eddystone, Royal Palm and Park Avenue hotels, but it was the Hotel Tuller for which he was known.

In 1909 the hotel advertised its newly refurbished Grille Room, offering a businessmen's lunch for 35 cents with "a menu to please the most fastidious." Its ballroom, added later at the top of the building, was promoted as Detroit's largest in a hotel. By 1913, an "After-the-Auto-Ride lunch" cost 65 cents and a special roadhouse dinner $1.50. A roof top garden featured the Postles String Quartet.

Renovations were made over the years to keep up with demand: in 1909–10 four stories were added to the original nine-story building; a 14-story addition was put on in 1914 increasing the number of rooms by 350; a final addition was built in 1923, giving the hotel 800 rooms with 800 bathrooms, a real selling point. The hotel's wood–paneled Arabian Room was popular for banquets and conventions and featured house bands led by Pete Bontsema or Gerald Marks in the 1920s. A lobby with marble columns with gilded capitals and a coffered ceiling welcomed guests.

The hotel was in receivership from 1931 to 1941, but, after barely surviving the Depression, in 1949 the Tuller underwent a top to bottom renovation, highlighting the improvements in a *Detroit Free Press* supplement. Its Cocktail Room was a popular meeting place, at that time featuring songstress "The Mink Lady," Suzanne St. Clair who always wore fur when she performed. The hotel building had several shops including St. Clair Furs, Gulian's Gift Shop, men's clothier Dave Roberts, a discount shoe store and the obligatory florist shop and cigar store.

Unfortunately the hotel suffered a tragic fire in January 1959, that started in the hat shop off the lobby. Four people died, three of them employees trapped in an elevator. Guests poured into the lobby of the Statler Hotel across the street to escape the asphyxiating smoke.

There were 300 residents in the Tuller at the time it closed, in September 1976. They were given a week's notice to find new shelter before they were turned out and the doors locked. In 1977 the Tuller was purchased by a group pushing for casinos in Detroit, but nothing came of the effort. The hotel stood vacant for 14 years before being demolished in 1991.

ABOVE *Taken after 1910, you can see the four stories added to the original nine.*

RIGHT *This 1906 photo shows Grand Circus Park, in front of the Tuller, a restful place for hotel guests to visit.*

LEFT *By this time the hotel had been amplified to offer 800 rooms, all with bathrooms.*

OPPOSITE PAGE *The Church of Our Father stood next to the hotel on Park; in the background is the Hotel Charlevoix, just recently demolished.*

Chalmers Motor Co **RAZED 1991**

There was a good deal of incest among the early Detroit car companies. Companies formed, merged with others, split off into new configurations, moved into abandoned plants like hermit crabs. The Chalmers Motor Corporation is a good example.

Hugh Chalmers was earning $72,000 a year at the National Cash Register Company by the time he was 35, a sum worth well over a million and a half dollars today. He had started there as an office boy at age 14 and worked his way to vice president. Budding automobile entrepreneurs Roy D. Chapin and Hugh Coffin convinced him to resign in 1907, offering him a partnership in their car company, E.R. Thomas-Detroit. Upon his acceptance they subsequently reorganized, renaming it Chalmers-Detroit Motor Company, and making Chalmers president. E.R. Thomas, of Thomas Flyer fame, was happy to sell half of his stock to Chalmers, giving the "three 'C's", Chapin, Coffin and Chalmers, controlling interest in the company.

Architect Albert Kahn already had a growing list of automotive clients during that period, Dodge Brothers, the Hudson Car Company, Packard and Ford, but didn't hesitate to design a new factory on East Jefferson in Detroit for Chalmers.

In 1908 the Chalmers-Detroit 30 made its appearance, designed by Howard Coffin. At this time there were 253 car manufacturing firms in the U.S. The model was highly successful but Coffin, Chapin and the other partners, wanted more control

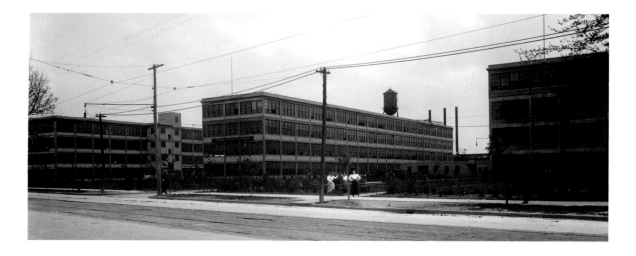

in the company. They split from Chalmers-Detroit and formed their own business, the Hudson Motor Car Company. Chalmers was a partner for a short time, but wanting to go a different direction, bought the Chalmers-Detroit holdings of the departing partners, and sold his shares in Hudson back to them. The Chalmers-Detroit Company became the Chalmers Motor Company in 1910. The tie was not completely broken: The Hudson Company wound up building their new plant across the street from the Chalmer factory.

Chalmers decided to concentrate on the large

car market. The 1910 car models were the Chalmers "30" and "40," the numbers were a general reference to the horsepower. Leather seats and gas-powered lamps were features and, unlike the Model T, a variety of exterior colors were offered. In 1916, their peak year, the company was reorganized as the Chalmers Motor Corporation. However, sales did not match increased production and Chalmers turned to the Maxwell Company for help. Maxwell leased their plants, and in 1922 the two companies merged, with Hugh Chalmers becoming chairman of the board. It was not a happy marriage. At that point the Chalmers Corp. was selling around 3,000 cars a year to Maxwell's close to 50,000, seriously affecting Maxwell's profits. The last Chalmers car was produced in 1923. Chrysler Motor Company absorbed the Maxwell-Chalmers Company, along with Willys-Overland in 1925, and later took over the Dodge Brothers Co. Incorporating the Chalmers-Detroit plant, it expanded its Jefferson Avenue operation, which reached its height of production in the 1950s. The Chrysler Jefferson Avenue plant closed in 1990. The Chalmers-Detroit factory built by Albert Kahn survived until 1991.

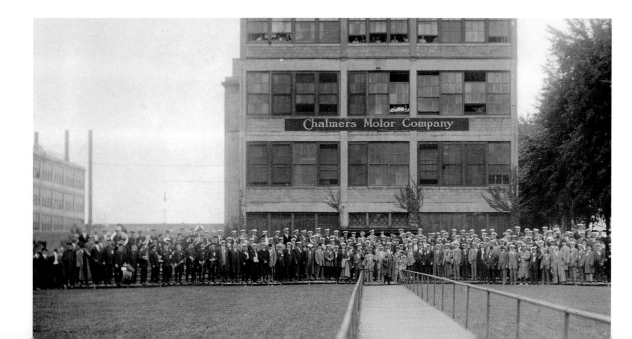

ABOVE *Albert Kahn added Chalmers to his growing list of automotive customers and built three equal-sized buildings, connected by walkways.*

LEFT *These are the workers who made Chalmers; in 1910 a Model 30 cost $1,500, or roughly $36,500 today.*

RIGHT *Spooner & Wells took this 1911 photograph of Chalmers cars outside the factory.*

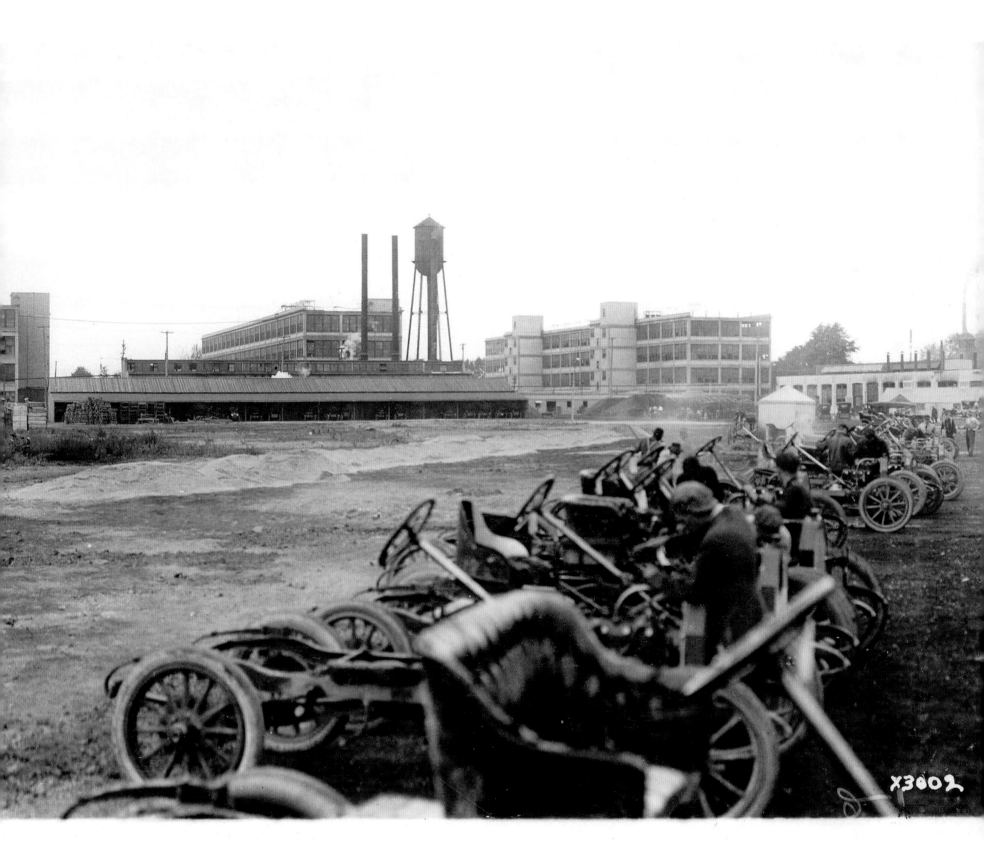

X3002

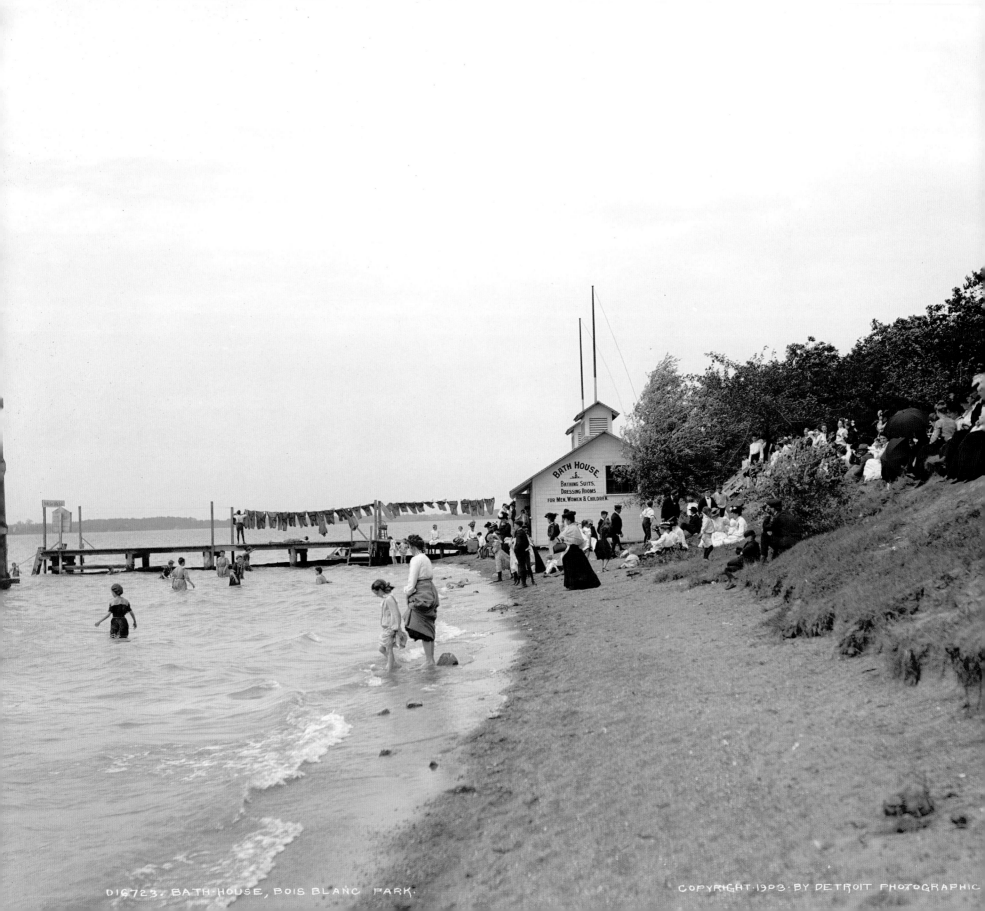

BATH HOUSE
&
BATHING SUITS.
DRESSING ROOMS
FOR MEN. WOMEN & CHILDREN.

016723. BATH-HOUSE, BOIS BLANC PARK.

Bob-Lo Island CLOSED 1993

Unlike Detroit's other premier recreation spot, Belle Isle, Bob-Lo could only be reached by boat, but that was part of the experience. Bob-Lo, an island in the Detroit River south of Detroit, was actually Canadian land, although Detroiters were its main visitors.

In 1866 Bois Blanc, as Bob-Lo was first known, was sold to Colonel Arthur McKee Rankin, who built a bathhouse, some cottages and a restaurant and had plans for developing the island, including connecting it to the U.S. mainland with a railroad bridge, via Grosse Isle.

Two Detroiters, John Atkinson and James Randall purchased Bois Blanc for $40,000 in 1887 and began laying out lots and streets. Randall sold most of his share to Atkinson, keeping his homestead on the island's north end. A property dispute in 1894 was won by Randall, but in the meantime Atkinson died and his heirs sold the major portion of the island to the Detroit, Belle Isle and Windsor Ferry Company.

The *Promise*, the first excursion steamer to make the 19-mile journey from Detroit, arrived June 20, 1898. For a 35 cent round trip fare visitors could, upon arriving, play baseball, ride bicycles, dance, swim, or just relax in a hammock. There were pony rides for children, the old blockhouse to explore, and refreshments. By 1901, Walter Campbell, president of the Detroit, Belle Isle and Windsor ferry line, had purchased all the property on the island with the exception of the lighthouse and cottage, the Randall property and some random plots. The *Promise* was a Detroit to Belle Isle ferry, so Frank E. Kirby, who built the *Tashmoo* for the competing White Star Line, designed the *Columbia* specifically for Bois Blanc excursions. He gave her a capacity of

3,200, two hundred more than the *Tashmoo*, and a wooden dance floor. In the summer of 1902 she made her inaugural trip.

One of the first attractions Campbell built was a dance pavilion, though intentionally without the huge array of electric lights popular in other parks, to discourage the late night element. Besides banning alcohol on the island and boats he stipulated that no "freak dancing" was allowed. The only acceptable dances were the fox-trot and waltz.

By 1906 a carousel was in operation and a new boat, the *Papoose*, for the Amherstburg crowds was added. The companion boat to the *Columbia*, the *Ste. Claire*, was launched in 1910. Before Campbell died, in 1922, a new dance casino was built, along with stone lavatories, a souvenir building, a ride called The Whip, and a new water filtration plant to combat pollution in the Detroit River.

By now visitors to the island had given up on correctly pronouncing the French, Bois Blanc, and the English version "Boys Blank" had migrated to Bob-Lo, though the name didn't appear in the company records until 1927. During the Depression

the park was closed two years in a row, 1933 to 1934, but reopened in 1935 when others made a move to turn the north end property, formerly owned by Randall, into a competing amusement park. The almost four decades old policy against alcoholic beverages ended in 1937.

The *Columbia* and *Ste. Claire* were sold in 1991 by the bankrupt Bob-Lo owners, but the park stayed open, though visitors had to cross from Amherstburg in Canada, or Gibraltar, downriver from Detroit. When the last owner, one of two partners from Seattle, had a severe accident in 1993, his backers sold the rides at auction, paid the park employees, including their benefits, and Bob-Lo, "where fun begins," was no more.

OPPOSITE PAGE *It appears observing was equally popular to swimming in this early Bois Blanc photograph.*

BELOW LEFT *Children are racing on Bois Blanc, the original name of the island before the French was permuted into Bob-Lo.*

BELOW *Dancers, restricted to the two-step and waltz, paid five cents a couple in the new dance hall, no charge to balcony onlookers.*

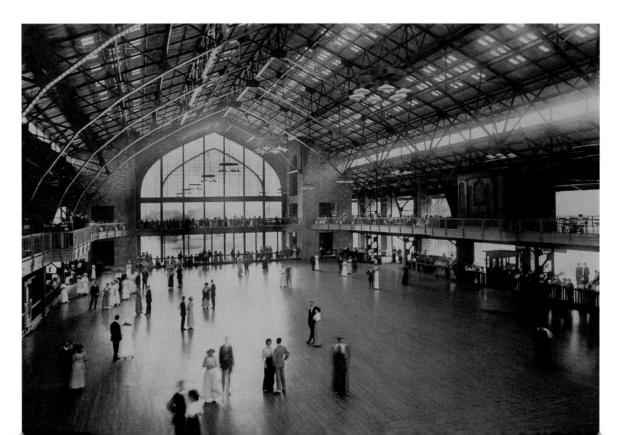

YMCA DEMOLISHED 1998

The Young Men's Christian Association (YMCA) originated in London, England in 1844, and arrived in the U.S. in 1851, first to Boston and one year later to Detroit. Jefferson and Woodward was the location of the first headquarters, which by 1875 had moved its way up to Campus Martius, following the pattern of the merchants and markets in the city. After moving around to various locations, in 1887 it occupied its first new building, at the corner of Griswold and Grand River, designed by Detroit architects Mason & Rice.

Here night classes began, leading to the formation of the Detroit Technical Institute. A 1902–1903 catalog lists classes in penmanship, bookkeeping, elementary and advanced mechanical drawing, architectural drawing, clay modeling, commercial law, languages, math and municipal affairs. Membership increased to 2,000.

The organization became concerned about the city's swelling population of young men flooding into Detroit to work in the automotive factories. A campaign for a new building raised close to half a million dollars in one month.

A cornerstone was laid at Witherell and Adams on April 11, 1908. The new location, just north of downtown Detroit, was at the far eastern corner of Grand Circus Park, close to where the new Detroit Athletic Club would open in 1915.

When the new YMCA opened its doors on January 1, 1909, a newspaper article heralded it as "the largest YMCA building in the world devoted exclusively to YMCA work." Detroit's population would reach 465,766 in 1910. The building was nine stories over a basement that contained a bowling alley, plunge pool, billiard and pool room, hand ball courts, a machine and forge shop, 31 showers in a "Palace of Baths," lockers and massage rooms.

There were gymnasiums on the first and second floors; classrooms, offices and an auditorium through the fourth floor were dedicated to boys' education. Floors five through eight housed 104 dormitory rooms.

The philosophy behind the YMCA was to promote programs that built a healthy mind, body and spirit. To this end the organization established reading rooms in places like the Post Exchange Building at Fort Wayne, and at the Grand Trunk railway station; this one also provided assistance to travelers. Their "Americanization" program reached out to companies with a large foreign population of workers, helping them to learn English.

By 1925 the "Y" was turning away an average of 50 young men a day looking for shelter and daily attendance reached 3,000. A 10-day fund raising campaign accumulated five million dollars, with major contributors being Mr. and Mrs. Henry Ford, Mr. and Mrs. Edsel Ford, the Fisher Brothers, Mrs. W.W. Hannan, and S.S. Kresge. Though eight branches were in operation in Detroit at the time, suburban branches were needed to meet the growing demands.

By 1956 the name was changed from Detroit YMCA to YMCA of Metropolitan Detroit. As branches were expanded, usage of the downtown building began to decline. When the Stadium Authority for Comerica Park, the city's new baseball stadium, purchased the "Y" in 1996 a protest was raised. People who worked downtown still used the facilities, but the offered price of "about five times the assessed value of $990,800" was too tempting. The 89-year-old building came down in 1998.

LEFT *The YMCA building was a landmark on the east side of Grand Circus Park for 90 years.*

RIGHT *The "Y's" educational courses and recreational activities were aimed at building healthy mind, body and spirit.*

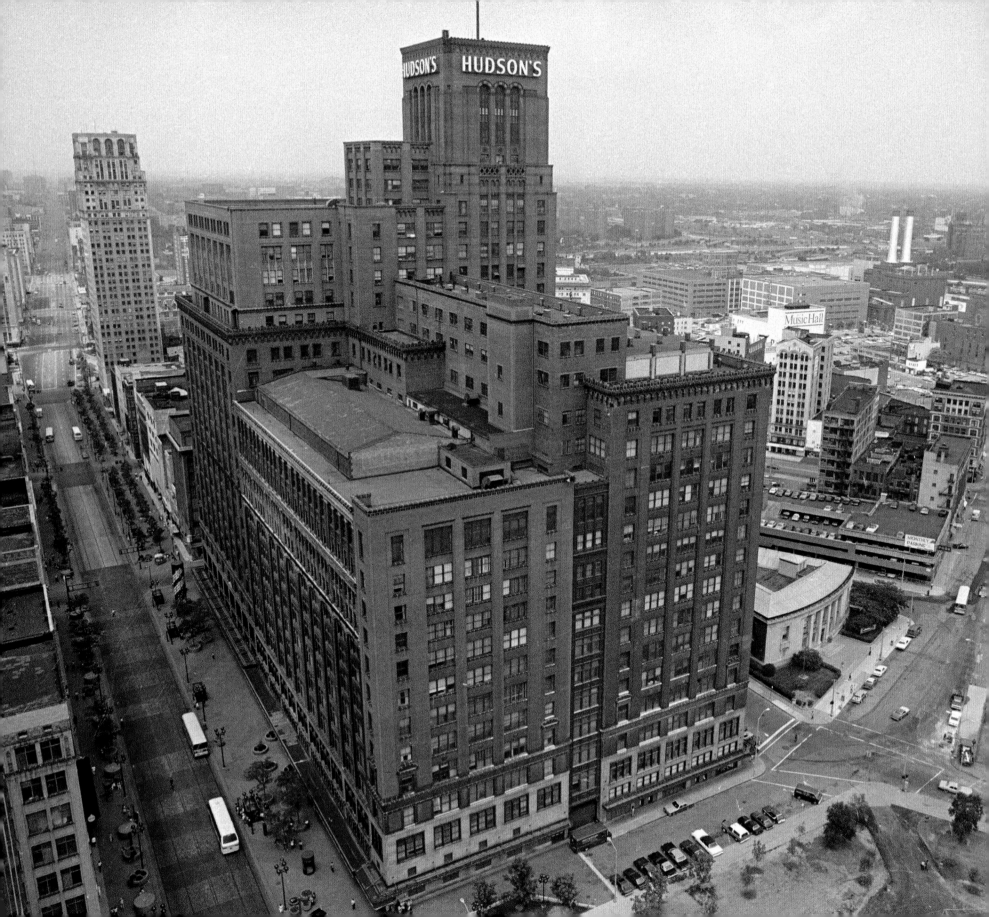

Hudson's DEMOLISHED 1998

It was the anchor that kept downtown alive. It was the massive building that filled Detroit's skyline. It was the family owned business that linked modern-day Detroit to its history. When the downtown Hudson's closed its doors in 1983, Detroiters couldn't help but hope that a new use would be found for the building. Fifteen years later, the sad shell met the wrecking ball, figuratively speaking, leaving behind the memories of generations.

Joseph Lowthian Hudson was a mover and shaker in 19th-century Detroit. Starting out in 1877 as a clerk in Mabley's store next door to the Russell House, he opened his own business in 1881 on the first floor of the Campus Martius Opera House. From there he moved to the west side of Woodward, the Henkel block between Michigan and State Streets before winding up at Farmer and Gratiot in 1891, where he would start to build his empire.

Over the next half-century, the store expanded, with some demolition and rebuilding along the way, to fill the entire block of Woodward, Gratiot, Farmer and Grand River. As it expanded it gobbled up some of its competitors, including Himelhoch's in 1923 and Newcomb Endicott which sold out in 1927. The Smith, Hinchman and Grylls-designed store wound up at 2.2 million square feet, the second largest department store in the world, next to New York City's Macy's. It had 25 floors, two half floors, a mezzanine and four basements.

But if the 25-story building was impressive and monumental in its spot in the middle of downtown Detroit, its features and services were even more so. Inimitable is maybe the best word, for what any early and mid-20th century department store the size and breadth of J.L. Hudson's had to offer. Besides the expected wares including all aspects of clothing, furniture, items for the home and restaurant services, Hudson's had a circulating library, auditoriums, an equestrienne shop, a Women's Lounge and Writing Lounge, dry cleaning, a designated Santaland, and sold hardware and artist supplies.

It published its own "Little Known Facts" that included best sales' year, 1954, of over $155 million in sales—well over one billion dollars today— and a record for the most dressing rooms in a single store, 705. It was the first department store in Detroit to be air conditioned.

What the Hudson's store couldn't control was the gradual demise of downtown Detroit, the city center. As people moved out of the city, shopping malls became the preferred destination, even though by 1978 there were at least nine branches in the metropolitan Detroit area, and several more outstate. The Central Business District made valiant attempts to keep downtown alive, revitalizing Greektown in the mid-1960s, creating Ethnic Festivals on the riverfront, and specifically for retailers, designating Downtown Detroit Days that began in the 1950s and extended into the 80s, trying to attract shoppers with massive advertising blitz and special events.

J.L. Hudson's great nephew closed the store on January 17, 1983. When the building was imploded on October 24, 1998, 50,000 people watched.

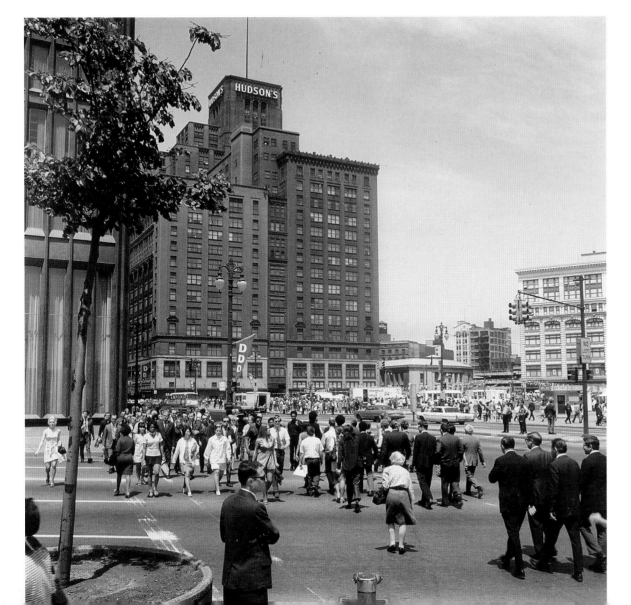

LEFT *"Downtown Detroit Days," meant to encourage shoppers to "buy local," are in full swing here.*

OPPOSITE PAGE *A view from Gratiot shows the tiny Detroit Public Library's Downtown Branch below the mammoth department store.*

Lincoln Motor Car Company DEMOLISHED 2003

Lincoln Motor Car Company began in 1917 as Lincoln Motor Company, a builder of airplane engines. It was a response to General Motor president William C. Durant's refusal to use his car production facilities to aid in the war effort. Henry and Wilfred Leland, who had already founded one automobile company, Cadillac, and stayed with it when purchased by General Motors, could not sit idly by when the country was in short supply of airplane motors. They offered their services to Washington, and went back to Detroit, bought some property and buildings, and got them ready to produce airplane engines.

The chief engineer at Packard, Jesse Vincent had already developed some plans and once the details were worked out, 10 manufacturers, including Cadillac (for Durant had changed his mind), joined in producing the parts for the engine. It was called the Liberty Motor.

The Lelands resigned from Cadillac. They christened their new company after Abraham Lincoln, as Henry Leland was an avid collector of Lincoln memorabilia; Lincoln was the first president for whom he voted. When the size of their government contract suddenly increased from 14 motors a day to 70, the Lelands knew they needed a bigger factory and found the spot for it on Warren Avenue on the far west side of Detroit. Construction started in October 1917 and machinery was operating in February 1918. Incredibly, over 90,000 special tools needed to be designed, built and obtained before production could begin.

Testing of the engines, reconfiguration of tools and equipment, personnel shortages and turnover all conspired to delay the production of the engines. The U.S. government was not happy and charges of incompetency and waste ensued. At the same time, Lincoln, Ford and Packard, the main companies producing the engines, had resolved the problems, and by the end of 1918 Lincoln alone had produced 6,000 engines.

Meanwhile, Henry Leland was designing a new car. It would reflect the apogee of his high standards and surpass the Cadillac in luxury and comfort. It would offer a V-8 engine and a "vibrationless" ride. And, depending on the model, it would cost from $4,600 to $6,600. A new Ford was selling for $370.

In 1920 the Lincoln Motor Car Company was incorporated. The factory on Warren Avenue had to be refitted for automobile production and 6,000 cars were planned for the 1920 model year. Despite the price tag, excitement among the public was palpable. However, lack of quality materials delayed the presentation of the car until September 1920. By this time, the economy was faltering and a number of orders were cancelled. But this wasn't the worst of it for the fledgling company. They received a four million dollar tax bill from the U.S. government for profits on the Liberty engine.

Henry and Wilfred were fighting to keep the company afloat. Even when the four million dollar tax charge turned out to be an error, only $500,000 was owed, it was too late; the directors of the firm had filed for bankruptcy.

Henry Leland had rescued the early Henry Ford Motor Company, turning it into the highly successful Cadillac Motor Company. Now Henry Ford would save Leland's Lincoln firm, though the circumstances were much, much, different. The negotiations had begun with a request by Wilfred for cash from Ford, to sustain the Lincoln company, but the end result was that on February 4, 1922, Ford purchased the bankrupt luxury car manufacturer for eight million dollars. As with the purchase of Cadillac by General Motors, the Lelands came with the company, but after only four months, they were fired, or as the *New York Times* put it, they "severed all connections," and called it a retirement. The 79-year old "master of precision," and the 20-year younger father of the Model T could not reconcile their views on running an automobile company.

Edsel Ford, Henry's son, was made president of Lincoln and was allowed to work independently from his father. Edsel retained the "elegant Leland engineering" and added his own flair for design, taking the Lincoln to a new level. It became known as the "car of presidents," and today, the Ford Motor Company, has reestablished The Lincoln Motor Company.

In 1952 Lincoln production was moved to Wayne, Michigan and the facility was later purchased by the Detroit Edison Power Company which used the site until 2002. In January 2003 the remaining factory and administration buildings were razed.

RIGHT *Detroit Tiger pitcher Herman Polycarp Pilette posing before a Lincoln car in 1923.*

BELOW *Women welding in this Lincoln factory was not an unusual sight during 1914–18.*

BOTTOM *The factory on Warren Avenue and Livernois began producing airplane engines before cars.*

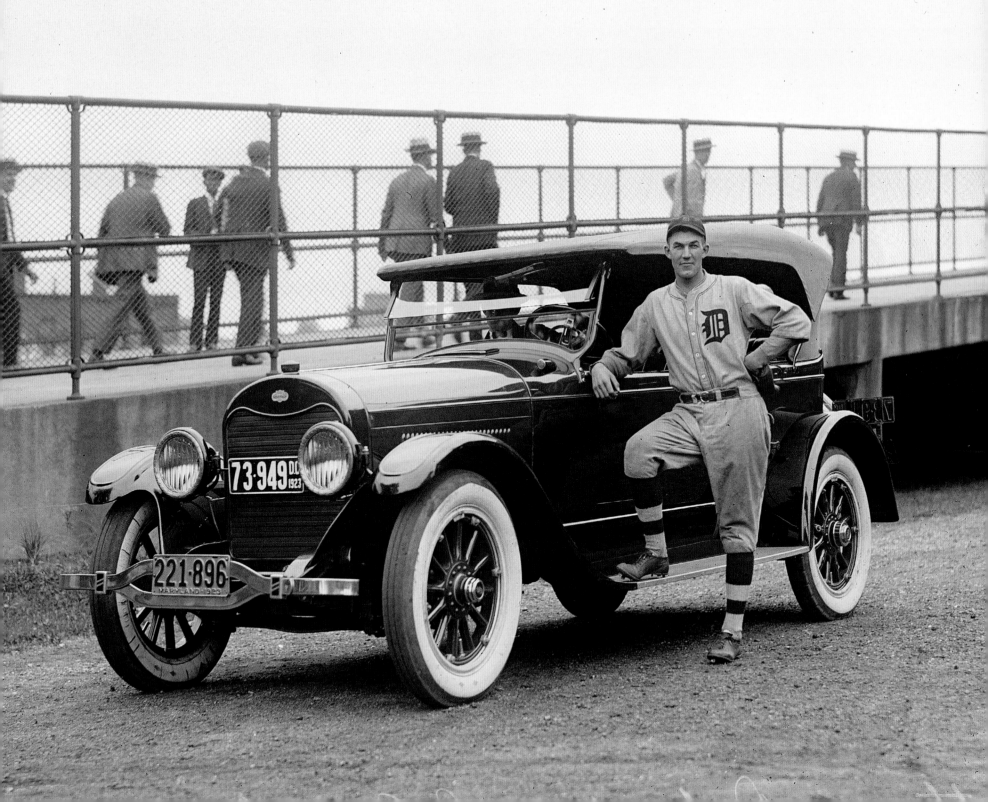

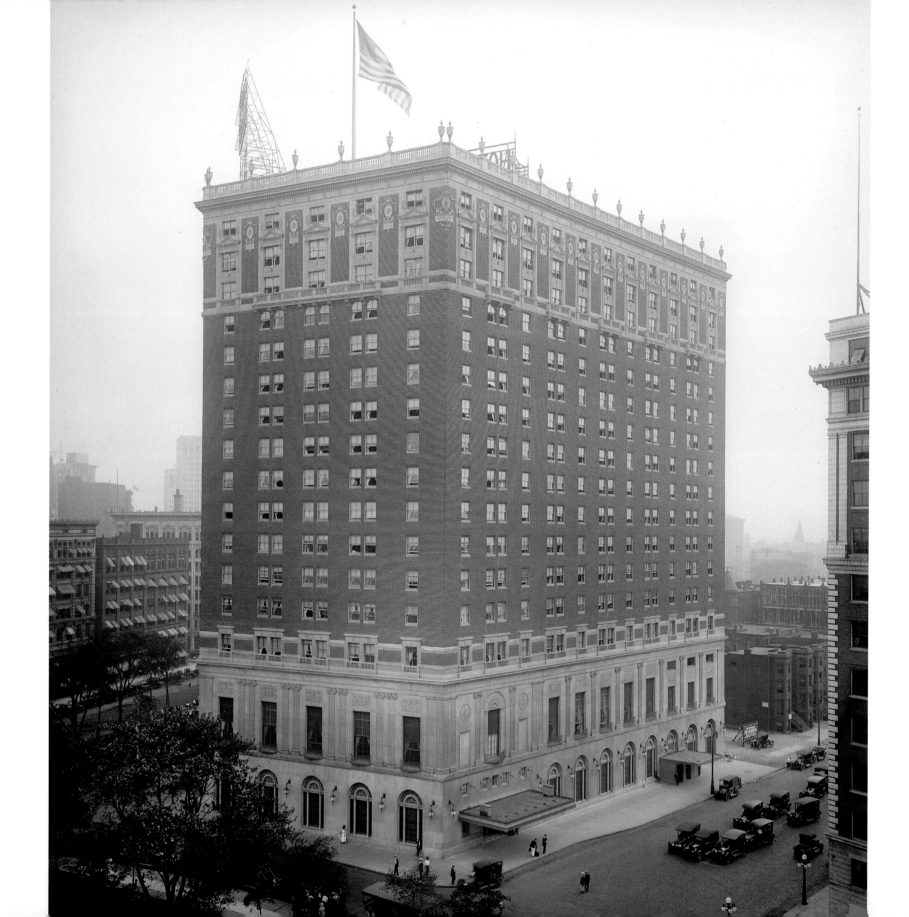

Hotel Statler DEMOLISHED 2005

The Pontchartrain Hotel on Campus Martius was Detroit's leading luxury hotel until 1915 when the Hotel Statler opened on Washington Boulevard. Offering private bathrooms with each of its 800 guest rooms, it quickly contributed to the demise of the "Pontch."

Ellsworth M. Statler started his chain of hotels for travelers, to provide clean and comfortable rooms, and a purposeful use of space. He began with a wooden structure in Buffalo, for the 1901 Pan-American Exposition and built his first permanent hotel, also in Buffalo, in 1907. He built another one in Cleveland in 1912 before beginning the Detroit project in 1913. Its location, on Grand Circus Park, put it slightly north of Campus Martius, the turn-of-the-century epicenter of Detroit.

The hotel was built on the triangular site of the John J. Bagley homestead, the first house in Michigan to have plate glass windows. Bagley, who made his money in the tobacco industry, served as governor of Michigan from 1873 to 1877. His "Italian villa" welcomed such notables as Ralph Waldo Emerson and Louisa May Alcott, as they passed through Detroit on the lecture circuit.

The 18-story Hotel Statler followed a restrained and classical Italian style. Designed by George B. Post, a New York architect who was responsible for many of the Statler hotels, it was considered a luxury hotel in Detroit when it opened in 1915, though Statler hotels were not originally intended as such. However, being the first Detroit hotel to provide air conditioned hospitality to its guests did put it a notch above the others.

Statler built six hotels in the Midwest before he died in 1928. Besides Buffalo, Cleveland and Detroit he put a Statler in St. Louis, Boston, and New York City. His success was attributed to the standardization of design and service, though some guests objected to the sameness of his hotels. Besides the copycat approach to hotel layout, placement of bathrooms, and amenities in the rooms, employees in all hotels were given written instructions to follow and told to memorize them.

The hotel underwent a variety of renovations over the years, starting with a 200-room addition in 1916. A few years later it added a 24-hour medical department for guests and employees, staffed by a doctor and nurse.

In 1937 the Detroit Statler was completely renovated, changing from the dark and heavy mode of early 20th century furniture and furnishings to a light and airy "contemporary" décor. On the ground floor the Grill and Men's Room were replaced by a shopping arcade and two restaurants were added, The Terrace Room and Lounge Bar.

In 1954 the hotel became part of the Hilton hotel chain, along with other Statler hotels. A remodernization effort in 1963 prolonged the life of the hotel for a little over a decade, when Hilton relinquished its management. Renamed the Detroit Heritage Hotel in 1974, the hotel was vacated in 1975 when Detroit Edison was forced to cut off service for lack of payment. It remained abandoned until its demise in 2005.

OPPOSITE PAGE *The classical looking Statler was designed by George B. Post, responsible for other Statler hotels in the country.*

BELOW *In 1946, in his first Detroit visit, Frank Sinatra appeared at the hotel's Michigan Room to address and thank record store clerks.*

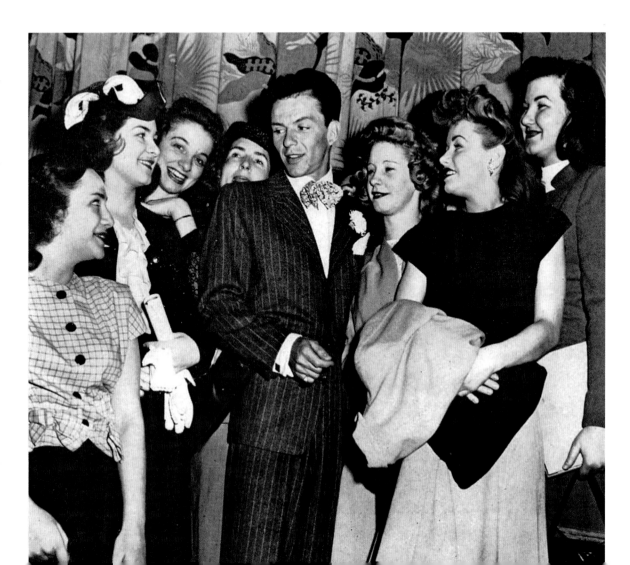

Madison-Lenox Hotels DEMOLISHED 2005

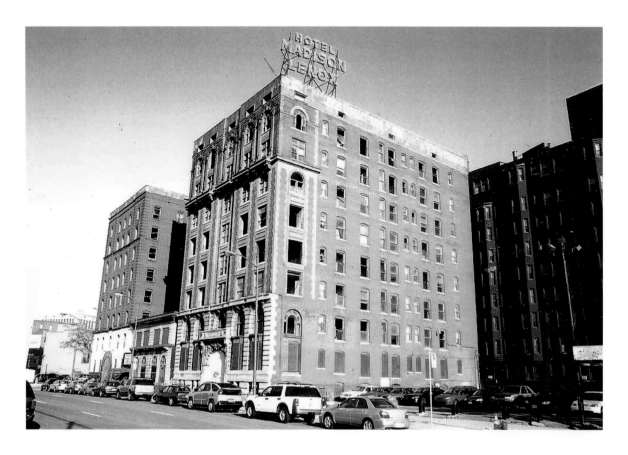

hotel training in Ireland. "They gave us a smattering of everything," he said, "from potato-scrubbing to flower arranging."

Business did not substantially improve, the tenants were mainly transients. A plan to renovate in 1987 failed to materialize. The hotels were bought by SVM Madison Lenox Corp. in 1989 with plans to make the hotel a luxury venue, part of a larger scheme to improve the Harmonie Park area. The 70 residents of the hotel were made to leave and given restitution, but the company claimed it was unable to maintain the building and closed it in 1992.

In 1998 the Madison-Lenox was purchased by Mike Ilitch, owner of the Detroit Tigers, Red Wings, Little Caesar's and the Fox Theater, which he and his wife restored. The hotel was one long block from the new baseball stadium that would open in 2000. Ilitch Holdings kept the buildings until 2005, unresponsive to preservation efforts and decisions made by the Detroit Historic District Commission against demolition. Proposals were made for use of the buildings, but according to the Ilitch family, "the numbers did not work for any proposals … it's best to answer the great parking demands."

The Madison-Lenox Hotel started out with two identities. The Madison, a seven-story building of pressed brick, cut stone and terra cotta, was built first, in 1900 by F.C. Pollmar, followed in 1902 by a similar, yet distinct building, The Lenox, by A.C. Varney. A two-story restaurant next to the Madison was deconstructed to form a connection between the two when the Lenox was built, and they became the Madison-Lenox Hotels, though variations of the name appeared over the years.

The unassuming, yet dignified buildings of the Madison-Lenox Hotels were at the corner of Madison and Grand River Avenue in downtown Detroit and were apartment, or residential hotels, though daily room rental was offered, as well as weekly and monthly. The Madison Hotel on the corner, had a view across Madison Street of the Detroit Athletic Club, and of Harmonie Park on its Grand River, east side. It was next door to the Harmonie Club. The Lenox fronted only on Madison Street.

A 1927 brochure boasted of the hotels' location: "The newest and largest theaters are close at hand…the great retail district is only two blocks removed." J.L. Hudson, Kern's and Crowley-Milner's were nearby, and the Capitol and Madison theaters just up the street. The brochure advised that "no heavy traffic passes our doors. Street car and bus lines are all around but each one is more than a block away." In two blocks' walk a visitor arrived at Grand Circus Park, with its fountains, benches and lush greenery.

In 1955 the buildings got a facelift, replacing clutter with simple lines, dark colors with light ones, chandeliers with indirect lighting, ornate fabrics with plain ones. A *Detroit Free Press* article on the renovation gives credit to hotel manager Tom Murphy, who attributed his decorating skill to his

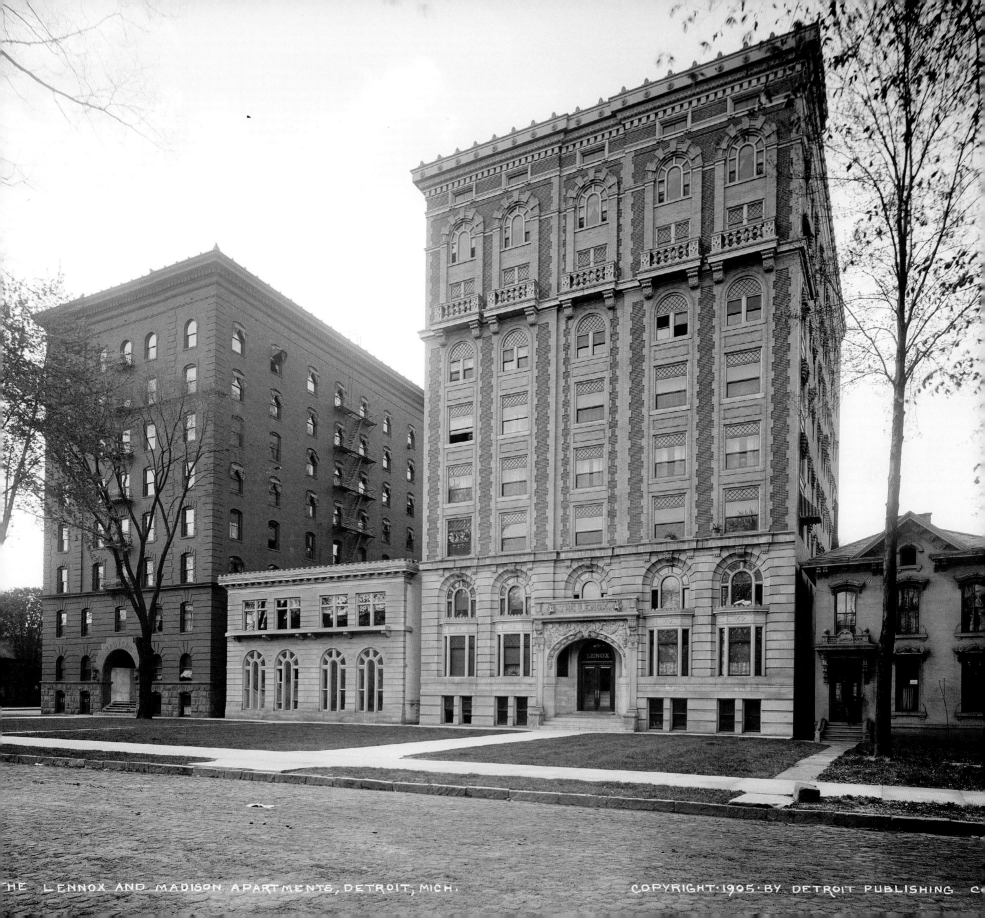

THE LENNOX AND MADISON APARTMENTS, DETROIT, MICH.

Tiger Stadium **DEMOLISHED 2009**

The original ballpark was named after Charlie Bennett, an 1880s Detroit Tigers' catcher who lost part of a leg in an accident. Bennett Park was located in Woodbridge Grove, a popular spot for picnicking and finding hazelnuts, and in 1875 site of the city's west side hay market. When Bennett Park opened in 1896 at the corner of Michigan Avenue and Trumbull, the corner would be synonymous with baseball for the next 100 years.

The Detroit Tigers were part of the Western League from 1895 to 1900 when the League changed its name to American. The first American League game at the ballpark was the 1901 season opener against Milwaukee. Charlie Bennett was there to catch the first pitch, something he would continue to do for the next 31 years.

Bennett Park was a wooden, rickety affair whose outfield was compared to a cow pasture early on. Cobblestones left over from the land's market days, and clay soil could make chasing a fly ball a slippery mess. The stands went from holding 5,000 fans to 13,000 by 1910, not including the wildcat stands built outside the left field fence. However, from the beginning, fans outnumbered available seating and standing room. This, combined with the poor state of the clubs' locker room, led the Tigers' owner, Frank Navin to erect a new stadium that was ready for the 1912 season.

Over the owner's modest protests the new ballpark was named Navin Field. Center field, formerly at National and Cherry streets was moved 90 degrees to Cherry and Trumbull and the new infield stands took care of the wildcat problem.

Another reason for the new stadium was the Tigers' winning seasons, 1907–1909, when they captured the American League pennant three years in a row. Unfortunately, they would not win another pennant until 1934, even with the legendary Ty Cobb. One of the franchises' most famous players, Cobb came on board in 1905, and would stay with the Tigers until 1926, acting as player-manager from 1921 to 1926.

The new stadium was built for 23,000 fans, though 26,000 managed to attend the 1912 opening game. Boston inaugurated its Fenway Park the same day, April 20. By 1936 the stadium had been renovated several times, a second deck added to the left infield stands, with a press box on top, to increase the capacity to 36,000.

Frank Navin died in 1935 and the team was purchased by manufacturing mogul Walter O. Briggs, who had been part owner since 1920.

Double decking was extended along the first base line, into right field and double decked grandstands were added to left and center field as Cherry Street, on the northern boundary, was closed. Seating capacity rose to nearly 53,000 in the renamed Briggs Stadium. The Detroit Tigers were not the only team to play on the athletic field. From 1938 to 1974 the Detroit Lions hosted their National Football League games in the bowl-shaped arena. No night games were held until 1948, however, when the stadium was the last in the American League to install lights.

When Walter Briggs, Sr. died in 1952, the team was passed on to his son, Walter O. Briggs, Jr., until it was purchased by a syndicate headed by John Fetzer, Kenyon Brown and Fred Knorr. John Fetzer took sole possession in 1960, and in 1961 the ballpark got a new name, Tiger Stadium.

The stadium and team had many highlights over the years: team announcer Broadcast Hall of Famer Ernie Harwell; 11 American League pennants; the only one of the original eight charter franchises to

retain the same name and city since the team's origin; and Al Kaline, the youngest player in the league to win the batting title.

When current owner Mike Ilitch announced that the team would build a new stadium, fan uproar could not change the decision. Debate arose over the cost of a new stadium, and the history the team and fans would lose. There was a ceremonial close at the Tigers' last game on September 27, 1999, with a procession to move the home plate to the new location.

Ideas were plentiful for the property's reuse, but none proved feasible, or found backing. Stadium "hugs" were held to publicize the plight of the old park by preservationists trying to save it. All was in vain as demolition began in 2008 and was completed in 2009. "The corner" was no more.

OPPOSITE PAGE *Briggs Stadium was the ballpark's name from 1938 until 1961.*

RIGHT *An aerial view of the ballpark taken from the bleacher side of the stadium, which also hosted the Detroit Lions.*

BELOW *Tiger Stadium remained shuttered after the last game, September 27, 1999, and was demolished in stages beginning in 2008.*

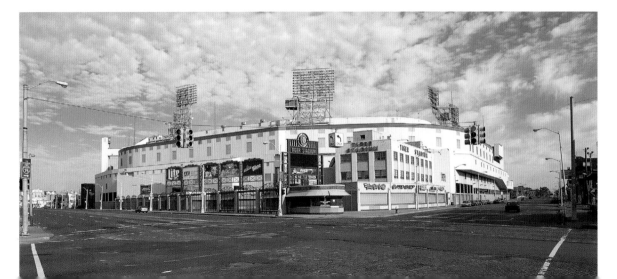

Henry and Edsel Ford Auditorium

DEMOLISHED 2011

The Saarinens' plan for the Detroit waterfront would have Ford Auditorium facing west, overlooking a long expanse of plaza, opposite the Veterans Memorial Building. Instead it was built with its back to the Detroit River, looking on to Jefferson Avenue.

In 1924 the City first commissioned Eliel Saarinen to create a plan for a Detroit Civic Center, a plan that was not realized. In the mid-1940s, he was hired again, this time working with his son Eero and associates, to design space containing a veterans memorial building, a convention center, a music hall and landscaping on 43 acres of riverfront property. Mayor Hazen Pingree had advocated for more park space and convention facilities on the riverfront back in the 1890s.

Eliel Saarinen died in 1950, his son Eero in 1961 and though their plan was not used, its tenets were observed in the location of the buildings, if not in the exact orientation.

The Henry and Edsel Ford Auditorium, more commonly known as Ford Auditorium, was built in 1955 with funds from the city, the Ford family and Ford Motor Company automobile dealers. Architectural firm O'Dell, Hewlett and Luckenbach created the simply designed mass enhanced by 8,000 blocks of mica-flecked Swedish blue pearl granite. The basketweave pattern on the curved front wall and the walls enclosing the stage was a subtle statement. White marble covered the rest of the building, unifying it with its civic neighbors. There was a U-shaped drive in front of the building and underneath the drive, parking for 750.

The 2,900 seat auditorium was not originally planned as the home for the Detroit Symphony Orchestra (DSO). In 1939 the DSO left Orchestra Hall, the venue that was built for it in 1919, to play in the Masonic Temple. They disbanded twice in the following decades, performing again in 1951 for Detroit's 250th anniversary. In the meantime, Orchestra Hall became Paradise Theatre and home to jazz greats like Duke Ellington and Lena Horne. The Paradise closed in 1951.

Mrs. Eleanor Ford thought the DSO needed a permanent home so theater designers Crane, Kiehler and Kellogg were asked to make the bare-bones auditorium suitable for the sounds of a symphony orchestra. The attempt was not wholly successful, as over the years, complaints about the auditorium's acoustics were legion. When it opened in 1956 sound was not optimum in the auditorium, but the building had a state-of-the-art recording studio in which the DSO recorded some of its finest albums.

Despite improvements, in 1989 the DSO left the auditorium to return to their former home, a newly restored Orchestra Hall. In 1970 the historic building was scheduled to be demolished, but a Save Orchestra Hall campaign prevailed and the orchestra returned to an acoustically perfect home.

The symphony's departure prompted Ford Auditorium's long demise. The building was still used for graduations and Ford stockholder meetings but revenue dwindled. Other uses, such as an aquarium, were proposed, but no ideas took hold. When the decision was made to remove the building, in the interest of redesigning the riverfront, approval from the Ford family was sought and obtained.

Inside the building were some treasures to be rescued. The foyer contained three metal relief sculptures by the famed Marshall Fredericks. When the building was demolished, two of the sculptures went to the Marshall Fredericks Sculpture Museum in Saginaw and the third moved to storage. An Aeolian-Skinner pipe organ was dismantled and given to St. Aloysius Church and a smaller pipe organ donated to the DSO.

Ford Auditorium was demolished in the summer of 2011.

RIGHT *When the Detroit Symphony Orchestra left Ford Auditorium for Orchestra Hall in 1989, the building began its long decline.*

FAR LEFT *Built in 1955, Ford Auditorium reflected part of the Saarinen firm's early plan for the waterfront.*

LEFT *The acoustics in the auditorium were not optimum for a symphony orchestra, despite several attempts to improve them.*

INDEX

OTHER TITLES IN THE SERIES

ISBN 9781862059344

ISBN 9781862059924

ISBN 9781862059931

ISBN 9781909815049

ISBN 9781909815032

ISBN 9781909108448

ISBN 9781909108431

ISBN 9781909108639

ISBN 9781862059351